"In the Mix"

SUNY Series in Women, Crime, and Criminology
Meda Chesney-Lind and Russ Immarigeon, Editors

"In the Mix"

*Struggle and Survival
in a Women's Prison*

Barbara Owen

State University of New York Press

Author photo on back cover by Greg Lewis.

Published by
State University of New York Press, Albany

For information, address State University of New York Press,
90 State Street, Suite 700, Albany, NY 12207

Production by E. Moore
Marketing by Dana Yanulavich

Library of Congress Cataloging-in-Publication Data

Owen, Barbara, 1953–
 "In the mix" : struggle and survival in a women's prison /
Barbara Owen.
 p. cm. — (SUNY series in women, crime and criminology)
 Includes bibliographical references and index.
 ISBN 0-7914-3607-1 (hc : alk. paper). — ISBN
0-7914-3608-X (pbk. : alk. paper)
 1. Central California Women's Facility. 2. Women prisoners-
-California—Social life and customs. 3. Women prisoners-
-California—Case studies. 4. Reformatories for women—California-
-Case studies. 5. Female offenders—United States—Psychology.
I. Title. II. Series.
HV9475.C3C876 1998
365'.9794—dc21 97-9013
 CIP

10 9 8 7 6 5

Contents

An Introductory Note

From March 1994 to November 1996, a team of research investigators from the Human Rights Watch Women's Rights Project (1996) visited prisons for women in four states and the District of Columbia. The investigators queried prison administrators, correctional officers, program staff, and women prisoners at each of the facilities they visited. They even spoke on occasion with relatives of women incarcerated in these institutions, and interviewed formerly incarcerated women as well as attorneys and others who work with incarcerated women. In a report released in late 1996, the investigators reported their findings:

> Our findings indicate that being a woman prisoner in U.S. state prisons can be a terrifying experience. If you are sexually abused, you cannot escape from your abuser. Grievance or investigatory procedures, where they exist, are often ineffectual, and correctional employees continue to engage in abuse because they believe they will rarely be held accountable, administratively or criminally. Few people outside the prison walls know what is going on or care if they do know. Fewer still do anything to address the problem (p. 1).

The Human Rights Watch Women's Rights Project investigators were not, by and large, doing criminological work. They were doing human rights work. Most of the investigators were attorneys or law school students, so they were probably guided by the traditions of legal investigative work. Their work was also informed by at least a general sense of feminist methods. Most important, however, is the fact that they went into women's prisons to learn what was going on inside. This doesn't happen too often, or often enough. As

they said in their report, "Few people outside the prison walls know what is
going on."

Contemporary criminologists, far too often, don't know what's happen-
ing inside either.

Criminologists, it can be argued, were once more knowledgeable about
what went on inside women's prisons (and men's prisons too). Twenty-five to
thirty-five years ago, criminologists in the United States produced a series of
qualitative studies of life in several women's prisons across the country:
David Ward and Gene Kassebaum (1965) at the California Institution for
Women, Frontera; Rose Giallombardo (1966) at the Federal Reformatory for
Women, Alderson, West Virginia; and Esther Heffernan (1972) at the
Women's Reformatory, Occoquan, Washington, D.C. In the intervening years,
however, during a time when the number of women's (and men's) prisons has
boomed, the number of women (and men) incarcerated to prison has soared,
and the technology for imprisoning women (and men) has advanced in a
way—in a pattern—unparalleled in any period of similar length in corrections
history, no American criminologist or sociologist has reported a full-length
study of ethnographic research conducted in a women's prison. With the
exception of journalist accounts of women's experiences in jails and prisons
by Sara Harris (1967) and Kathryn Watterson (1973, 1996) and fictional
accounts by writers such as Andrea Freud Lowenstein (1984) and Patricia
McConnel (1989), there have been few academic, qualitative treatments of
life in women's prisons.

Barbara Owen breaks this cycle of neglect. For a three-year period,
Owen regularly went into the largest women's prison in the world, the Cen-
tral California Women's Facility (CCWF). While inside, she observed and
spoke with a diverse universe of women (and some men), some of whom just
worked there, most of whom lived there. Her findings, reported in the pages
that follow, are published in this first volume of a new SUNY Press series on
"Women, Crime, and Criminology."

In the Mix is about the struggle and survival of women confined in a
correctional facility with nearly four thousand women housed at all security
levels in a state with one of the highest rates of incarceration in the world. The
story of these women's lives is not a simple story and it is not a story told sim-
ply. Owen, who teaches criminology at California State University–Fresno
and has worked as a researcher for the Federal Bureau of Prisons, uses her
intellectual skills, her experience conducting research in prisons, and her
observational acumen to good advantage. The tasks of observing and assess-
ing such a large prison world of prisoners, staff, and managers are daunting.
Owen no doubt could have used a team of investigators herself. But she
wisely focuses on what she calls "a partial story of life within the fences of
CCWF." Also included in this volume are data Owen carefully culled from a

separate study of almost three hundred interviews with women prisoners throughout California she conducted with her colleague Barbara Bloom (Owen & Bloom, 1995a), a sociologist who has written important works on women offenders, community corrections, and family and extended family services.

Owen's research centers on the culture of a contemporary women's prison. Keenly informed by the experiences and voices of women prisoners, she closely examines how incarcerated women themselves learn about, navigate, and shape the prison experience. For Owen, this process often starts in the streets (and the county jails), well before women arrive at the prison. This process, too, reflects these women's experiences—exploitative and otherwise—with males and the larger society. And, finally, Owen argues, it evolves in anticipation of life after prison. By venturing into this complex world, Owen pries open a door for other research investigators to continue and to broaden the project she reports here. Owen's discussion of gaining entry into this world, and the methods she used to compile her data, is an important addition to the literature. Most important, her conceptual examination of being "in the mix" builds on and expands beyond prior works in this oft-neglected area of criminological research.

In the Mix is an exciting opening to what we hope will be a stimulating and dialogue-producing series of important books covering the wide and interrelated fields of "women, crime, and criminology." In early 1970s, a number of important, ground-breaking articles and books appeared on "women and crime." Unfortunately, while the literature on women as victims of crime grew in the intervening years, scholarship on the woman offender and her experience of the criminal justice system has lagged. In recent years, research activity has again begun to revolve around diverse realms of the "women and crime" universe. Any number of reasons are suggestive of why this may be the case: the soaring number of women in prison, the growing interest in the problems of young girls on the economic and political margins of society, and heated policy debates about strategies to reduce violence against women, fear of crime, and the general victimization of women.

It is clear that critical, feminist perspectives are needed on girls' and women's experiences with the juvenile and criminal justice systems. This series invites academics, practitioners, scholars, and other writers to submit for consideration in this series manuscript ideas (and actual manuscripts) that involve original empirical research, new historical study, qualitative fieldwork, and policy-oriented analyses. It is our hope that this series will be interdisciplinary and international in scope. We are also hoping that this series will become a vibrant avenue for publishing major works in the field. Owen is first to set foot in the fresh snow of this series, but we hope other authors will fol-

low adventurously down her trail while still other authors will forge new trails of their own. Please send your ideas, thoughts, and writings to Series Editors, "Women, Crime, and Criminology," State University of New York Press, Albany, NY 12246-0001.

RUSS IMMARIGEON
MEDA CHESNY-LIND
SERIES EDITORS

Acknowledgments

Many persons contributed greatly to this project. At California State University—Fresno, I am indebted to the Chair of my department, Dr. Max Futrell, and the Dean of the School of Social Sciences, Dr. Peter Klassen, for their personal and material support. Both the School and the University contributed financial support through release time and research funds. I am particularly grateful to Judy Garrett for her consistent interest during the course of the project. My graduate students, Brenda Siefford and Susanne Taylor, assisted with manuscript production and interviewing. Throughout the past six years, Robin Button helped me in every way possible, as a transcriber, administrator, and friend.

In the California Department of Corrections, several persons in the Research Branch provided access and technical support: Robert Dickover, Katie White, John Berecochea, and Judi Angell deserve mention. I also received significant encouragement from members of the SCR 33 Committee. At the Central California Women's Facility, gracious assistance was provided by almost all the staff, particularly the line officers who put up with my intrusion for over two years. I want to thank Ramiro Munoz, who facilitated my long-term fieldwork; Daniele Lopez, whose support was critical to the beginning of the project; and Max Lemon, a former student and colleague from whom I have benefited greatly.

I have also received ongoing encouragement from the community of scholars who study women prisoners. Joy Pollock, Jill Rosenbaum, Candace Kruittschnitt, and, most important, Gene Kassebaum offered their advice and encouragement. Gene Kassebaum deserves extra credit for telling me to "get it done" at several stages of the writing. Meda Chesney-Lind has given us all a model to follow, both as an intellectual and as a lovely person. Russ Immari-

geon and Meda Chesney-Lind serve as editors for this series, with Russ giving me additional editorial assistance in the final stage of writing.

The profile data collection was supported by grants from the Robert Presley Institute and the National Institute of Corrections. Some of the profile interviews were conducted by Linda Grubb and Elizabeth Leonard, as well as Barbara Bloom and me. Cheoleon Lee assisted in the analysis of the survey data.

I hope my work shows the far-reaching influence of several of my teachers and colleagues: John Irwin, Marsha Rosenbaum, David Matza, Troy Duster, Connie Weisner, and William Saylor. Terry Arendell has influenced my thinking as a student of the feminist perspective and qualitative research. Brian Powers continues to be an essential friend and colleague.

Several prisoners were invaluable to me. Linda, PJ, Sandra, and Margie were key to my understanding of this world and became colleagues through their unselfish contributions to this work. Without their willingness to share their experiences with me, I would still be wandering around, wondering what to do.

Two women deserve acknowledgment for their involvement in this project from beginning. Warden Teena Farmon allowed me into her prison and gave me unlimited and uncensored access to her world. This sponsorship was crucial in the initiation and completion of this book. I would have been left outside the fence without her personal and professional approval. My research partner and road dog, Barbara Bloom, has a long investment in the study of women prisoners and she, too, has accompanied me on this road. Our work together on these overlapping projects has been a real joy. I am more than grateful to both of these wonderful people and hope they know how much I appreciate their contributions.

Finally, to my husband, Vince, for proving that romance is not dead.

Chapter 1

In the Mix:
Struggle and Survival in a Women's Prison

Both criminology and sociology have traditions of examining the culture of men's prisons,[1] but the experiences of imprisoned women have long been ignored. Giallombardo (1966), Ward and Kassebaum (1965), and Heffernan (1972) have written classic studies of women's prisons, giving us vivid and enduring pictures of the prisons of that time. But women's prisons today are larger, more plentiful throughout the country, and housing populations that grow greater in number each year (Immarigeon & Chesney-Lind, 1992). The day-to-day world of female prisons now requires a new description and analysis. Recent scholarship on women in prison covers the history of female institutions (Freedman, 1981; Rafter, 1983, 1985, 1992), the nature of female criminality (Pollock-Byrne, 1990; Simon & Landis, 1991), demographic characteristics of female prisoners (Owen & Bloom 1995a & b; Fletcher, Shaver, & Moon, 1993), and female prisoners and their children (Gilfus, 1992; Baunach, 1985; Bloom & Steinhart, 1993), among other topics. But the modern era of women's imprisonment and its prison culture requires closer descriptive examination.

This book reports the results of ethnographic research conducted at the Central California Women's Facility (CCWF), the world's largest female facility. The initial question that remains the central core of this study, is "How do women in prison do time?" Once familiar with the world of imprisoned women, however, my inquiry soon found other questions equally important. How do women learn to do time? How does this meaning of time differ across the wide variety of women who come to prison? Does the length of one's sentence shape one's approach to doing time? How has prison culture for women changed from the findings of earlier empirical research? How have

the contemporary problems of overcrowding, the "war" on drugs and gangs, and racial division among prisoners affected the way women do time?

In my observations of the women in this institution, I learned that female prisoners organize their time and create a social world that is quite different from contemporary men's prisons. I suggest that, like most experiences, imprisonment and its subsequent response is a gendered one. Just as their offense patterns seem tied to differences between men and women, so too is the social organization of their prison lives. In investigating how women organize their lives in prison, I found some support for the importation theory of prison culture, that is, that each prisoner's pre-prison experience has critical impact on the way she negotiates and lives through the experience of imprisonment. At the same time, evidence was found for the indigenous theory of prison culture, that is, that the social organization of women in a contemporary prison is created in response to demands of the institution and to conditions not of their own making. The facts of these prisoners' lives as women and girls, the pervasive influence of patriarchy, limitations created by economic and social marginalization, and the stigmatization of criminality shape both offense patterns and their response to imprisonment.

The chapters of this book describe the variety of accommodations to this imprisonment. The opening chapter offers an overview of the theoretical context for this study. In the second chapter, I describe the project site and the research methods, including "quasi-ethnographic" techniques of intensive interviewing, active observation, and a feminist perspective used to collect and later assess data. Chapter 3 describes the lives of women before imprisonment and suggests ways in which these experiences come to bear on prison culture. As discussed in chapter 4, time and place in the prison contribute to the direction of this response and the nature of women's accommodations to their living and social environment. Chapter 5 describes the relationships women develop and maintain during their imprisonment. These relationships with significant others inside and outside the prison walls have a critical impact on the way women do their time. Family members "on the street," particularly children, hold a special place in this prison culture. Within the institution, the relationships women develop and maintain with each other structure their lives, their behaviors, and their prison culture. The final chapter concentrates on the dimensions of prison culture, or the "axes of life," as Schrag (1944) describes elements of prison culture. In concentrating on the daily experience of life in this prison, this book describes the ways women create a complex society within its walls. This culture develops in ways markedly different from the degradation, violence, and predatory structure of male prison life. In some ways, the culture of the female prison seeks to accommodate these struggles rather than to exploit them. The title of this study captures my intent.

The "mix," in this context, is the "life" as described by Heffernan (1972) and is characterized by a continuation of the behavior that led to imprisonment, a life revolving around drugs, intense, volatile, and often destructive relationships, and non-rule abiding behavior. But I also found that, especially for women serving short prison terms or serving repeated prison terms, their lives in prison are intimately tied to their lives before and after their imprisonment. To be sure, men on the economic and racial margins of society face oppression that contributes to their criminality. But differences in gendered experience account for the differing pathways to imprisonment for men and women. Men do not share the same struggles with patriarchy or the pervasive sexual and personal oppression found in the lives of women.

THE STUDY OF PRISON CULTURE

The world of women in prison is markedly different from that of male prisons. Still, the study of women's prison lives has been of only minor interest in the sociological literature. Beginning with Clemmer (1940) and his analysis of the prison community, a strong social science tradition concerns the ways in which men organize and "do their time." Studies in this tradition include descriptions of the nature of the inmate social system (Sykes, 1958; Sykes & Messinger, 1960), the inmate code (Sykes, 1958; Irwin & Cressey, 1962), race relations (Carroll, 1974; Davidson, 1974), and the history of these forms of social interaction (Irwin, 1980). Thus, the picture of the prison in the minds of the public and in the pages of the literature is decidedly male-oriented. For the most part, male prison culture has been described as violent and predatory (Irwin, 1980). While there is little description of contemporary prison culture among men, current discussions suggest that men band together in these organizations to act out this violence and to gain protection from others. Much of the writing on men's prisons also examines the impact of racial divisiveness on this culture (Carroll, 1996). McCorkle (1993) further suggests that male prison culture is marked by individual accommodation to violent behavior.

Although the bulk of sociological attention to the prison has been directed toward the male world, classic studies of women's prisons exist. The first of these seminal works, Ward and Kassebaum (1965) and Giallombardo (1966), discuss a social structure based on the family and traditional sex roles and same-sex relations. In the third, Heffernan (1972) describes "the square," "the cool," and "the life," descriptive titles for three forms of orientation and adaptation in the inmate world. From these first sociological studies on women's prisons in the mid-1960s, several studies (Larsen & Nelson, 1984; Leger, 1987; Propper, 1982) have described the female inmate culture in

terms of the pseudo-family structure and homosexual relations, following themes developed by Ward and Kassebaum (1965) and Giallombardo (1966). These studies uniformly suggest that women create lives in prison that reflect elements of traditional family roles and the street life. This social structure revolves around their sexual identity and attendant social roles, mirroring their relations with males on the outside. Descriptions of inmates as mothers are related to this theme (Baunach, 1985; Datesman & Cales, 1983; Koban 1983; Henriques, 1982) and argue that a key problem for female inmates is their relationships with their children.

More broadly, several studies have been conducted on the impact of the women's movement on criminality (Adler, 1975; Hoffman-Bustamonte, 1973; Klein, 1973; Smart, 1976; Steffenmeiser, 1980). Introducing the theme of "partial justice," excellent histories of the women's prison have been conducted, suggesting that women prisoners traditionally have been afforded lower priorities and unequal treatment (Dobash, Dobash, & Gutteridge, 1986; Freedman, 1981; Rafter, 1983, 1985). These studies have also introduced the concept of the female prisoner as the "double" deviant, implying female prisoners break both gender roles and the criminal law. This monograph extends these descriptions and adds contemporary detail to the study of women in prison.

LANDMARK STUDIES OF THE CULTURE OF WOMEN'S PRISON

Three important studies provided an early understanding of the world of the women's prison. Ward and Kassebaum (1965), Giallombardo (1966), and Heffernan (1972) conducted in-depth investigations of three prisons during the 1960s. These studies found striking similarities: the world of women's prisons was quite different than that of the male culture; prison culture among women was tied to gender role expectations of sexuality and family; and prison identities were at least partially based on outside identities and experiences. Below, I summarize each of these studies with an eye toward foreshadowing the major issues and ideas that were found in my study of the world of women's prisons. As I reviewed these landmark studies, once before starting my fieldwork and again while analyzing the data, I was struck by the overall consistency and stability of their analyses. As subsequent chapters show, much of women's prison culture has changed little. Personal relationships with other prisoners, both emotionally and physically intimate, connections to family and loved ones in the free community (or, "on the street" in the language of the prison), and commitments to pre-prison identities continue to shape the core of prison culture among women. At CCWF, three additional components contribute to the shape of contemporary prison culture. First, the

size of the prison and its population have a profound impact on the day-to-day life of the four thousand women held there during my fieldwork. Second, the tremendous increase in drug offenders has placed its stamp on prison life. Third, race and ethnic identities provide a subtext to prison life, although they are clearly secondary to the dominant issues of personal relationships.

Ward and Kassebaum's Frontera

In *Women's Prison: Sex and Social Structure*, Ward and Kassebaum (1965) searched for female prisoner types that correspond with the male prisoner types found in the penology of the period. Through interview and survey data collected at the California Institution for Women (CIW) in Frontera, they found little evidence for the roles of the centerman, the right guy, the merchant, the tough, and other male identities described by deprivation and indigenous prison culture theorists (Sykes, 1958). Instead of focusing on the pains of imprisonment, the authors describe the development of identity and prison role adaptation in examining the phases of incarceration and the dynamics of the "homosexual relationship."[2]. As prisoners are processed into the prison, they experience status degradation, disorientation, and apprehension over the coming prison term. Combined with the indeterminate sentence system in place at the time of their study, these events removed feelings of autonomy or control. The prisoner social system, with an emphasis on female role expectations and the homosexual relationship, is, then, an attempt to regain some feeling of control and autonomy in the women's prison. Although they suggest several other adaptations that require further investigation, Ward and Kassebaum concentrate their study on the personalized relationships among the women at CIW. In direct contrast to a male prison culture grounded in prisoner solidarity, Ward and Kassebaum found little group cohesiveness in the prisoner population at Frontera. Instead, they suggest that identity and allegiance among the women are found in small, intimate family groups. One implication of the absence of prisoner solidarity is a greater tolerance for informing, or snitching.

While agreeing that one's adaptation to the prison world is based on degree of criminal experience or maturity, Ward and Kassebaum suggest that women prisoners suffer from "affectional starvation," the need to have emotional and reciprocal relations with another, and possess "psycho-sexual" needs for interaction with men. At CIW, they found that a female culture was developed to meet these needs through emotional and sexual dyads composed of female and male roles. While distinctions are made between women serious about their sexual identity and those "just playing around," homosexuality is seen as a functional adaptation to the gendered deprivations of imprisonment as experienced by the women.

Ward and Kassebaum conclude that this prisoner culture reflects tradi-
tional gender and sex roles in the free community. The absence of biological
men necessitates the creation of socially defined men through the substitution
of homosexual relations for heterosexual relations.

Giallombardo's Alderson

In *Society of Women*, Giallombardo (1966) describes the social order of
the prison in terms of sex role adoption and family/kinship structures. She
argues, much like Irwin and Cressey (1962), that the informal social order of
the prison is based on identities imported from the outside world. Giallom-
bardo suggests that identity in the society of women is based on adoption of
a variety of traditional feminine roles, such as wife, mother, or daughter.
Expression of this femininity, in her view, requires a juxtaposition with male
roles that are in short supply within the women's prison. She suggests that this
need for juxtaposition creates masculine roles in the all-female world. The
male role thus includes adoption of male dress, hairstyle, language, and other
specifically masculine behaviors. In Giallombardo's study, the traditions of
femininity find expression in the role of the "femme," with the masculine role
adopted by the "stud." Her evidence suggests that most women prefer the
femme role, leading to a scarcity of studs. This shortage in turn creates a form
of polygamy, in which the stud may be involved in multiple relationships at
one time.

For Giallombardo, the family or kinship structure is also based on this
sex role framework. For those prisoners who choose not to "play" (the prison
term for same-sex involvements), the family structure within the women's
prison is the basis for primary group membership. This family structure also
reflects socialization patterns of the outside world. Family bonds in the prison
take on similar forms as those in the outside world: women use the terms of
mother, sister, daughter, and sometimes cousin to denote intimate, nonsexual
relationships with other women. These relationships serve to define intimate
bonds and create trust and solidarity among the prisoners. Giallombardo's
study concludes with a discussion of the traditional and conventional role def-
initions available to women in the free world. She argues that imprisonment
blocks women from attaining the traditional goals of wife or mother and sug-
gests that the social order of the prison provides an alternative way to achieve
these internalized expectations.

Heffernan's Occaquan

In *Making It in Prison: The Square, the Cool, and the Life*, Heffernan
(1972) found that the existing descriptive and theoretical models of prison
culture were based on a male version of the prison and thus were inadequate

for describing life in the women's prison. She begins her work by asking questions about the inmate social system, its functions and levels of gender differences. She also builds on the work of Ward and Kassebaum and Giallombardo by investigating the interrelationship between inmate behavior and outside sex roles. Using Sykes's (1958) hypotheses, Heffernan looked for an inmate social system that functions to address the "pains of imprisonment." Specifically, she searched for key roles and norms that enable the inmate social system to act cohesively and to reject the rejecters. She found no clearcut support for Sykes's role adaptations among her women prisoners, but her descriptions of argot labels implied a variety of accommodations to prison life. She called three such patterns the Square, the Cool, and the Life. The Square denotes the woman tied to conventional norms and values. Those in the Life embrace a more deviant criminal identity based on the culture of the street world of prostitutes, thieves, drug users, petty criminals, and the like. Those described as the Cool have developed a certain form of doing time that involves control and manipulation within the prison.

Heffernan argues, much like Irwin (1970), that a woman's initial orientation to prison was often based on pre-prison identities, with the noncriminal adopting the Square adaptation, the habitual petty criminal living the Life, and the professional organized criminal acting as the Cool. She found that women who create a life in the prison, often through "familying," were the "happiest around here," except when they were arguing with their "wives" because they were living in the prison and not thinking about the outside world (Heffernan, 1972:41). Like the women at CCWF who are invested in the mix, the women in Heffernan's prison sometimes lacked an outside orientation but instead enjoyed some status in the prison. For those women, prison became "everything." With this involvement in the life of the prison often came trouble (Heffernan, 1972:42). Like previous studies, Heffernan found that the family was a critical element to the social order of the prison. While some women saw the family as rubbish or manipulation, other women organized their time around this pseudo-relationship. In sections on "Doing Time" and "Keeping Busy," Heffernan discusses how women organize their prison life around pre-prison identities and differential adaptation of the three-part prison culture.

The prison culture described in these landmark studies has remained relatively stable over the decades between them and the present investigation. This study argues that the world of the women's prison is shaped by pre-prison experiences, the role of women in contemporary society, and the ways women rely on personalized relationships to survive their prison terms. Women's prison culture, then, is decidedly personal, a network of meanings and relationships that create and reproduce the ways women do their time. As the following chapters show, this culture is mediated by structural forces and

personal choice both within the prison and outside each woman's immediate control. Economic marginalization, histories of abuse, and self-destructive choices speed women along a pathway to imprisonment. The degree to which these behaviors continue to shape these lives, in turn, is dependent on the nature of one's experience in the prison and attachment to competing systems and identities of meaning.

SURVIVING THE MIX

Two central themes weave throughout my description of prison culture for women. First, as women begin to organize and negotiate their time in prison, the importance of developing a liferound (or a "program," in prison terms) emerges. The imposition of an individualized structure on the uncertainty of this world is accomplished by developing and maintaining this program. Work assignments and ongoing relationships with other prisoners and with prison staff are initial steps to avoid the self-destruction of the mix, giving women some control over their immediate living environment, particularly in their rooms. Finding privacy, providing for material needs, and developing personal, educational, or vocational skills are further steps toward surviving the mix. Most women want to do their time, leave the prison, and return to the free world. They want to avoid the mix of risky and self-defeating behavior. Women can get caught in the mix through self-destructive behaviors such as drug use and fighting or damaging relationships that interfere with one's program or limit freedom through placement in restrictive housing or the addition of time to one's sentence. Most women avoid the mix. Some dip into the mix at the beginning of their prison terms, leaving when they establish a more productive program. Others invest permanently in the destructive spiral of the mix and its attendant activities. For a small minority of women, the lure of the mix, with its emphasis on the fast life (Rosenbaum, 1981) and the excitement of drug use, fighting, and volatile intimate relationships, proves too hard to resist.

Second, the world of this women's prison, like those described in the classic studies, highlights the critical significance of personalized relationships. Both the play family and the intimate dyad form the basis of prison social structure, as well as offering a means to avoid and survive the mix. The play family, with its interpersonal satisfactions, its web of mutual social and material obligations, and its ultimate sense of belonging, creates the sense of community and protection that the tips, cliques, and gang structure provide for male prisoners (Irwin, 1980). These relationships with other prisoners mediate how women learn to do their time and may also provide some protection from the self-destruction of the mix. Thus, surviving the

mix is grounded in a woman's ability to develop a satisfying and productive routine within the prison and the nature of her relationships with other prisoners.

THE SITE OF THIS INVESTIGATION

The Central California Women's Facility (CCWF), holding over four thousand women in mid-1995, is the largest prison for women in the world. Located in the middle of California's Central Valley, this prison houses every type of female prisoner: women from all over the state, women of all security levels, short-termers, long-termers, and, as of this writing, the seven women facing the death penalty. Although of average size by male prison standards, this institution is the largest female facility anywhere. CCWF is a complex world, populated by several thousand women prisoners, hundreds of staff, and prison managers who, each on their own terms, attempts to negotiate its complexity and find a place in the prison community. The complexity of this community has an additional implication for those wishing to study, describe, and somehow understand this world of women prisoners. Life at CCWF resists a complete description, partially due to its size, partially due to its shifting nature.

FEMALE CRIMINALITY

In setting the stage for this discussion, this section reviews ideas about female criminality, the nature of the prison, and its relationship to the status of women in society. Simon and Landis (1991) review contemporary theories of female criminality and classify these approaches into four themes: the masculinity hypothesis; the opportunity thesis; the economic marginalization thesis; and the chivalry thesis. The economic marginalization theory best fits my understanding of the criminality of women that leads to this study of women in prison. The work of Chesney-Lind (1991, 1986), Feinman (1986), and Steffensmeir (1982) supports this thesis in demonstrating that female criminality is based on the need for marginalized women to survive under conditions not of their own making. In this view, women's criminality reflects the conditions of their lives and their attempts to survive. Beyond and on the margins of conventional institutions, many women struggle to survive outside legitimate enterprises.

Compounding problems of patriarchy and racism, drug use often contributes to this marginality. Drug problems and violation of the ever-increasing drug laws bring women in contact with the justice system and aggravate existing personal and social problems. Drug crimes account for an increasing

proportion of offenses committed by women and girls. Bureau of Justice Statistics (1991a & b, 1992) and FBI statistics (Greenhouse, 1991) agree that women are much more likely than men to be incarcerated for a drug offense and that this increase in arrests is driving the skyrocketing imprisonment of women. Drug use is tied to criminality, oftentimes as a result of emotional and psychological traumas caused by abuse and prostitution, as well as living on the street (Miller, 1986) and "in the life" (Rosenbaum, 1981). According to an American Correctional Association survey (1990), about 20 percent of the nationwide female offender population is imprisoned for a "drug abuse violation" and 25 percent reported that obtaining money to pay for drugs was the reason behind their crime. Several measures show that women are more likely to use drugs, use more serious drugs more frequently, and be under the influence of drugs at the time of their crime than males (National Institute of Justice, 1991; Bureau of Justice Statistics, 1992).

DEMONIZING THE FEMALE OFFENDER

The trend toward demonizing the female offender (Chesney-Lind, 1993) also contributes to the further marginalization of female prisoners. This trend (Baskin, Sommers, & Fagan, 1993) suggests that the nature of violence among females is increasing, but evidence from California paints a different picture. Several years ago, the California legislature convened a work group to examine the needs of female prisoners and parolees (SCR33 Commission, 1993–4). California Department of Corrections (CDC) data for the years between 1982 and 1992 show that there has been a significant increase in the proportion of commitments for drug-related offenses and a decrease in both property and violent commitment offenses. Table 1.1 highlights this trend:

Table 1.1
Offense Profiles for California Prisoners

| | December 1995 | | | |
| | Females | | Males | |
Totals	8,940		125,183	
Violent Offenses	1,969	22.0	53,880	43.2
Property Offenses	3,023	33.8	30,908	24.7
Drug Offenses	3,565	39.9	31,785	25.4
Other Offenses	383	4.3	8,436	6.7

Source: California Department of Corrections, Offender Information Services Branch (1996).

These numbers show significant differences in degree and type of criminality of females and males, illustrating the gendered nature of offense patterns. Most notable is the difference in the nature and percentage of violent crimes committed by male and female offenders. In almost every category, males are convicted almost twice as often for violent crimes. A different picture emerges with property and drug crimes. Women are somewhat more likely to be convicted for property crimes, typically more minor offenses such as petty theft with a prior conviction. Comparisons for drug offenses show other significant differences. Women are more likely to be convicted for drug crimes, particularly low-level offenses such as possession. Almost 40 percent of the women held in California prisons in 1995 were convicted for drug offenses, while just about 25 percent of the men were convicted for that offense. Women are much more likely to be convicted for possession offenses (almost 29 percent; compared to males at under 17 percent) and somewhat more likely to be incarcerated for drug sales. These figures also provide a profile of women and their conviction offenses that identify three fundamental features: the majority of women are convicted for nonviolent crimes; women are more likely to be convicted of less serious property offenses; and women are much more likely than men to be convicted of drug crimes, with possession of drugs the modal offense for women.

These official CDC data show that the majority of women are incarcerated for crimes that are far less threatening to the community than those committed by men. These findings reject statements that women offenders "are getting worse" and suggest, instead, that the system itself is becoming more punitive in incarcerating women for drug-related crimes (Bloom, Chesney-Lind, & Owen, 1994).

The offense profile also suggests that women tend to commit survival crimes to earn money, feed a drug-dependent life, and escape brutalizing physical conditions and relationships. Rather than finding a new demon female offender, these data suggest that women in prison have been marginalized from traditional roles, becoming castaways from conventional life rather than "liberated female criminals" (Adler, 1975). Most of the women interviewed in this study held quite traditional views of gender roles. They generally saw themselves as wives and mothers, not as newly liberated, vicious criminals. These traditional views of life, when combined with drug habits, histories of physical and sexual abuse, lack of economic preparation or job skills, and decreasing financial and child-rearing support, create strata of displaced women. Once displaced from the economic security of conventional society and the dependent roles of most women, prison becomes an institutional option for women who are not able (or do not chose) to act within expectations of conventional life or traditional female roles.

Two particular dimensions to these traditional expectations are note-

worthy here. First, the promise of the status (and protection) of motherhood is not realized in the lives and experiences of women in prison. Early pregnancy, especially when combined with leaving parental homes and dropping out of school, becomes a part of the downward spiral for many women. These events further diminish labor market participation because of child-care responsibilities and lack of marketable work skills. Without the traditional economic support of a working spouse, the expected rewards and economic protections of motherhood are absent.

Sexual and reproductive capacities of women can also be tied to further marginalization and criminality. Sexual abuse and early sexual activity combine to create conditions whereby women enter into lifelong patterns of destructive and self-defeating behaviors. Much of this self-destructiveness takes the form of substance abuse. Early sexual activity, a desire for status gained through sexual desirability, and the need to escape from intolerable home situations often lead to early pregnancies. For these women, their roles in the world are defined in terms of their sexuality and reproductive status. This definition, for most women, is a double bind, often leading to decreased opportunities, moving farther and farther away from full economic participation in society. The lack of birth control, family planning, and supports aggravates these obstacles. All of these concerns are exacerbated when women are marginalized by minority membership or low level of educational achievement. Early sexual activity, and its delimited, brief status, is often a rite of passage for women. Sexual activity and motherhood are often the only bargaining chips in society available to these marginalized women. Such activity has negative consequences for their life-chances. Ironically, these activities are the very things that most women are socialized to do, and the consequences, particularly the birth of children, further limit their participation in viable economic activities. Women on the margins are often dependent on sex role socialization that assumes a middle-class, patriarchical view of the female role.

Second, many of the women interviewed subscribe to the "Prince Charming Myth" that a man will arrive to provide the care and support promised by the myth of motherhood. Commitment and investment in such romanticism are directly contradicted by these women's experience, but its existence was borne out in interviews with staff and prisoners. For most women who come to prison, societal messages of motherhood and being a good wife have limited utility. The role of women vis-à-vis men is also an important aspect of this understanding of female criminality. Abusive fathers and husbands, the absence of male breadwinners, and the pressure for early sexual activity also affect the status of these women. Supportive men for these women and children are missing. The romantic view of life is further buttressed by the lack of other economic options. These romantic images assume

a middle-class world where men are providers, not abusive or absent, and a community where viable employment is a reality. These romantic images also assume two-parent families and incomes that allow a woman to stay home and care for children. These images do not fit their reality: the world of drugs, abusive men, no jobs, and no social support for women and children that most women in prison inhabit. There is little in mainstream culture that encourages or supports alternative economic roles for women, particularly those on the margins of society. Roles that model non-motherhood, roles that encourage educational and vocational preparation outside the traditional middle-class role of wife and mother are absent in the worldviews of most women in prison. The mixed message of "staying home and caring for children" versus the negativity of the "welfare mother" plays out in the contradictory struggles of their lives. Motherhood is thus praised in principle but not supported in practice.

Even within the context of insufficient economic support, the pervasive violence against women and girls in society, gender and racially based oppression, and bad choices made within these contexts, the majority of women across all class lines find ways other than criminality to live their lives, raise their children, and meet the varying conditions of their existence. When confronted with the personal turmoil and structural barriers of conventional society, most women find ways of living that don't lead to imprisonment. But some women do, and this monograph describes a narrow aspect of their accommodation—imprisonment.

THE NATURE OF PRISON

This study raises concerns about the nature of prison and its presumed utility in modern society. Prisons, for both women and men, are misunderstood (and misused) institutions. For most of the free community, prisons are seen as abstract places of punishment and deterrence. These philosophical perceptions may not fit the reality of the contemporary prison. While the connection between the motivations for crime and the deterrence effect of imprisonment is unclear at best, the general community continues to believe that prisons should have some effect on the crime rate. In California, and throughout the nation, this has not proven to be the case. As prison populations continue to rise, there seems to be little appreciable difference in crime rates (Irwin & Austin, 1994). Irwin and Austin further argue that, particularly in California, the rising correctional-industrial complex has done little to decrease crime, with enormous social and economic costs. They suggest that this failure of prison policy to reduce crime is based on an incorrect belief in the power of deterrence (Irwin & Austin, 1994:163).

Other conditions also drive the increase in women's imprisonment
rather than a rising crime rate (Bloom, Chesney-Lind, & Owen, 1994).
Between 1980 and 1993, the number of women incarcerated in California
increased over 400 percent, from 1316 in 1980 to 7232 in 1993. The huge
increase in the women's prison population is the result of shifts in the crimi-
nal justice system response to female offenders. A punitive response to drug
use is a direct result of the war on drugs. Nationwide, as well as in California,
about one-third of the women in prison are serving time for drug offenses. In
addition to drug offenses, minor property offenses also account for a signifi-
cant proportion of female incarceration:

> The increasing incarceration rate for women in the State of California,
> then, is a direct result of short-sighted legislative responses to the prob-
> lems of drugs and crime—responses shaped by the assumption that the
> criminals they were sending to prison were brutal males. Instead of a pol-
> icy of last resort, imprisonment has become the first order response for a
> wide range of women offenders that have been disproportionately swept
> up in this trend. This politically motivated legislative response often
> ignores the fiscal or social costs of imprisonment. Thus, the legislature
> has missed opportunities to prevent women's crime by cutting vitally
> needed social service and educational programs to fund ever-increasing
> correctional budgets (Bloom, Chesney-Lind, & Owen, 1994:2).

PRISONS AND THE STATUS OF WOMEN

For Kurshan (1992), the imprisonment of women is tied directly to their
status under patriarchy. Stating that prisons are used as social control for both
men and women, she argues that the imprisonment of women "as well as all
other aspects of our lives, takes place against a backdrop of patriarchical rela-
tionships" (Kurshan, 1992:230). Defining patriarchy as "the manifestation
and institutionalization of male dominance over women and children in the
family and the extension of male dominance over women in society in gen-
eral," she continues:

> [T]he imprisonment of women in the U.S. has always been a different
> phenomenon than that for men: women have traditionally been sent to
> prison for different reasons, and once in prison, they endure different
> conditions of incarceration. Women's "crimes" have often had a sexual
> definition and have been rooted in the patriarchical double standard.
> Therefore the nature of women's imprisonment reflects the position of
> women in society (Kurshan, 1992:331).

Thus, the study of women in prison must be viewed through the lens of patriarchy and its implications for the everyday lives of women. When women's imprisonment itself is examined separately, it may well be that the rising numbers of women in prison are a measure of the society's failure to care for the needs of women and children who live outside the middle-class protection afforded by patriarchy. The rising numbers of women in prison reflect the cost of allowing the systematic abuse of women and children, the problem of increased drug use, and a continuing spiral of marginalization from conventional institutions. Currie (1985) sees that the lack of adequate economic and social supports for women and children in society is a key feature in the rising crime rates. The poverty of their lives on the street, the lack of educational opportunity and economic advantage, makes crime a reasonable choice for some women, with subsequent imprisonment a predictable outcome.[3]

In questioning the role of women in society, more specific issues emerge concerning the gendered experience of women in prison. The imprisonment of women may be a direct result of the worst treatment of women in society. Economic and personal struggles are played out in their crimes and subsequent imprisonment. Many of the personal struggles are faced by women of all classes: physical and sexual abuse happens in middle- and upper-class families, with middle- and upper class women as victims as well (Straus, Gelles, & Steinmetz, 1990). But there is some evidence that women of these classes may have wider, less self-destructive options in managing their struggles. It is clear that women in these middle-upper and upper classes have more noncriminal options for meeting the conditions of their lives.

A second perspective on the prison underlies this investigation of the modern female prison. I argue that the contemporary prison is expected to deal with the failures of other social institutions, an expectation that the prison is both philosophically and practically unable to meet. While this is also true of male prisons, the female experience is compounded by gender discrimination in contemporary American society and its inability to deal with women whose behavior is outside the traditional definitions and expectations of a patriarchical society. Violating both legal and gender norms, these double deviants perplex the criminal justice system in two ways. First, women, as a class, tend to commit fewer and less serious crimes (primarily nonviolent, low-level property and drug-related crimes) when compared to men. Second, there is some evidence that women persist in these crimes, even in the face of repeated arrests and community sanctions. While some argue that this persistence in crime is evidence of entrenched criminality, feminist criminologists argue that this persistence is evidence of the primary motivation for the vast majority of female crimes: survival (Daly & Chesney-Lind, 1988). This motivation includes emotional and psychological survival mechanisms as well as economic survival in a society that physically and emotionally brutalizes

women and girls and denies them competitive economic opportunities.

The concept of the double deviant can be applied as an institutional analysis as well. The increasing number of women in California prisons illustrates the double failure of conventional institutions to both protect women from the oppression and brutalization of patriarchical society and provide women economic and educational opportunities for themselves and their children. The failures of specific social institutions, such as the family, the school, and the labor market, often consign women to limited opportunities and inhibit their abilities to fully participate in conventional life. For many women and girls, the family is less a protected environment than it is a place of sexual and physical violence. Straus and Gelles (1980) found a high correlation between economic dependency and violence among married couples. As Pollock-Byrne (1990:60) suggests, "The woman who has been battered and psychologically abused by her husband or boyfriend for a period of time may see no way out of her pain and danger other than to kill him. When she does, the same criminal justice agencies that were unwilling or unable to protect her are now ready to prosecute." Gilfus (1988), Browne (1987b), and Ewing (1987) agree that childhood and adult battering has a significant effect on future violent acts among female offenders. In her 1990 study of women, crime and prison, Pollock-Byrne (1990:77–78) agrees with the characterization that women in prison may come from more disordered backgrounds than men in prison do, and cites additional research that supports the assertion that abuse, disorganized families, and other social and personal difficulties mark the lives of women prior to incarceration.

High school dropout rates among criminal justice populations are another example of the failure of conventional institutions. For many women, school is a place of failure rather than learning and achievement, further marginalizing them and handicapping their participation in economic life. For most of the women on the pathway to prison, economic participation is marginal or nonexistent. These institutions combine to further oppress and marginalize women, often blocking their participation in conventional life and leaving them with few options other than survival crimes.

Women in prison thus represent the double failures of conventional institutions: traditional life has failed these women as individuals and as important members of society—those who raise children and thus reproduce not only the members of its society but their behavior and life-chances as well. Much of the current work focuses on the importance of the parenting role (Baunach, 1985; Bloom & Steinhart, 1993), but one caution must be sounded in narrowing the focus on women as childbearers. Defining women solely as mothers continues the concentration on their sexuality and reproductive powers, excluding alternative roles such as worker or student. It is precisely this narrow definition of women that contributes to their inability to function in alternative, perhaps more self-sufficient roles, leading to the

double bind of bearing and rearing children without support.

These problems and issues—abuse and battering, economic disadvantage, substance abuse, unsupported parenting responsibilities—are best addressed outside the punitive custodial environment. Under current policy, these complex problems are laid at the feet of the prison by a society unwilling or unable to confront the problems of women on the margin. As a whole, the prison system is designed to deal with the criminality of men and their behavior while incarcerated. The women confined to California prisons are enmeshed in a criminal justice system that is ill-equipped and confused about handling the problems of women—the problems that brought them to prison and the problems they confront during their incarceration. The prison, with its emphasis on security and population management and deemphasis on treatment and programs, is left to deal with the failures of society's institutions. The institution is called on to deal with a set of deep and complicated problems of these women that society ignores. We expect too much from prisons and are puzzled when they fail to work.

But for the women who live in them—and the staff who must work with them—the prison is a world that must be lived through and negotiated daily. The women in prison struggle with and accommodate the problems of their outside lives and their lives in prison, solving them through a complex social organization and reconstitution of self. Prison culture among women is a dynamic, changing framework that provides opportunities to make their way in a world of women. The lack of a male influence (with the less immediate presence of male staff) has a significant impact on this culture, but the culture of the prison is shaped by the struggle to survive, just as the women's pathways to prison are grounded in survival as well.

FINAL NOTES

The stories of women in prison are multifaceted stories. They involve lives before prison and how their lives are set on the path to imprisonment. These stories draw attention to the interplay among the roles of women in contemporary life as well as the role of imprisonment in society. Examining how women make a life in prison requires us to question our sense of prison and our images of women. What does this tell us about prison and its purpose? What does this investigation tell us about the unintended consequences of incarceration? How is the prison experience of women different from the prison experience of men? How can this be explained—through these differences in the male and female prisons or the differences in the ways in which women confront the problems of imprisonment? While profile data and official statistics are useful summaries of the characteristics of the women of CCWF, the details of their lives inside and outside prison can only be conveyed through rich,

detailed narratives obtained through participant-observation within the prison.

As discussed in the next chapter, I used a method called empathetic observation to learn about the lives and worlds of the women doing time at the prison and count myself fortunate to have experienced a partial glimpse of this world. Many of the women "took me under their wing," and tried to explain and describe their world to this white, middle-class woman. A good number of the staff also assisted in mapping my way through this complicated world. Initially unsure of my intentions and questioning my presence, most of the staff eventually came to accept the presence of an outsider and assisted my observations in two ways—sometimes by answering my questions and describing the prison world from their perspective and, more importantly, sometimes by ignoring me and leaving me to interact and observe the women as they went about their liferound. The latitude afforded me by the staff was critical in my conducting more natural observations in this setting.

In the first year of the fieldwork, the uniqueness of the world of the lifer, and that of the HIV/AIDS population convinced me there was a need for an investigation separate from this more general study. Thus, this book discusses the ways in which lifers contribute to and live in the prison culture but excludes a detailed description of these very different worlds. The lifers are, of course, a significant part of the culture at CCWF and their world coexists with the more general culture. Women lifers are somewhat of a paradox in the terms of the commitment to criminality and a deviant lifestyle. A significant proportion of lifers are in fact first-time offenders, with the majority receiving life-sentences for the homicide of a battering partner. While hard data on this question are difficult to assess (once again supporting the need for a separate study of women lifers), many lifers are not committed to a deviant or criminal identity, an apparent contradiction in terms. This is particularly the case among older women. I also have no specific data on the experiences of women with HIV and AIDS. While I provide brief descriptions of the needs of disabled and pregnant women, much more in-depth investigation of these issues is required. Health problems and issues are complex and they, too, require separate study (Resnick & Shaw, 1980).

All fieldwork is intensive work, developing relationships with participants in foreign worlds, spending enormous amounts of time and emotion trying to understand parts of the world not normally accessible. The women of CCWF shared their world with me and helped me view an environment that is shaped by struggle and survival of conditions beyond the ability of most people. Often, in telling their stories, women would say, "You must think I am such a loser." To the contrary, the story of female prison culture is the story of survival, of conditions not of their making, conditions brought on by bad choices and illegal acts and by living in the prison world. The following chapters describe these struggles and the ways in which women survive, suffer, and, in some ways, triumph, over these conditions.

Chapter 2

A Quasi-Ethnography of Women in Prison:
An Overview of Methods

> *Ethnography is the science and the art of cultural description. Culture is to be found in the doings (and the sayings) of people.*
> —*Frake, 1983:60*

James Spradley, a cultural anthropologist, once observed that "ethnography starts with a conscious attitude of almost complete ignorance" (Spradley, 1979:4). For Berg, ethnography is simply the science of cultural description (Berg, 1995:87). Although I have a history of work in male prisons, my initial experience at the Central California Women's Facility was one of almost complete ignorance. Women's prisons, I rapidly discovered, were dramatically different than male institutions. In this book, I offer a cultural description of the complex world of a large women's prison that is largely invisible to the general public (and to many criminologists). In this chapter, I describe my approach to field methods and use of the feminist perspective. This approach included ethnographic and other qualitative methods, supplemented by a traditional survey methodology. The chapter also provides details about the overlapping techniques and strategies I used to gain entree into this closed world and to develop trust among the respondents. Specifically, the chapter addresses gaining physical entree and explaining my presence to the line staff, learning the physical location of the prison and optimal times to show up, gaining acceptance by the prisoners, becoming a familiar figure at the prison, developing research relationships with key players, and collecting more "systematic" data through a profile survey.

FIELDWORK

Like all fieldwork, the study required a lot of "hanging around." Initially, I spent time learning things about the prison world that enabled me to

formulate specific research questions, using traditional and less formal methods of learning about the culture of this institution. My fieldwork resulted in several hundred pages of field notes and, where possible, taped interviews. Individual and group interviews were conducted in prisoner rooms, staff offices, the yard, the living units, the gym, the chapel, and work units. Formal as well as informal interviews were also conducted with staff and management at the institution. The sample for these qualitative and often ongoing interviews emerged from chance meetings with individuals at a variety of places within the prison. Initial interviews were used to establish a frame of reference as an introduction to this world. Later, I used snowball sampling and individual referrals to build and extend my initial network of contacts. At first, I attempted to make contact with different women in classrooms, self-help groups, living units, and work areas, but these efforts were initially without much success. Nonetheless, several months of these efforts allowed me to learn my way around the prison and conduct some short interviews that led to some basic research questions.

Many months after my initial contact with the prison, I met ten women who worked in one particular office. With permission of the staff supervisor, I was allowed to witness the ebb and flow of the workday. During this time, I gained the confidence of the inmate work supervisor, and as I became a more familiar figure in this office, the women came to accept me as an interested party and we began to develop enduring research relationships that lasted for the next two years. These office relationships led to other relationships through referral or "co-signing," the prison term for vouching for someone. I found out later that this period of "checking someone out" was a critical part of being allowed entree and becoming trusted. Through these initial contacts, my reputation and purpose were established with both staff and prisoners.

QUASI-ETHNOGRAPHY

For this study, I borrowed the term "quasi-ethnography" from Inciardi, who used it to describe his study of women and crack cocaine (Inciardi, Lockwood, & Pottinger, 1993). In general, qualitative methods, and ethnographies in particular, seek to understand the types and range of people's behavior through studying them in their natural world (Marshall & Rossman, 1989). Using these qualitative techniques, I began the process of documenting the world from the perspective of imprisoned women. Such work involves in-depth interviewing to determine "domains of understanding" (Marshall & Rossman, 1989:10). Qualitative methods also involve a symbolic interaction perspective that seeks to understand how individuals take and make meaning in interaction. These approaches occur in natural settings through immersion in daily life.

Marshall and Rossman (1989:91), like Berg, posit that ethnography is a cultural description reporting how people describe and structure their world. Entree is a key problem and my experience into the prison world is described below. Concerns over reliability, validity, and representation haunt such work, as well as concerns about observer/interviewer effect. Borrowing from anthropology, ethnography employs "thick description" (Geertz, 1983), a rich, detailed description of specifics, usually based on the narratives supplied by the respondents. Thick description details the context and meaning of events and scenes that are relevant to those involved with them. The context of behaviors and narratives is as important as those behaviors and narratives themselves.

Geertz notes that ethnography is a personal experience, involving commitment of time and emotion to fieldwork. (Geertz, 1983:39). Faupel (1991) says he learned that ethnographic research is a social relationship; the interview, he says, is principally a conversation, with rules similar to those that guide casual relationships (Faupel, 1991:xiv). Beyond observation, ethnography involves developing an appreciation for the distinctive concerns, forms of life, and ways of behaving found in particular social worlds (Emerson, 1983:14). Emerson quotes Matza, who suggests that fieldwork "compels the worker to comprehend and to illuminate the subject's view and to interpret the world as it appears to him" (Emerson, 1983:14).

As I use the term, "quasi-ethnography" indicates deviation from a "true ethnography" in terms of the researcher's ability to become fully immersed in the social world. The methodology—in-depth interviews, detailed observation of everyday life—and the analysis—describing culture in terms of the meanings and interpretation of the members under study—is approximately the same as that of true ethnography. However, the structural barriers of the prison inhibit a full immersion in the lives and daily routine of the women under study. Their liferound—getting up, going to work, working, meeting other programmatic obligations, having privacy, locking up—was only partially available for my observation and interviews. With rare exceptions, I was unable to spend long periods of time in the private realm of the prison, the rooms and cells that make up the women's living quarters at CCWF. While I had full and unlimited access to the "public" areas of the prison, access to these private areas was somewhat restricted. Over time, I suspect I could have gained staff cooperation in accessing these areas, but another barrier kept me from pursuing this option. Privacy and the search for it is a key element in prison culture among the women at CCWF. As I became more familiar with this world, I had to make judgments about how much I would violate this privacy.

A third barrier to ethnography is that some behaviors in this prison world are rule-breaking behaviors—drug seeking and using, contraband

exchange, sexual activities—and thus are unavailable for observation. I was able to interview women about these areas, particularly key respondents, but unable (and unwilling) to observe many of these private activities. I had to identify optimal times for my observations—learning that the two hours around 4 p.m. were bad times, or that respondents' involvement in several personal activities (phone calls, intense conversations with intimates, arranging some illicit or other priority activity) were inappropriate times to make contact with the women. In addition to the barriers presented by front-stage and back-stage activities, a remaining central issue prohibits this investigation from being a true ethnography. The very nature of the prison and the facts of my life required that at some point I leave the institution and return home. The fact of my freedom—and their confinement—prohibited my full participation in the liferound of the prison. Despite many trips to and hundreds of hours at the prison, I feel I am offering at best a partial description of the culture of female prison. The separation between the perspective of the free person and that of the prisoner leaves some gaps in this description. The reality of prison life contained in these pages is necessarily an interpretation made by a middle-class white woman who did not experience the reality of confinement. I did not join in the daily living of the women in prison, no matter how much time I spent there. I did not eat, sleep, shower, dress, or often use the toilet facilities in the prison. Although I used ethnographic interviewing techniques, the field itself placed limitations on the ethnography. As Reinharz (1992:18) suggests, interviewing differs from ethnography in not including "long periods of researcher participation in the life of the interviewee." She adds: "Intensive ethnography frequently requires the ability to suspend personal and work obligations, to travel and expose one's self to risk" (Reinharz, 1992:73). Except for the time I spent in the institution, my daily life did not change significantly. I taught my courses, met with students, worked on other projects, and maintained my life in the outside world.

This study is also quasi-ethnographic in that my role as an outsider was never in question. I was an outsider to the staff and to the inmates, often encountering an awkward "no person's land," particularly in new situations. I made no pretense of becoming a member of this world, always taking the role of an observer, not a participant.

As I discuss in the introduction, there were several critical aspects of prison culture that I deliberately chose to exclude from my analysis. The women on death row, while very polite, asked to be excluded from the book. Women serving life, while quite cooperative and willing to participate, were also omitted to a large degree. I discovered that the experience of doing life—or extremely long terms stretching over ten years—required a separate investigation. I also learned that women living in the prison who had tested HIV-positive lived in a separate world, due both to their diagnosis and to their role in the prison culture.

FEMINIST METHODS

I also undertook feminist research methods (Nielsen, 1990; Reinharz, 1992) as a way to collect and consider evidence or proof for analytical assertions (Nielsen, 1990:2). For Nielsen, feminist methods begin "with the idea that the less powerful members of society have the potential for a more complete view of social reality than others, precisely because of their disadvantaged position" (Nielsen, 1990:10). Survival, she argues, attunes subordinate persons to the perspective of the dominant class. Further, she notes:

> To the extent that women as a group are socially subordinate to men as a group, it is to women's advantage to know how men view the world and to be able to read, predict and understand the interests, motivations, expectations and attitudes of men. At the same time, however, because of the division of labor by sex found in all societies and sex-specific socialization practices, sex segregation and other social processes that guarantee sex differences in the life experience, women will know the world differently from men (Nielsen, 1990:10).

Cook and Fonow (1990) see the significance of gender and gender asymmetry as a basic feature of social life. Acknowledging the pervasive influence of gender, they say, is the first hallmark of feminist work. Thus, feminist methodology begins with research devoted to description, analysis, explanation, and interpretation of the female world (Bernard, quoted in Cook & Fonow, 1990:73). As they argue, much of what masquerades as sociological knowledge about human behavior is in fact knowledge about *male* behavior. Lastly, this acknowledgment also attends to the researcher as a gendered being.

Cook and Fonow also state that central to feminist methods is the use of at least one qualitative and one quantitative method so that the findings from each may inform and complement each other (1990:82). Reinharz (1992) discusses a range of methods that can be classified as feminist: interview research, ethnographic research, and multiple methods research (or triangulation). She argues that the researcher wanting to understand the world of the members under study must have a commitment to thoroughness in data collection as well as to spending lengthy time in the field. Such a commitment of method and time allows for the description of social change during the course of the study.

This project shares the goals of feminist ethnography (Reinharz, 1990:51) in striving to document the lives and activities of women, understand the experience of women from their own point of view, and conceptualize women's behavior as an expression of social contexts.

In the next section of this chapter, I follow Berg's suggestion that initial ethnographic activities involve four general aspects: taking in the physical setting; developing relationships with inhabitants; tracking, observing, and eavesdropping; and locating subgroups and stars. He also describes the difficulties in leaving the field or disengaging (Berg, 1995:104, 115).

GAINING PHYSICAL ENTRY

Emerson (1983:13) states:

As the fieldworker increasingly began as an outsider to the groups and settings under study, directly crossing major ethnic, class and status barriers, the process of establishing trust and rapport, of sustaining ongoing personal relations under difficult circumstances, became problematic.

In this study, three "outsider" problems were encountered: obtaining administrative access, gaining cooperation from the prison staff, and penetrating the world of the women themselves. My work in the prison, at each of these levels, was dependent on being accepted and introduced by several significant gatekeepers, including administrative staff, line staff, and, ultimately, prisoners. Administrative staff members were instrumental to my gaining entree to the physical world of the prison. Prison gates and fences keep people out as well as in. I was fortunate to receive a high level of support from several administrators. Without the help of these persons, the project would never have gotten off the ground. One staff person supported my request and presented it to the warden, who was wholly supportive of this activity. The warden was given a brief written description of the project, emphasizing the lack of data on female offenders and the utility of this information for management purposes. I was also able to present my past credentials of having conducted research with the California Department of Corrections (CDC) and prior employment as a researcher with the Federal Bureau of Prisons. The warden has been generous with her endorsement and support of the project, granting every request throughout the course of the study. About two years later, I asked why she was so willing to open her institution to a total stranger. She replied that the combination of my research background, my past work with the Bureau of Prisons, and her interest in knowing more about the population led her to support this project. I would add that her enduring commitment to her own work also led to this support.

Throughout this fieldwork, I was given full access to every aspect of the prison. This access was facilitated by a staff identification card that was iden-

tical to those issued to the employees of the institution. This ID card was to allow me entry into the prison, using the staff door at all times, day or night, weekdays and weekends. Although the card was identical to the staff card, some of the staff at the visiting gate were perplexed by it. The card looked like a staff ID, but I was clearly not staff. A few items were placed in the staff newsletter, ostensibly introducing the project to the staff, but most staff at the gate were confused by the project and my desire to enter the prison with equipment (tape recorders and the like). Entrance to the prison was gained quickly when I encountered staff that had checked me through previously. New staff made this first step much more time-consuming and a little frustrating. Even months into the project, calls to the front administration office would occasionally be made as new staff tried to figure out who I and my graduate students were and what we wanted. Many staff had a hard time realizing that I was not a typical official visitor. Again, phone calls to the administrative building or to the captain's office would be made in search of an explanation. I also used the time in the visitor processing area to use the restroom. As I discuss later, the stratification between staff and inmate restrooms had a direct bearing on my access to a toilet.

This entrance was also used for processing visitors, a potentially time-consuming event. I tried to avoid coming at peak visiting times but sometimes was stuck within the lengthy visitor process. Attorneys routinely cut in front of the visitors and even now I am not proud that I took this advantage. If I was in a hurry (usually), I exercised my privilege to cut in front of the visitors, always feeling bad about it but doing it nonetheless. As I became familiar to the regular staff, I would strike up conversations with them, explaining who I was, what I was doing, and describing my work and findings. Most staff would tell me that I should be writing a book about them, that the correctional officer was something worth studying. Luckily, I had a snappy answer for them because my first book was a study of correctional officers at San Quentin (Owen, 1988). This eased my initial contacts with correctional staff and others throughout the fieldwork. Entering the prison involved taking off one's shoes and any metal items (jewelry, belts, and the like), presenting one's briefcase, and passing through a metal detector. After leaving the front gate, one passes through a sally port, a double-gated area controlled by the tower officer. A good rule I have followed in all my prison work is making contact with the tower officer, primarily so I would be recognized when I left.

The contact with the administrative and processing staff was only the first of many steps in explaining my presence to the line staff. The front gate officers were accustomed to outsiders; those stationed inside the prison were not. After walking through the sally port, one proceeds down a walkway in front of the Family Visiting Units, off to the side of A Facility (also known as A Yard or Reception), and toward the middle of another building that houses

reception visiting, the Control Center, and, to the far right, the two visiting rooms and their outside courtyards. A regular visitor proceeds to the far right, a visitor to the more controlled A Yard to the left, and staff members to the middle door. This door is locked, and opened by the control room (Control) inside. This door also functions as half of a second sally port, meaning only one electronic door can be opened at a time. There is a subtle etiquette to ringing the bell and closing the door. I choose to ring in once and wait patiently; more bold staff ring the bell more than once. Politeness also calls for holding the door so that it does not slam shut, closing it softly until it clicks shut. I learned this while working for the Federal Bureau of Prisons, but occasionally forgot, marking myself as a novice in this world. At the control window, one again shows the ID. Staff here would sometimes ask my destination, but their casual behavior led me to believe that they accepted my presence as I had passed the closer scrutiny of the front gate.

Once leaving this second area, the basic geography of the prison spreads out in front of the viewer. To the immediate left of the Control Center is the locked gate to A Yard. Unlike the gates to B, C, and D Yards, this locked gate is used only by staff and is the primary entrance to this unique housing area. The other yards are almost identical in structure, housing mostly general population prisoners in similar housing units. When standing at this door, the main yard is immediately in view. Across the grassy expanse is a series of program buildings, including the two chapels, arts and crafts rooms, the gym (at one point used to house women under the increasingly crowded conditions), and the library. The housing units for B, C, and D Yards are to the side of A Yard, forming the far left perimeter of the entire facility. Other parts of the prison (educational and vocational program space, the main kitchen warehouse, and the firehouse) are not visible from this vantage point.

Getting into A Yard, with its locked gate, was yet another barrier. Unlike in the other yards, the prisoners and the staff do not routinely pass through this gate at all hours. Other units also have an administrative building with a door facing the main yard, but A Yard does not. Usually, I would wait for a staff member to pass through this gate, discussing my purpose and presence as they let me through. Staff passing by the control door would sometimes ask my business and walk over and open the door. On some occasions, Control staff would notice me waiting and come out to open the door.

STAFF

In the beginning, staff were often unclear about my presence and purpose. While almost unfailingly polite, they frequently needed assurance that I was a legitimate person with legitimate interests and that I was not there to

spy on them or otherwise discredit staff members. Later, once they learned that I was who I said I was (a nosy college professor), staff told me they had previously assumed I really was someone from Internal Affairs or a plant from the warden's office. During my fieldwork, I encountered staff whom I had met during my research at San Quentin, during other work with the CDC, and even from my local university. Several individuals were instrumental in clearing my reputation with both staff and prisoners. One person in particular was invaluable, orchestrating my contact with staff in sensitive areas of the prison. He introduced me to staff that literally opened doors that would have been very difficult to open. With his introduction, staff were quite cooperative, allowing me to interview women in the Security Housing Unit, which would have been highly inaccessible otherwise. During the time I spent in this unit, I came to know the staff quite well. I later encountered some of these same staff in the other housing units, which eased my work considerably. Once a staff member decided that I was "okay," other staff members took their cue from this acceptance, and in a process similar to a snowball sample, I was accepted by most staff as I went about my business. During one evening visit, housing unit staff in a general population yard questioned my presence and told me I would have to check with the yard sergeant. Dreading yet another explanation, I was pleasantly surprised to meet a woman sergeant from A Yard, who knew me and my study well. She "co-signed" me to the staff and I went on my way.

In addition to suggesting that I should write a book about officers ("we have the real story"), staff members liked to give me their analysis of the women in prison and the reasons they were there. While sometimes this analysis was one-dimensional ("the inmates are all lazy and not willing to work"), many times I heard a fairly thoughtful, well-informed, and often sympathetic analysis (for example, acknowledging the nature of these prisoners' lives on the streets, such as their experience with abuse or the difficulty of having to support children under such trying circumstances).

I spent considerable time in informal conversation with staff, especially when entering a new area, with the primary goal of "cooling them out," removing their suspicions that I was there to report on staff members or their activities. When I would arrive in an area—whether I was known or not—I would report to the staff. Over time, as I became more familiar, particularly in the housing unit that became my base, officers would welcome me with a nod as I announced, "Just checking in." I also would look for the lieutenant or sergeant supervising the larger area. I had made a point of seeking out these individuals and discussing my project with these supervisors, as I knew the unit or program officers would contact them when questioning my presence. There are fewer supervisors than line officers, so this strategy was a good investment. I also made a specific effort to elicit staff opinions about the

prison (How has the prison changed since it opened? How is working with women prisoners different than men prisoners?). In addition to gaining staff trust and cooperation, I also was able to collect additional perspectives about this world.

An experience I had during my early days on this unit illustrates the importance of developing staff contacts. In the beginning, staff in the administrative area would call down to the housing unit and warn them of my arrival. At this early point, most staff could not figure out the reason for having such free access. During one of my first group interviews, the women told me that the staff were being especially nice to them because I was there. It seems that an announcement was made over the PA system that "we have company coming; be on your best behavior." One woman remarked that it was "like when you are home and your mother says the preacher is coming over." As time passed, I became an accepted part of the prison landscape, and staff and prisoners no longer saw my arrival as anything noteworthy, and I was more or less accepted as part of the expected routine. On occasion, staff would ask me where I had been if they had not seen me for a while. In contrast to my first visit to this unit, I later heard the same officer announce to the women, "The yard is open: get out." I took this to mean that my presence was no longer suspicious and things were a little back to normal despite my presence.

But while staff contacts and cooperation are critical, the prison researcher must avoid overidentification with the staff. While less suspicious than male inmates, the women prisoners were also wary of a stranger's entrance into their world. Being too cozy with the staff could result in obstacles in reaching the prisoners. In this study, the women were the object of study, and gaining their acceptance was paramount.

LEARNING THE PHYSICAL LOCATION OF THE PRISON

As Schatzman and Strauss (cited in Berg, 1995:93) suggest, a "casing and approaching style" is best used during initial contacts in the field. The physical location of the prison was an initial challenge that continued throughout most of the fieldwork. The institution was the first prison designed to hold women in the new era of prison building in California. The institution occupies 1240 acres, with the main complex built on 480 acres. Secure areas occupy 110 acres. The institution is divided into three general population housing units, each designed to hold 512 prisoners (B, C, and D Facilities). The Reception Center (A Facility) was designed to house 356. Each housing unit held about twice its design capacity toward the end of my fieldwork.

Each of the general population facilities contains four housing unit buildings. These general population units are arranged in individual rooms, originally designed to house four women each. Each room eventually held eight women, who share two sinks, one toilet, and one shower. In the fall of 1994, the gym area had been turned into dormitory space to meet the pressures of crowded conditions.

The Reception Center (A Facility) contains 100 single cells, with 50 cells in Administrative Segregation (Ad Seg), 38 cells for long-term Security Housing Unit (SHU) inmates, and 12 cells for death row inmates. In the less restricted reception housing units, there are 648 reception beds, with 100 two-bed cells and 448 dormitory beds. A Yard has three different housing configurations: one secure housing unit holding women in single cells, one unit with more traditional two-tiered cells, and two units designed like other general population housing units. This unit is self-contained, unlike the other three, which are more open to the rest of the facility. The differences in the architecture of the prison shaped the variety of recruitment, interview, and observation strategies used in this study.

The women on A Yard live in the most physically contained environment. Women enter the prison through a vehicle sally port, ending up in the Receiving and Release (R and R) building. Women are processed into and out of the prison through this area. It seemed to me that I should start my research here, just as the women start their time in this building. I spent several days observing the routine of the R and R area, mainly talking to staff during brief lulls in their busy schedule. I attempted to approach women entering the prison on their first days, but I had very little luck striking up any conversation. Much later, I had a better sense of the state of mind of these new arrivals, but in my early days in the prison, I was awkward in approaching women who were understandably nervous and anxious. The women prisoners who worked in this area volunteered to talk to me after their shifts. (At this early juncture, I didn't know enough about the workday and the leisure time in the housing units to comprehend, and thus accept, their invitation. I eventually learned that most women prisoners were very busy during their workday and I needed to make appointments to meet with them during non-work hours.)

The next stage in the reception process involved moving to the celled housing unit. Much later in the study, I interviewed many women in this unit during their first days in the prison but, early on, I lacked the systematic plan that would have led me to this next logical step. I eventually found my way back to A Yard, interviewing women in the "new arrival" housing and in the secure housing units and having some very preliminary interviews with the women on death row.

The prison is very large and took some months to fully negotiate. In addition to the large size, the security nature of the prison impedes movement,

even for a free person. Internal security is designed "to observe inmates and others, to screen, manage, and observe people entering the security perimeter" and to oversee "the screening, management and surveillance of visitors" (Lemon, 1992:25). Once inside the security perimeter, "these people are allowed to enter only areas necessary to perform specified functions" (Lemon, 1992:25). I had a steep learning curve in negotiating this formal (and informal) security as well.

Once inside, the sheer size of the prison puzzled me. Where should I start? Despite the small victory of getting through the front gate, I was still not near potential respondents. I decided, after several unescorted walk-around tours of the prison, that I had no idea where to start and that I needed to find a place that I could fit in and feel comfortable. I figured that, as a teacher, I should probably start in the education building: at least I knew some things about that setting. I contacted staff in educational programs, located behind the housing units and reached through a series of gates. The school is in a separate building, also secured by a locked gate. I decided to observe classroom activities in a pre-release class and in an elementary education class. Staff in both areas were accepting and understanding of my purpose and welcomed me to their classrooms. I initially thought that the classroom was a natural venue to start this investigation, but I was not entirely correct. The structure of the classroom was such that there was little opportunity to interact casually with the women. This was an early lesson in the liferound of the prison. With some exceptions, I learned that the women in school (and at work) were typically unavailable for long interviews during daytime hours. Women in prison are busy, with their time structured by activities and schedules. I had to learn not only how but when to approach them. I was in the classroom, but there were few opportunities to interact with the women beyond a quick introduction and an explanation of my project. I asked some women when was a good time to contact them to continue our discussion. I also told the women that I was new to this world and trying to find my way, inviting women to approach me if they saw me walking around the institution. One young woman accepted this invitation and ran up to me in a housing unit when I was still in my "wandering around" period and said, "Miss, you told us to come up to you if we saw you." This woman was out of school that day and sat down with me for one of my preliminary interviews. The "wandering around" method was useful for learning the geography of the institution, but it did little initially to put me in direct and prolonged contact with the women I was trying to study.

As I learned the geography of the prison, I gained some insight into how the spatial organization of the prison ordered the women's lives. My trouble in learning how to get around, how to get through the gates, and what to do once I got to a certain place made me wonder how this "learning curve" played itself out in the process of doing time. I also learned that I had to identify access

points into the world of the prison. I was a little discouraged during this time. The prison world swirled all around me and I could not figure out how to gain access. Although the "wandering around" method acclimated me to the layout and made staff at least somewhat familiar with my presence, it was not productive in making real contact with the women. I clearly needed a new plan.

GAINING ACCEPTANCE FROM WOMEN PRISONERS

After touring the prison, I learned that the largest number of "non-busy" women were in A Yard, at least during daytime hours. I later learned to visit the prison in the evenings and on weekends for better access to the general population. Although the women on A Yard experience the most controlled movement in the institution, they are allowed to walk their small yard at scheduled intervals. As the A Yard population is not allowed on the main yard, this is the only recreation area open to them. Early in the fieldwork, I struck up conversations with a group of women hanging around A Yard: Ro, Brandy, and one or two other women. In addition to important information about life on A Yard, I learned several initial lessons about interviewing in the prison. Unlike my experience with interviewing male inmates, I found that women are quite eager to be interviewed and, for the most part, enjoy the process and are pleased to be asked for an interview. In fact, as I became more familiar to them, I was often approached by women who asked, "How come I am not being interviewed?"

The women were more amenable to being interviewed in groups than I expected. Often, while interviewing a single woman, others would join in, forming groups that got bigger or smaller as women came and went. In my previous research work in male prisons, rarely did I ever encounter men who were willing to talk with me on any subject in front of other prisoners. Male prisoners may agree to talk, but usually want to know, in great detail, the reason, extent, and use of the interview. They almost always wanted to talk "somewhere where we could be alone," both to be alone with a woman but, equally important, to avoid being seen with someone, no matter what gender, who somehow could be defined as an authority figure. Men are much more concerned with appearing too close to anyone who might conceivably be a staff member. With Ro and friends, I learned that approaching women was much simpler than approaching male prisoners and that group interviews were a fruitful method. I also learned that women had few qualms about being taped and that I needed to write down sufficient information about the women should I want to follow up. With Ro, as an example, I learned to note not only her name and housing unit, but also her release date. With a median time served of ten months for women in California prisons (SCR 33, 1993/4), I learned that some women I wanted to talk to again had to be caught before they left.

Ro was an extremely articulate "old-timer," with a significant invest-
ment in the "convict code." She was able to describe many significant cultural
phenomena to me with both an authentic and somewhat analytic voice. I man-
aged to return to the prison and track her down on the day of her release, inter-
viewing her in the R and R area. When I requestioned Ro about the organiza-
tion of the prison play family, she commented, " I figured you did not know
much about this last time we talked." I learned from her that women liked
being considered experts on the subject of their worlds and their lives. As the
interviews progressed, this became increasingly apparent. Despite my famil-
iarity with "the literature" and previous work with male prisoners and their
culture, I soon found that this world was more complex and multifaceted than
I had imagined. My conceptual understanding developed from studying male
institutions did not apply at CCWF.

Later, when I found my way back to A Yard, I got in the habit of visit-
ing the administrator of the unit when I first arrived, both because he had
sound insights into the institution and because he could smooth my entree into
the housing units. Through his sponsorship, I began a series of interviews with
women in the most secure housing units. Through his intervention with the
staff of Ad Seg, I was able to meet and gain the cooperation of the sergeant in
charge of the unit. It was my good luck that this woman had a very strong rela-
tionship with the women in her charge. She would approach women in their
cells and ask them if they would like to speak with me. Because of unit secu-
rity, I was not able to approach these solid steel doors and engage women in
conversation. At that point I had to rely on the sergeant's positive relationship
with the women as my recruitment strategy. I was fortunate in that the first
three women she asked agreed to talk to me. The sergeant was also gracious
in allowing us to use her office for private interviews. With these initial con-
tacts in Ad Seg, I was able to snowball my sample from this beginning in this
unit. Although the women are confined to their cells, there is some communi-
cation among them, primarily by shouting through the doors across the units.
Over the next several weeks, I interviewed many women in the Ad Seg hous-
ing unit. I was less successful in recruiting women in the Security Housing
Unit (SHU). Even with the intervention of cooperative staff, several women
refused to talk to me. I was able to interview about five women, plus have
brief conversations with the women on Death Row.

GATEKEEPING

During my days in A Yard, I met a woman who became the most piv-
otal respondent in this study. Divine was a true gatekeeper in every way. As
all ethnographic studies argue, the need for a gatekeeper, or guide, is critical

to field studies. She worked as an inmate clerk and had opportunity to observe me and my actions. Through the time I spent in that work area, I believe she came to appreciate my interest in her world and began to tell me about her life before prison and how she lived her life in prison. These informal conversations led me to ask her if we could spend some time in more formal sessions. She agreed. Divine was pivotal in three general areas. First, as a third-timer, she had insights into the contemporary prison as well as into its past forms. She was an extremely articulate respondent and was able to give me rich, "thick descriptions" over a comprehensive range of topics. Second, in her office, she held sway with both staff and inmates, introducing me and "co-signing" me (offering her stamp of approval). The other women in the office area took their lead from Divine, and I was able to establish long-term interview relations with about ten women who worked in that office. Even after Divine was released, I continued my contacts with other women in these work and housing areas. I conducted both individual and group interviews with the women working in this area over the next year or so and was able to observe workplace interactions over long periods of time. These contacts with the women also had a snowball effect, as I was able to establish "anchors" in the various housing units, contacts that I continued to use over the course of the entire study. Finally, my relationship with Divine transcended the work setting and carried over to her housing unit, her room and roommates, and her circle of friends. In an extremely generous gesture, Divine arranged an "open house" in her room one Sunday morning. She had recruited a large variety of women to meet me and talk in a group about their lives in prison. I spent the entire day sitting on the floor with my tape recorder as women came in and out of Divine's room. The officer on duty upon my arrival wondered about my presence, but allowed me to interview in the room. In those valuable hours, I made contacts with women that continued throughout the study.

The importance of Divine's introduction and her stature among the prison population cannot be overestimated. As one of the women I met that day stated, "We love Divine to death. If Divine had not introduced you, you would be sitting by yourself. Either that or you would get a snitch [an informant]. . . . When Divine looked at me and (gestured, "come on"), I did without any question." Later, another lifer told me that having Divine "say I was okay" made her trust me too. As she put it, "We all know what Divine did." This ripple effect resulted in a pleasurable moment later in the study. Many months later I was sitting on the yard and I greeted (probably a little too brightly) Chicago, one of the women from that Sunday "open house." Her companion said, rather derisively, "So who is that?" As Chicago passed almost outside of my hearing, she said, "She's okay, she's a homegirl."

The bulk of my observations about the living unit were made in Divine's home unit and many of the interviews were conducted with women

I had met that Sunday morning. Sometimes the officers let me interview in the rooms, but most often they asked me to sit out in the dayroom. Officers were sometimes nervous about my being in the rooms, even when they would let me in. One officer, as an example, continued to check on me, asking, half-teasingly but with real concern, if I was "all right," adding, "I just wanted to make sure that you were not getting beat up." All of the women in the room laughed at this remark, but I appreciated his concern.

The dayrooms are open, public spaces with three seating areas. The officer's station, a glass-enclosed "bubble," is in the middle of the room. This area had pluses and minuses for interviewing and observations. I was able to observe and talk to a large number of women, and ask questions about events and behaviors observed here. As in A Yard (and elsewhere) women would join in the group out of curiosity, with informal ease. Women would most times ask, "Who are you?" and I would try to describe my purpose for being there. Over time, women who made up my "regular" respondent group would answer the question, often explaining my study in perfect detail. These group interviews yielded different types of information than the more intimate ones, but they were very useful in touching on the "collective conscience" of the group, as well as prompting dissent ("That's not how it is for me") and other comparative discussions. There were some women who politely declined to enter into any in-depth conversations with me at first approach, but they came around as I spent many months in their unit. I became such a part of the routine that women who I had not talked to directly would approach me to tell me "something I thought you might want to know about" or that they were being released or transferred and they wanted "to say good-bye and good luck on your book." By the end of my visits to this unit, most women who had declined to talk to me in the beginning had warmed up and conversed more openly. I don't claim that all women were forthcoming, but many women did "come around" during the course of the study.

Sometimes I would visit the unit when none of my regular respondents were available. While I was standing around, puzzling over what to do next, women would approach me, saying, "I always wondered what you are always talking to Randi about." Sometimes, however, no respondents were forthcoming. I then hit upon a very productive technique. During the day, many women made a special point of coming out to the dayroom to watch specific soap operas. As I had a passing familiarity with two particular shows, I would first ask permission to sit next to someone and then proceed to watch the show. Women were sometimes surprised that I shared this interest, but were always welcoming. As I did not keep up with the "stories," I first asked questions about the events ("When did Jill marry him?") out of curiosity about the program, but immediately learned that this was a way of introducing myself and gaining access to new groups of people. Watching soap operas with

groups of women became an excellent way of gaining acceptance on new units. During the course of the study, women with whom I had watched the soaps would approach me with an update on the recent episodes. These conversations led naturally to more relevant interviews.

Friday night movies also provided an opportunity to make observations and new contacts. These events took on much of the character of a "date night" or a "night out" in the units. I learned to arrive early because many of the women attempted to "save" seats for their friends. While there were several ways of saving seats, the most successful involved staking out an area and sitting for the several hours between dinner unlock and the start of the film. During this time, women sat out in the dayroom with nothing much to do but sit. This pattern made for an ideal interview setting.

But the dayroom interviews had significant disadvantages. The room could be smoky, noisy, and public. The tape recorder made some respondents uncomfortable, particularly those approached for the first time. Most women had no problem with being taped, especially after I explained to them that no one but me would listen to the tapes. In one interview, a respondent tells me that all her friends are looking in on us and "they are all probably tripping off this tape recorder, but I am okay with it. I don't care." In this public setting, interviews were often interrupted when other women would approach or when the woman being interviewed saw a friend she needed to see.

REVEALING THE RESEARCHER

When fieldwork involves continuous on-site interviews with various subjects, researchers have to decide how much of themselves they want to expose. At CCFW, I was careful about discussing my life because I was concerned about the obvious, and sometimes not so obvious, contrasts between my life and theirs. I soon learned, however, that most women wanted to hear about my life. As a teacher remarked to me in the early days of the study, the women liked to hear about free people's life on the outside. Women would ask me about the kinds of restaurants I visited, or what I had done the night before. Beyond that, some women were more philosophical about the lack of reciprocity in our relationships. As Randi noted, "We know you have to keep some distance from us." I told her that I was aware that they shared their lives with me and I felt like I should share some of mine with them too. She then stated, "I know there is a barrier which keeps you from doing that because you are not supposed to get close to inmates." I then suggested that my life sounds pretty boring compared to theirs, which sound so fascinating. Another woman in the group, Tory, said, "Well, it is fascinating to you; it is not fascinating to us."

While I thought my status as an outsider (a "free person") was almost always apparent, occasionally both the inmates and the staff would ask me if I was an inmate. More than once, an inmate would interrupt my discussion and ask, point blank, "Are you an inmate?" I would invariably reply, "No, if I was, I would not be asking so many stupid questions." This remark was always good for a laugh. Sometimes, thinking I was an inmate, the women, seeing my carrying case, would ask me, "How did you get that purse in here?" When staff mistook me for an inmate, they would challenge me ("Where do you think you are going?"). When I would show them my badge and identify myself as a "free person," they always apologized. This gave me a brief sense of how women were treated and a small glimmer of how it felt to have my mobility restricted.

My outsider status had implications for mundane human activities, such as using the toilet. In the public areas, women used toilet facilities that had a large window that exposed these activities to officers as well as other inmates. Staff toilets, in contrast, had a solid door, affording the privacy most of us take for granted. Staff toilets were locked and using them required that I ask officers or other staff to open them for me. I felt very self-conscious that my use of staff toilets underscored the difference in the privacy rights between me and my respondents. Staff indicated that I should only use the staff restroom. While I was reluctant to bother them with my need to use the toilet, I had little choice. Inmates took this distinction and their lack of privacy for granted and were amused when I mentioned my concern. When I was in their rooms, women would use the toilet and the shower in front of me with little pause.

COLLECTING "SYSTEMATIC" PROFILE DATA

As members of a task force charged with collecting data on female prisoners and parolees (SCR 33, 1993/4), Barbara Bloom and I felt the clear need for a systematic survey of women in California. The available official data did not contain the detail we felt was necessary to describe the characteristics and dimensions of this neglected population. I also decided that I needed some "systematic" survey data to complement my ethnographic data collected in the field. Funded by The Robert Presley Institute at the University of California–Riverside and the National Institute of Corrections, we developed a profile survey that used standard survey methods that allowed the collection of data from a systematic, representative sample of women throughout the CDC system. (In this ethnographic study, any information obtained from this survey is referred to as "profile" or "survey data" and is reported in full in Owen & Bloom, 1995 a & b).

Data were collected to provide a detailed population profile of women

confined within California's four female prisons: the Central California Women's Facility (CCWF), the Northern California Women's Facility (NCWF), the California Institution for Women (CIW), and the California Rehabilitation Center (CRC). The population profile describes the demographic characteristics, the offense and incarceration histories, and the family and educational/employment background of women incarcerated in the state. In the summer of 1993, we conducted 294 face-to-face interviews with women selected randomly from an April 30, 1993 count of 7043 female prisoners by the California Department of Corrections (CDC) Research Division. The initial sample size was 500 women. Sixty-one of these women had been released by the time of the interviews and 77 women had been transferred to other institutions or were in camps. Twenty-one women declined interviews, representing a refusal rate of approximately 6 percent. The majority of closed-ended questions allowed easy frequency tabulations; some open-ended questions have proved a bit more stubborn to analyze.

LEAVING THE FIELD

Leaving the field was problematic because of the complexity of this world, the amount of time I spent in the field, and the relationships I enjoyed with my respondents. As the prison became more and more crowded, daily life and the very nature of prison culture were visibly changing. The crowding in the housing units, the elimination of some educational programs, and conflict engendered by these changes created new patterns of interaction and forms of accommodation. While I had already decided to concentrate on the everyday life of the prisoners, I felt (and continued to feel) that much work was left undone. Many aspects of prison life for women require further investigation. But, like all fieldwork that is bounded by artificial demands from the outside world, I had to leave the field at some point. I did my best to say goodbye to key players. But I know I was not successful in taking leave of all the staff and prisoners who were helpful to me. I still wish for a more complete way to disengage from the field. I do hope to return and conduct smaller, more in-depth studies of this world, but for now my job is to report what I saw and learned.

A NOTE ABOUT NAMES

I have changed the names of the women interviewed for this study, and have assigned fictitious names to everyone mentioned in this book. Several women, including Divine, Blue, Tootie, Randi, Tracy, Daisy, Ro, Misty, Tabby, Tuck, and Zoom, were interviewed and observed repeatedly over the

years in the field. In addition to these core respondents, I interviewed well over one hundred other individuals, in either in-depth interviews or passing conversation. Women mentioned only once or twice are also given names for ease of reading, rather than any particular identification. Many women wanted their real names used. This was especially tempting because their names, particularly their prison or street nicknames, were highly appropriate, colorful, and descriptive. In changing their names, I have tried to protect their identity, although I hope they will recognize themselves.

The use of the term "girl" has become a convention. The term is used by staff and prisoners alike and seems to carry little negative connotation. While the term sounds inappropriate to my free world ears, none of the dozens of women I asked were offended by the term. I include that term as used in the interviews.

CLOSING COMMENTS

From the beginning of this project to the end, I was struck by how reasonable the women were in discussing their past lives and their time in prison. Almost everyone I met—staff and prisoners alike—was polite and helpful to me. The exceptions, such as the rare refusal in SHU, were few. In almost every case, women would tell me that "it is pretty interesting to talk about this." As Tootie remarked, "It is helpful for us to be able to sit up here and talk about this; it is almost like an AA meeting or group." Sometimes women would inquire about the money I might make from the book and how they could get their share. As one older inmate remarked, "Go ahead and use my name, but I want some of those benefits." Tabby, a young first-termer with a history of juvenile incarceration, reflects the cooperative attitude of most of the respondents I encountered:

> I really wanted to be in your book because I wanted people to know what it is like to be so young and be in here. I have never read nothing about someone my age being in prison. When I was in juvenile hall, I read lots of books and there was never anything about someone like me. Maybe it won't help but maybe it will help someone think about what they are doing, when they realize that they could come to prison.

The lessons found in the writings on feminist methods strengthened my commitment to field methods, both in legitimating techniques that made intrinsic sense to me as well as guiding my data collection and subsequent analysis. As I learned about the world of the women in prison, I came to a keener appreciation of the privileges afforded by my class position. Many of the women

telling the story of their lives, the mistakes they have made, and the troubles they have experienced seemed to be on the verge of remarking, "You must think I am such a loser." I replied that this was not the case. In fact, I came to appreciate these women as survivors of situations and deprivations that I doubt I could survive. I developed relationships with my respondents that turned into genuine friendships in several cases, leading me to question—at least initially—the false notion of "objectivity" in research. While I never pretended I was a part of their world or offered anything more than a rudimentary understanding of their lives, I feel that I came to reject the artificial separation between researcher and subject. As the women came to trust me—to the extent that they did—I realized that the subjectivity of this work was its strength. A participatory strategy, in my view, requires an awareness of the researcher's position and the development of relationships that at least attempt to establish equal footing between the researcher and members of the world under study. In attempting to document the lives and activities of women and trying to understand the experience of women from their own point of view, this study strives to offer a picture that not only contributes to a "scientific" understanding but to a political awareness of the status of women on the margin.

Chapter 3

Pathways to Imprisonment:
Women's Lives before Incarceration

> *You do have people who are not trying to go home. They act like they don't care if they go home. They don't have nothing to go home to. Prison is a vacation from the streets to them— they feel like they are glad to be here. The streets is too rough if you don't own the street. Prison is better if you don't know what it is like to have a bed; to have clean clothes. Some girls don't have a place to go home to when they get out. You know a person is coming back here when they don't have family, like if they have burned all their bridges with the family. General Assistance takes a long time, and it's not enough to find a place. How do you support yourself? It's back into drugs and the wild life.*

This quote from Dahlia, a forty-year-old first-timer, illustrates a central irony of this study: for many women, prison is a better and safer place than their disrupted and disruptive lives on the streets. This irony suggests one of several ways that prisons for women are a gendered experience, quite different places than prisons for men. Female offenders' second-class status as women shapes their lives before prison, whereas patriarchical privileges extend to all classes, ethnicities, and races of men, regardless of their economic marginality. For many women, their lives on the street are tangled in personal and structural domains that speed their path to imprisonment. The personal domains of drug and substance use, physical and sexual abuse, oppressive relationships with men, and the lack of economic skills shape their

immediate experience. The structural domains of racism, sexism, decreased economic opportunity, and the devalued status of women, particularly marginal women, limit their access to conventional roles.

This combination of destructive personal behavior and limited structural opportunities produces conditions that often result in criminality. While an in-depth discussion of criminality is beyond the scope of this study, some attention must be given to the nature and conditions of women's lives before prison. With few exceptions, women's crimes are largely embedded in the conditions of their own lives and their roles as women and girls within patriarchical society. Beyond the patriarchy that defines and limits the options and personal choices of all women in contemporary society, women within the criminal justice system are also women on the social, racial, and economic margins of conventional society. Women in prison are victims of multiple marginality or "triple jeopardy" (Bloom, 1996), in that their gender, race, and class have placed them at the economic periphery of society.

This chapter summarizes these life histories and provides some background to the understanding of their lives in prison. These stories also have a present tense to them as well: as Divine, serving her third term, stated, "All this is going on in the streets, right now, while we talk." When I first conceived of writing this book about women's prison culture, I had not thought through this aspect of women's lives. As a description of prison culture, I felt that the work should concentrate on the prison. The bulk of the literature on male prison culture describes the lives of male prisoners inside prison, with scant attention to the notions of cause or types of crime. Some exceptions are found in Irwin and Cressey's (1962) concept of the culture of the thief or Garabedian's (1963) U-shaped curve, which examine aspects of pre- and postprison lives. This, too, was my original intent in pursuing a study of the culture in a women's prison. But as I became familiar with this culture, and as the women shared their lives and experiences with me, I began to focus on the way a woman's life before imprisonment shapes her experiences in prison and thus shapes prison culture. In examining their lives before prison, three central issues specifically shape the study of prison culture for women: multiplicity of abuse in their pre-prison lives; family and personal relationships, particularly those relating to male partners and children; and spiraling marginality and subsequent criminality.

MULTIPLICITY OF ABUSE

As the previous literature shows and our survey data support, the majority of the women in prison have had lives shaped by a multiplicity of abuse. Chesney-Lind and Shelden (1992) summarize research on girls that shows how

early abuse and neglect, particularly in terms of sexual exploitation, fore-
shadow their lives as adult women. Their summary, as well as previous work
on women and criminality,[4] affirms that the lives of many girls and women,
particularly those of color, those on the economic margins, and those without
any political or personal power in relationships or in society, are in "worlds of
pain" (Rubin, 1976). Our survey data show that, overall, about 80 percent of
the sample indicated some type of abuse at any time in their lives. The in-depth
interviews also document this abuse history. This issue is complex and requires
separate research to provide a more comprehensive understanding of the inter-
action among abuse, offense patterns, and incarceration. These data, however,
provide some indications of the amount and type of abuse experienced by
women prior to incarceration. As one of the many pathways to imprisonment,
the abuse of women and children must be addressed and understood.[5]

Patrice, a young black woman with a history of violence as a juvenile,
sees her behavior tied to her emotional state during childhood:

> I'm a neglected child. I was abused and molested and raped. I think I
> took drugs, gang-banged to get attention. My homeboys were always
> there for me. I think I could have died on the streets—shooting at peo-
> ple in robberies. Especially if I was high or tipsy. I could have been
> blown away. I was a brat, gang-banging, [with] a "not give a fuck" atti-
> tude. I also used to be the kind of person to let people run right over me.
> But I have changed. I took a lot of the self-help courses—(I became) a
> mind-seeker. I now know myself inside and out.

Physical and sexual abuse is a defining feature in the lives of many women
in prison. This abuse often does not end at childhood but continues to be a dam-
aging feature of adult experience as well. The profile survey asked a variety of
questions about abuse, dividing such experiences into categories of emotional,
physical, and sexual abuse as well as abuse occurring in childhood and adult-
hood. A simple measure of frequency was also employed: a single, one-time
event; more than once but not recurrent; and an ongoing, recurrent event. These
questions are quite basic and do not get into the necessary detail to explore the
effects of abuse on criminality; however, these preliminary data provide some
basis for examining the relationship among criminality, imprisonment, and abuse
in the pre-prison lives of women. Table 3.1 illustrates prior abuse histories.

Our data reflect findings from other research on female prison popula-
tions. The Bureau of Justice Statistics, for example, found an estimated 41
percent of those in prison reported previous physical or sexual abuse. The
American Correctional Association discovered that 50 percent of the women
it surveyed reported a history of physical abuse, with 35 percent reporting
sexual abuse. This abuse was likely to be at the hands of their husbands or

Table 3.1
Prior Abuse Histories (in percent)

Type of Abuse		Extent			Most Often Mentioned Abuser
		Ever	More Than Once	Ongoing	
Physical Abuse					
Under 18	29	7	21	71	Father/Stepfather/Mother
18 and Over	59	8	30	62	Spouse/Partner
Sexual Abuse					
Under 18	31	29	29	41	Father/Stepfather/Other Male Relatives
18 and Over	22	30	30	40	Spouse/Partner/Boyfriend Stranger
Emotional Abuse					
Under 18	40	1	14	85	Mother/Father/Stepfather
18 and Over	48	1	12	85	Spouse/Partner/Boyfriend
Sexual Assault					
Under 18	17	56	18	25	Stranger/Father/Stepfather
18 and Over	32	56	34	11	Stranger/Peers/Tricks/Johns

Source: Owen & Bloom, 1995a.

boyfriends. Other research reflects these findings (Pollock-Byrne, 1990; Chesney-Lind, 1992; Gilfus, 1992; Widom, 1989). The ethnographic interviews provide more descriptive detail for these statistical indicators. Many women at CCWF reported patterns of abuse that began as children and continued through adulthood. As Sissy says simply, "I was abused in three ways—I experienced emotional, sexual, and physical abuse." A young black woman now serving a short second term for forgery, Sissy describes the event that led to her first imprisonment:

I was twenty years old the first time I went to prison. I had an abusive boyfriend who would not allow me to go outside or make phone calls. He would not let me have any contact with other people. I got out and followed him one night to see where he was going and what I seen I didn't like. I found him with another woman.

I had a gun and I used it. I know I dealt with it unthinkingly, out of hurt and anger and I tried to kill him and the girl that was involved with him and her sister was in the car. . . . I shot him and I tried to shoot all three of them and got three counts of attempted murder.

I was young and didn't know any better. I had left home at an early age to be with him and I felt that he betrayed me. He was all I knew, all I had. I didn't know how to work. . . . When it was over, I had no one else to depend on.

In reflecting on her abuse experiences, Marie, a twenty-eight-year-old black woman, muses:

In every relationship I have ever been in, I always wonder why it didn't work. Maybe we don't really look at things we should be looking at. My first boyfriend was abusive. He used to beat me all the time for no reason. I think that was just the thing to do—he wouldn't never fight none of the guys but he would come home and fight me. My mom used to say I drew the crazy people. I would tell her that I was through with him this time—look at my nose, my eyes—I had a gash on my face. She would tell me I was a crazy bitch to give him another chance. The neighbors would call the cops and they would come when he would beat me.

The impact of abuse has long-term consequences on the lives of women in prison. Zoom, a lifer in prison for killing an abusive husband, discusses the problems she has had with trust in her life:

I would love to be able to trust someone again. But because of all the time that I have done, and the people that I have had to deal with, trust is a hard thing to come by now. It is very hard for me to trust now. I have been hurt too bad. I've been hurt too bad. I have been hurt by the same people I've trusted. People (who) tell me that they love me are the ones that have hurt me the most. Everybody who has come into my life and told me they loved me hurt me. So it's like I don't know if I want nobody to love me no more.

In addition to physical, sexual, and emotional abuse that shapes both the early lives of girls and the adult lives of women, the abuse of drugs and alcohol is a key factor in the lives of a majority of women before imprisonment. Research points to the same conclusion: drug use and its surrounding criminogenic factors of drug-based lives have a direct impact on crime and criminal lifestyles for both males and females. Anglin and Hser (1987:360) describe this relationship among women users, noting there is "a higher frequency of crime rates both among active offenders currently using drugs and among those with histories of drug use." Two studies that closely examine the street life of drug users are *Women on Heroin* (Rosenbaum, 1981) and *Women and Crack Cocaine* (Inciardi, Lockwood, & Pottinger, 1993). Based on in-

depth interviews with street heroin users, Rosenbaum (1981) describes how
women enter the world of heroin, through an examination of their meaning
systems, motivations, and coping strategies. Inciardi et al. (1993) found that
the "multiplier" effect between drug use and crime held: the heavier users
were more likely to be involved in more crime. They also note the gender
complexity of the crime–drug connection by saying that "the ways in which
the economic drugs/crime connection actually work are less well understood
for women than men, because most of the research on this issue has dealt with
men" (107).

These themes are likewise played out in our survey data and in my inter-
views with women prisoners. Substance abuse paves the pathway to impris-
onment. The California Department of Corrections (1995a) reports that drug
offenses make up the largest category of new admissions to the system. In
1994, 42 percent of the women admitted to CDC were convicted of drug
offenses: 20.5 percent for "possession of controlled substance," 12.3 percent
for "possession of controlled substance for sales"; 6.2 percent for "sales of
controlled substance" (the remaining 3 percent were convicted of manufac-
turing marijuana and other drug offenses). A common experience for many
women convicted of drug offenses is aptly described by one woman I inter-
viewed: "I was so stupid," she said. "I had stopped but then I started using
again. I don't do crimes, I don't commit crimes. It is always drugs possession,
possession for sales and under the influence while on parole."

The profile survey also asked a series of questions about past substance
abuse. These questions focused on five basic areas: (1) Did you ever use (a
given) substance? (2) Was the use of this substance ever a problem in your
life? (3) Did you use this substance the last year you were free? (4) If so, how
often? (5) Did you ever drink alcohol while using this substance? Questions
were also asked about age at first use, alcohol abuse, the use of needles, and
treatment history. The following preliminary descriptions report percentages
for the entire sample, rather than for the users of a particular substance. For
most substances, the daily use rate is reported. In almost all categories, fre-
quencies other than daily use were generally not significant. About 13 percent
of the entire sample reported no drug use at any time in their lives. Table 3.2
reports these findings.

When we asked the women about their age at first use, almost three-
quarters of the sample reported drinking alcohol before the age of eighteen.
About 11 percent of the sample reported drinking before the age of ten.
Almost one-fourth (18%) of the sample started drinking when they were ages
twelve or thirteen. About 15 percent reported never drinking.

In terms of drug use, 59 percent of the sample indicated initial drug use
at age eighteen or younger. Almost one-fourth of those interviewed began
using drugs at ages fifteen or sixteen. Fifteen percent of the sample began

Table 3.2
Drug Use by Women in California Prisons (in percent)
N = 294

Substance	Any Prior Use	Problem	Use Year Before Prison	Daily Use	Use with Alcohol
Alcohol	85	28	53	19	—
Marijuana	77	11	28	11	36
Heroin	50	27	28	25	20
Powder Cocaine	63	41	35	26	28
Crack	50	34	33	25	23
Amphetamines	35	19	19	12	11
Speedballs	37	25	25	10	12
PCP	10	34	11	2	0
Prescription Drugs	40	21	12	7	16

Source: Owen & Bloom, 1995a. Percentages refer to any use and thus do not total 100 percent.

using drugs between the ages of twelve and thirteen. Just under half (49.8%) of the respondents indicated use of a needle to inject drugs at some point in their lives.

Celia, a young Latina, tells her story of how drug use at an early age and throughout her adult life contributed to her downward spiral toward imprisonment:

I started using marijuana at age of eight, with my sisters and my cousin. I started drinking about that time too. Then I started cocaine binges. I started running away when I was eleven. It seems like I have always been in trouble. My family was having trouble when I ran away at eleven. I was angry and always fighting. I was put in juvenile hall and group homes because I could not live at home. I did not want to stay put. I was sent to YA when I was fourteen. The first time was for stealing a car—in 1976 or '77. YA was very boring, just a routine, but I went to school. I paroled and went home. I went to trade school, but I got in a fight and stabbed a girl on the street. I stabbed someone I knew—I had a lot of anger. My friend tried to stop me and I hurt her too. I was sent to YA for four years then. I am not the same person I was then. I realized that I was out of control and that I did not want to be that person. I still need to deal with my anger.

I was last paroled from YA in 1984 and I was working as a cashier. I was twenty-one years old and living with my folks. I started college but then

I met a guy who was dealing cocaine and PCP. I started using about a month after I was out of prison. I got real scared and then I got saved and became a Christian. But somewhere along the line I robbed this guy who offered us a ride. My friend and I decided, "Let's just rob this guy." He rented a room and while he was in the bathroom, we took his car and his money. I had nothing going in my life—no job, I wasn't working. So I went to help my sister with her kids—she was in trouble and I needed to help her. I got picked up on auto theft from there.

Then I got sixteen months for the auto theft and did seven months in CIW. Then I went to work furlough. At work furlough, there were lots of drugs and I started using cocaine there. I was there one month and then I climbed out of a window and I was gone. I sat around in bars, met a guy that I had been writing to, but he went back to jail. I stayed with my sister and then I met a new guy. I met him because I was in a park and someone jumped me and tried to rape me and he rescued me. He worked and I worked. But I broke up with him because he was too much of a mama's boy and he was jealous. I left this guy, with everything that I had worked for but by that time I was arrested as a work furlough escapee in 1987 and I went to CIW, and then Stockton for sixteen months. I paroled from there in 1988. My mom picked me up and I got the same job back, but they went out of business. But then I got a violation for being out of the area with no travel pass. I also got in a fight while I was drunk with another girl and got busted for being under the influence at the parole office. So here I am.

As the vast majority of women cease their drug use during their imprisonment, their time in prison can be used to reflect on the effects of this use on their lives as well as those close to them. Helene tells how her deteriorating relationship with her daughter made her realize how damaging her drug use was:

I used crack when I was on the streets. I was always high on drugs. I used [crack] with my boyfriend who sold it and I never had to pay for it, so it didn't seem like it cost. I now see all the abuse from him that I had to put up with to get it, but because I didn't have to pay for it, I never thought about the costs.

Now I have been off drugs for two years. Now I have a better relationship with daughter and family. But then I had a constant attitude being on drugs. I was up all night, slept all day. When my family would call and ask me over for dinner, I would scream at them and slam down the phone. I thought everybody was against me.

My daughter made me realize I needed to get off drugs, to stop using. That was the first time I thought about my priorities—and my priority is my daughter; not the crack, or the man that I had been chasing. I don't have that many childhood memories of *my* mother and I pray that it is not too late for her. But I want her to have some memories—with me coming to jail now, I explained it to her. . . . [When I told her that] "Mama can't be there for Christmas" and she said, "Mama, that is alright. You were here last year and you can make it up to me next year."

Daisy, a repeat offender, admits, however, that while on the streets, drugs were her primary concern: "On the streets I was into drugs more than I was into my family—I knew my baby would be better off with my family."

This comment typifies the drug experience of many of the women at CCWF: "I started getting high when I was young. I started out by drinking, celebrating, and then pretty soon I did it every day. The initial desire became a need. I can honestly say that drugs became my number one lover." Valerie, serving three years for drug sales, holds a B.A. from a prestigious private university in California, but claims that crack allowed her to turn her back on that world:

Smoking crack is the most intense drug. I still think about it every day. I remember what it did for me. I lived like a bum. It didn't make any sense for me to do that. I guess I get bored easily. I have to keep busy with my computer work—here and on the streets. But when crack comes in the window, you can just forget about everything else. You just don't care. Being a dopefiend, you have to start all over in so many ways when you get clean. You have to start over so many times that we get used to it. We are adaptable. You are either free, sick, or in jail.

Pregnancy creates an additional complication to drug use, as this woman suggests:

I didn't know I was pregnant when I was locked up. I was smoking crack. I spent the longest time trying to get into a program on the streets. But the judge always refused to place me in a program but I never knew why. I have spent a lot of time trying to understand why I use drugs. I have been doing a lot of time. At thirty-two, I have been locked up about nine years. I have hurt a lot of people behind this—I have hurt myself too. My husband does not use (drugs). I hid my habit from my husband and always made excuses about my time, money. But when you smoke, everything catches up to you. So this time I was convicted of possession of twenty dollars worth of crack and I received three years.

EARLY FAMILY LIFE

For most women interviewed for this study, the difficulty and disorder of their personal relationships with their families, their mates, and their children are played out in the path to prison. Elliott Currie (1985) argues that material disadvantage and quality of family life are intimately related and may in fact combine to create conditions that foster crime. Bottcher (1986) and Rosenbaum (1993) argue that early family experiences, particularly those involving inadequate or disrupted parenting, have profound effects on the adult criminality of girls enmeshed in the juvenile justice system. While research on girls and delinquency has been overshadowed by the vast literature on male delinquency, there is an emerging body of knowledge about girls' lives. Only recently have female delinquency and criminality been given attention (Chesney-Lind & Shelden, 1992). Two studies of girls in the California Youth Authority system elaborate on these themes of family disorder. Jill Rosenbaum (1993) found that disordered families contributed to, rather than diminished, delinquency. She also suggests that inattention from the mothers was highly correlated to delinquency:

> Maternal passivity, cruelty, absence and neglect all were highly related to their child's commission of crimes at an early age, the commission of a wide variety of crimes, and the persistence of crime into adulthood (Rosenbaum, 1993:401).

Rosenbaum suggests that most of the women came from extremely disordered homes, with little stability and some histories of family criminality. Family violence and conflict, directed by the parents toward the children and each other, characterized the nature of these families. As Rosenbaum states, "The mothers of the CYA wards tended to marry young. . . . The mother's psychological and financial resources were obviously limited and the added burden of children appeared to increase the strain" (1993:407). She further notes that the wards' mothers did not have the support or resources needed to cope with their environments. For these mothers, "just trying to survive depleted whatever emotional resources they once might have had" (1993:408).

Another aspect of these lives comes from a second study of girls in the California Youth Authority. Bottcher's study of "Risky Lives" endeavors to "develop a more authentic image of the female delinquent" (1986:1) by interviewing young women in the custody of the California Youth Authority. In examining the life circumstances and patterns of female delinquent behavior, she develops three themes: unusually early independence; considerable free, unstructured time; and inadvertent routes to crime. In addition, Bottcher found "an unusual riskiness (that) pervaded all their lives" (Bottcher,

1986:13). She (1986:33) argues: "For some, crimes seemed part of a lifestyle that evolved in some unintentional, unexamined way." She also notes that many of the young women were more actively or self-consciously living a life of crime.

While these detailed descriptions of the lives of women in the Youth Authority contribute to our understanding of girls' lives on the street, several additional important themes were also found in the present interviews; specifically, how the roles of drugs, abuse, poverty/limited opportunity, and early parenthood shaped the lives of these women to an extent that "normal" existence (defined by standard middle-class values) was unlikely. Surviving the circumstances structured by these "multiple marginalities" places women in circumstances that are likely pathways to imprisonment. In ways strikingly similar to the family backgrounds described by Chesney-Lind and Shelden (1992), Rosenbaum (1993), and Bottcher (1986), the family lives of many CCWF women were disordered, often to the extent of total disintegration. For some women, their early childhoods were marked by either the absence of or emotional estrangement from their parents. In spite of these circumstances of child-rearing, Daisy, a woman with a highly disruptive upbringing, made this comment:

> You talk to a lot of girls and they are all bitter and angry because of their childhood. You cannot hold on to that. You have to let it all go. Yes, I was robbed of a childhood, but I can't get it back. You just go on.

With drug and alcohol problems shaping their own lives, many of the women interviewed were deeply affected by their parents' substance abuse. Zoom describes her alcoholic parents:

> While my grandmother was a Christian, my father was a whore and my mother was a drunk. My mother was an alcoholic for a lot of years. She just stopped drinking for the last three years. I grew up with her drinking. It is one of the reasons that I think I grew up like I did. I remember undressing her, putting her to bed. I remember feeding her . . . taking care of small brothers and sisters, you know, being their parents. From thirteen, fourteen on, that is when I became the parent.
>
> I'd get up in the morning, fix myself some cereal . . . (after school) run back home and check on her . . . check on my brothers and sisters. And that was when my stepfather started becoming abusive so I was constantly throwing my little brothers and sisters out the window cause they were in there fighting and I didn't want them around that.
>
> (My stepfather) treated me and my sister good, just like we were his. He just changed (when) he started drinking heavily. When he drank, and

got very, very violent. One time I just set my mother down and just begged her, I pleaded with her, just leave this man. I will help you.

To be raised in a home with alcoholic parents is like walking on eggshells. Between my mother and my stepfather, it was not an easy life. It was like you have to think about . . . well, if I do this, is it going to tick him off? Her off? Or, is this going to make them fight? What can you do? Nothing. You sit there and listen to her holler and scream and take the whooping and then go and lock yourself into your room and sulk. You do everything you can to avoid anything happening. You're always walking a tightrope.

But one time I came home and he was beating my mother. I will never forget this. I went to the kitchen and got a steak knife and it seems like I must have stabbed that man fifty thousand times. But I guess I was not doing any damage because he didn't stop. So the police came and handcuffed him and took him away and took my mother to the hospital.

But even this dramatic event didn't stop the abuse of her mother by her stepfather:

They have so many arrests on him, and her pressing charges, and her trying to get restraining orders on him. That system does not work for women for real. Them going to the police and calling the police and getting restraining orders, that does not work. Not when you have a man who does not want the relationship to end. A restraining order is not going to keep the man from bothering you. You or the children. It is sad that these men won't leave these women alone.

Another aspect of these disordered lives is the imprisonment of a family member, usually a father or a brother. A number of women at CCWF were separated from at least one parent during their childhoods by the parents' imprisonment. About 70 percent of the women in our survey sample had family members with arrest histories, with about 60 percent reporting the incarceration of a family member at some point. Jackie, serving a life sentence for a drug-involved murder, tells of violence between her parents and of her father's incarceration:

My father was in jail a lot, and then he went to prison. My father shot my mother in the back—I was standing right next to them. He fought my mom a lot, then they went through the divorce thing when I was about in the fourth grade. Mom took us to county (jail) to see him; I

remember the long line to visit him; I still remember that to this day, standing out in the rain and snow; she brought us to see him even when they weren't getting along.

I visited him in CDC. I remember thinking the prison looked like Disneyland, and then he pointed out the bullet holes in the wall; he was proud and showed us off to his friends. Now I look back, I think about my mom visiting me here and what it must be like.

Tessa is serving a short sentence for drug possession but has been to prison four times previously. In the year before this interview, she and her mother were serving time together at CCWF. In this comment, she recalls her mother's early incarceration:

My mom went to prison when I was seven months old. For murder. She got a six to life sentence. I was shifted back and forth between my grandmother and my aunt. I had a beautiful grandmother. My mother got out of prison when I was almost seven.

My mom did six years for first-degree murder—she had moved to LA from New Orleans and she was always hassled by the other girls. She says she was scared of them because they would take her shoes, her purse, and throw them away. The girl (she killed) had been threatening her, telling her not to go anywhere. The lady had a big knife and a guy gave my mom a gun to protect herself. And the next time she was threatened, she shot that lady six times at a dance.

She would not tell us for a long time why she killed the lady. She was eighteen in 1960. I don't remember her being in prison until I was about five years old and I remember the phone calls and the pictures. CIW was real pretty and it didn't seem like she was in prison. I didn't know her; all I knew was a picture and seeing that was my mom. They told us she was in prison, but we were not supposed to tell anybody where she was. We were supposed to say she was out of town.

The problems started coming in school. Other kids' moms would not let them play with me. They would say, "Our mom says we can't play with you because your mother is a murderer. She killed a lady." I didn't understand what was going on. I was the real strong person; my other sister is real timid. I had a big sister—[Tessa whispers] and she is a prostitute now. She has always been distant to me and my mom. She told me she hated my mom because she made her life rough. She never really forgave my mom for leaving.

Other kids would taunt me and I would tell them, "Well, if you bother me, she'll probably kill you too." That was my way of fighting back. I was rebellious. Kids would say to me, "Why your mother leave you? She must have left because she didn't want you. . . ." For a kid, it made me think she didn't want us. I didn't know about the drugs and everything. Until I was seventeen, and then she said I was following in her footsteps.

My grandmother was very overprotective but I was rebellious and did things to irk my mother. I was kind of mad with my mom. When she went to tell us to do something, or fuss with me, I would tell her I didn't have to. At one point in my life, I hated my mother and I know that was wrong. She was a beautiful person, but it was the drug use [that ruined her]. She started using immediately after her release. By the time I was ten, I knew my mom was using drugs—I saw her fixing. I happened to look in there and she was putting things on her arm. It was the look on her face. I told my sister, and all my friends to come and look. I would find her needles—I would go through her purse and find them. I stole something and I would blackmail her—she could not tell my grandmother or I would tell on her. She would call me a little monster. She would tell me just to be quiet and let life happen.

I always used to hate her and never looked at the good stuff. Now I wouldn't change her for no mom. She is a good-hearted person that has had a lot of hang-ups. Maybe if I had more of my mom's time, attention, and guidance, even she did do drugs, that mother image. If she had just been there.

I always wanted someone to be there. Maybe it would have been different for me. My aunt, my grandmother was there, but I wanted my *mother* to be there. That is something I have lost for a lifetime. She did not even come to my school events even when she was out. I had a graduation, a modern dance thing, and she never got to come because she was out using. I always wanted to ask what was more important. Why was drugs so important?

When I would disobey, she would whip me. I told her that she did not have the right to whip me because she was never there for me. She was never there. I have lost that forever.

This is my fourth time in prison—my mom went to prison thirty times between 1960 and 1976. In 1985, when my sister died, my mom relapsed and now she is in and out of prison. She started drinking, using heroin, coke, anything. She just paroled from here—we were here ten

days together this year. But now she is fifty-one and she is tired of coming back. She is doing good, going to counseling. She said that she never did anything to keep her from coming back. She is looking for reasons not to come back.

As women make the transition from childhood to adulthood, their family lives do not necessarily improve. Caryn describes her experience with a husband who became abusive:

He was using drugs and he struck me a few times and I knew it was time for him to go now. Cause I would not live like my mother lived. I would not go through what my mother went through. I watched my mother get beat all the time. I won't be subjected to it. I finally took my daughters to my mother's house, cause I knew it was time for me to leave because things were getting really bad. I was physically afraid of him. I knew it was going to get real violent. I knew he kept a gun in the house. It happened over a long period of time. I am summarizing here, but he just became a different person, an ugly person. And it was like, how did I fall in love with you? How could I love somebody like you? Drugs had just changed him so much.

But not all women interviewed report coming from disordered families. Mindy, a very young lifer, discusses the problems of being a young inmate facing a long prison term:

We are young. We didn't get to have no kids. We have left our mommies and our daddies. . . . We are used to freedom and here we are way out here [in this prison] and we don't know what is out there. I come from a good family. . . . My mom is a college teacher and my dad is an engineer. I was spoiled. I am not used to being away from home. But I chose to run with a fast crowd and things happen. If you chose it, even though your mother told you not to, well, sometimes you just have to learn these lessons yourself. I don't think they should have gave me this time (life) on my first offense, but things happen. I have to keep the faith that I will go home someday.

CHILDREN

Relationships with children are central to the lives of many of the women at CCWF. The presence of children in the lives of these women shapes their pre-prison experience, as well as how they serve their time, as we will

see in chapter 5. These relationships, however, often duplicate the disorder and disorganization of their own childhoods, bringing these problems full circle. Daisy, a repeat drug offender, states that her relationships with her children are important to her, even though she does not live with them on the streets:

> I don't know my younger boy at all. I don't know what he looks like. The older one does not want to live with me. He says he has to be with my youngest son. I have never lived with my seven-year-old. I have only seen him once. I used to give my sister money for them—money I made from drugs. My sister is verbally abusive to my oldest son—if he sees me, she tells him, "Go ahead and go with her. Be just like her." I communicate with him by seeing him outside her house. But I don't have any way of knowing how he is when I am locked up.

This woman has a serious history of physical abuse as a child and sees that neither the family of her parents nor the family of her children has been her "real family." Currently married to a man serving a long sentence at San Quentin, Daisy further states:

> Convicts have always been my family. My heart's desire is to have someone close to me who is blood, rather than just convicts as family.

Women prisoners are more connected to the outside world through these relationships and child-rearing roles (Bloom & Steinhart, 1993; Hairston, 1988; Koban, 1983; Morris, 1967). Our survey found that almost 80 percent of the women had children, many at a young age. Initially, having children at a young age propels women into quasi-adult roles for which they are often unprepared. Just under 15 percent of our survey sample left school because of an early pregnancy. This premature motherhood undermines any attempt at gaining the education or skills necessary for adequate employment. Pregnancy leads to dependence on family or public assistance systems, or an income generated outside conventional means. Darlene describes the effects of her early motherhood:

> I had a baby when sixteen. I grew up fast with family responsibilities. I had no time to be a child and a lot of things I did later were out of childishness, not as an adult. My mother had her own problems and she didn't have the time for me. My grandparents raised me and then I was pregnant at sixteen. My grandmother told me I reminded her of my mother, who they did not like. My mother was doing drugs. Her sister, my aunt, was killed in a struggle over a gun with my father. And then

my mother's family killed my father in a real brutal way. It grew me up bitter. My mother says I remind her of her when she was young. . . . I have buried a lot of that now that I have grown up.

She describes her concerns over having a child before she could support a baby:

There is one thing that I vowed and that is I would never get on welfare if I had a child. I did not want to have a child on welfare. It was degrading to me. You know, because it was like what society, what everybody, expected. You are young, you are black, you got a baby, you must be on welfare. And I never, ever wanted to do that.

Having children continues to limit the life-chances of these women, as this comment by Matty illustrates:

I had to quit school when I got pregnant—there was so much going on. There was no one to take care of my kids. You have to really worry about who you leave your kids with. Later I got involved with a program that paid for child care, paid to remove my tattoos. I was on probation and, in some ways, my probation officer helped me. But I just went wild. It was "la vida loca" and I never looked back.

THE STREET LIFE

For some of the women, these disordered lives translate into an early history of juvenile crimes and some gang-related activity. In surveying these data, one must be reminded that gang activity and youthful incarcerations are present only in a minority of the cases of women in prison. This nineteen-year-old young woman, Tabby, serving a short sentence for drug-related crimes, describes her life on the streets:

I am just wild. I have always been wild . . . it is just something in me. I had been in juvenile hall before. I have been gang-banging hard since I was ten. I started hanging around with my older brothers and sisters in the hood. I am from the hood. I am an Elm Street Piru—that means I am a Blood.

I was raised on the streets. My family is pretty damn good, but I grew up in the hood. My parents both worked and they were too busy worrying about my older brothers and sisters. When I was eight, nine years old, it became a real big thing to emulate the dope dealer on the corner.

You wanted to be like the dope dealer on the corner, with the fly ass car. I wanted fresh new clothes. Sure I got a few new pairs of pants, but I wanted more. I wanted the Guess overalls, so I had to do stuff to get it. I had to rob and steal and start gang-banging.

I was nine when I went to juvenile hall for disturbing the peace. I was there three weeks. I remember walking in, being kind of real scared and then I thought automatically, I am not going to be scared. I went in there, and I was scared inside, but I didn't let nobody know it. . . . I was a tyrant. Whooo, they probably thought, "Where did this kid come from?" Yeah, there were older kids than me, but I lashed out at everybody and then I wasn't scared anymore.

Although many of the women interviewed in this study described having trouble in school, this was not always the case. Tabby describes her need to do well in school. Although this woman served two terms in Youth Authority, identifies herself as "being down for her hood," and has two children under five years old, school was important to her:

I always told myself that I would not be stupid when I grow up, even if I was a gang-banger. School was a priority for me. When I talk to people on the streets, or people in here, sometimes I have to change myself—not use so many big words—to make people understand me, I have to say something like, "Ah bitch, you know what I'm saying?" Rather than let them think that I am trying to intimidate them with my vocabulary. Sometimes people will say to me, "Where do you get off talking like that?" But I have always loved words. I still try to read the dictionary every day and think about words.

I started looking up words in school. The teacher would use a word and I would want to know what it means, how to pronounce it correctly. I always felt like I was an outcast because I am a mulatto. I didn't fit in anywhere. I was too light to be black and my hair was too kinky to be white. People started calling me when I was very young "spaghetti head"—things like that. So I started looking up words for something to do. I didn't play with anyone, never went to the playground. I just stayed inside because no one would talk to me.

But, in her neighborhood, doing well in school did not translate into a feeling of achievement or belonging. As she says:

I think I joined the gang to feel like somebody, to be accepted. At age seven, I was following my brothers and sisters to the street. My broth-

ers and sisters were already in trouble. I stayed out until midnight. At first, my brothers told me, "No way, you are going home," but they eventually saw that I was not going to go home, I was saying, "I ain't going nowhere," and they let me stay. My oldest brother is now in San Quentin for murder. . . . My dad is there too, for burglary. My stepfather was killed by the BGF (Black Gorilla Family) on the streets.

Celia recalls her desire to look "hard" on the street and her feeling of being an outsider:

All my life, I wanted to look hard, to look mean. I wanted to keep people away from me. I used to shave my eyebrows, paint them back in. I wore lots of makeup. At times I even wore men's clothes and shoes. I didn't want anyone to approach me. I dressed very hard on the streets—it was insane. I don't want to look hard now. When I see old pictures, I am embarrassed. But I just wanted a place to fit in so I tried to fit in on the streets.

As Bottcher's (1986) interviews show, involvement in criminal acts or the street life may be accidental or completely purposeful. Drug use provides an introduction to the fast life, as well as to criminality. Zoom, a thirty-two-year-old black woman, describes the danger and the lure of the fast life, once she became involved with a man dealing large amounts of drugs:

It's a lifestyle that I got caught up in. You know, you get yourself in this situation. And you think "My God, How did I get from point A to point B? How did this happen?" You are in over your head, and [others] want you to try this. And you think, "Well, I can handle that and that is no big deal," but inside you are petrified. And you want out but you do not know how to get out.

For many women, the advent of children made them pause and consider their behavior and involvement in crime. Zoom later found that becoming a mother made her evaluate the direction of her life:

After I was pregnant with my second daughter, I felt it was time for me to get away from all this. To get away from that lifestyle. It was time for me to be a mom, a mom for real. [Time to] square up, because I don't need it now. You just get tired. I learned from being in the life that it is when you get greedy is when you get caught. I just had that feeling that it was time to leave it alone. It was time to square up and raise a family. With all the drugs, the fast money, just hanging around all those people there comes a time when you have to put it all away.

Of course it is exciting. It was like a dream. You are living in a dream world because reality has not set in yet. Because the reality of it is that you are doing something that can get you sent to prison. You know that you are living a dangerous lifestyle. For real. You don't think at first you are in over your head.

I told my husband, "That's it." I want out and I want out now. I want my own house for me and my daughters. I don't want to be a part of this. No more.

[You realize] that money is the root of all evil. [But] to be without, growing up for so many years and you have an opportunity to have anything you want. You let that materialistic stuff start to have so much value. You forget about your other values. You put aside the deep instilled values. Money will change you. It will make you do things you normally wouldn't do. It'll make you accept things that you normally will not do.

Most of the women interviewed here accept the responsibility for their behavior and see their criminal behavior as a result of conscious decision-making. Kiki's narrative illustrates a common experience:

But I done got myself in this trouble. I have to deal with it. [In prison] they take care of you. They give you food, they give you soap, they give you your personal hygienes. I can deal with it as long as I have food in my stomach, clothes on my back, and something to clean myself with. I am cool, because I done got myself in this mess. My kids have to have more than that so my family has to take care of them . . . that was the same way I was on the streets. I got into selling dope, using dope, smoking dope. I started selling dope just to get high. I never once went to my family to get money. I got a check the 1st and the 15th of every month, because I wasn't working. I told my auntie that money was for the kids . . . if you need anything in between come to me and I will have the money. They disagreed with my selling dope . . . and I left the house so I would not be disrespecting the kids by selling dope in their house. I sold dope in another place. . . . I called the social worker and told her to switch everything to my auntie because she was taking care of the kids . . . but then she got [her parole] violated and returned to prison for ninety days.

I made my living selling dope. I tried for jobs and jobs and jobs and I didn't get any jobs. So I tried selling dope. I knew it was a quick hustle and that I could make some money. That is what I did.

Once involved with the street life, women moved farther and farther from attachment to conventional ties. Tanya, serving time for a drug possession offense, describes her life on the street:

> I was running the streets, but I would come to see the kids. I had a room mostly every night, selling dope out of the room. My auntie said I could come and stay the night and visit the kids, but in the morning I had to be out if I was selling dope.

> I was looking for a job at the same time . . . but I couldn't find a job and went right back to the hotel and sold dope. If my auntie called and said my daughter needed shoes, I would say, "Here, come get the money." My daughter knew what I was doing, but I tried to tell her about drugs, not to let anyone give it to her, to stay away from it. . . . I told her that I would not always be with you because I knew what I was doing was dangerous.

> But I had to have money and I could not see myself standing on no corner, messing my body up. My mother always told me that if I was doing that, no decent man would want me by the time I was twenty-five because every man in the universe had me. I took to that. The only thing that I regret, the bad thing that I did, was selling dope. But I can't say that I will never do it again—if I get desperately broke and my kids need it, that is what I am going to do. I have to pay rent, supply them with food, clothes. The county doesn't help that much. I was a single parent, by myself. Their father was out shooting dope, doing his thing with other females. I didn't have time to trip. I had my kids, I had to raise them. I tried to raise them the best I knew how. If there was something I didn't understand, I would ask my mom. My kids are alright out there on the street with my mom and my auntie.

Divine, a forty-seven-year-old black woman now serving a three-year term for drug sales, had previously served a long term for manslaughter, for killing an abusive man. She describes the difficulty of living on the streets:

> Most people can't understand how a woman could be convicted of a murder-robbery. I am from South Central. That happens and we all know how that comes about. Maybe you did kill an innocent person. But that is on you. We know why you did that because of the environment we were in. I have had to face it myself out there on the streets. It is conceivable that I could be in here for murder-robbery a lot of times. Because I was shooting dope and ain't no telling who I might have hurt. And you don't know what she was doing when you hear about someone's crime. You are just a product of your environment.

SPIRALING MARGINALITY:
ECONOMIC DISADVANTAGE,
AND SUBSEQUENT CRIMINALITY

Related to the interweaving of substance abuse and the street life is a category of life known as "the fast life" (Rosenbaum, 1981) or "la vida loca," the crazy life. For women on the economic and social margins, looking to escape home lives or simply looking for excitement unavailable through the conventional world, the fast life becomes a reasonable survival option. This life is shaped by the overlapping dimensions of drug use, crime, and, often, violence. The pathway to imprisonment is shaped by choices made by women looking for excitement or lucrative hustles or otherwise unable to make it in the traditional world.

Once again, these data also suggest that the prime motivation for most women's crime is economic, psychological, and emotional survival. The profile data show that the majority of women in the representative sample had few skills and little education. These findings from the survey data show that, for the majority of women interviewed, crime as a survival skill becomes a viable alternative. We asked a series of questions about educational and work backgrounds.

Women in prison are generally undereducated. Almost 40 percent of those interviewed reported that they did not finish high school: 28.2 percent said they finished one to three years of high school with no GED and another 11.6 percent did not graduate from high school but completed GED requirements. Just under 15 percent finished high school. Over one-fourth of those interviewed indicated some education or training beyond high school; some combination of college, or technical or trade school. Of those with vocational training, courses in business/secretarial, medical/dental assistance, and cosmetology were the most common trades studied.

About half of those responding to our survey indicated that they had never worked at any time, with a somewhat larger number indicating they had not worked the year prior to this incarceration. The most often cited reason for not working was substance abuse problems: almost one-third of those not working reported a drug and/or alcohol problem as the reason for their unemployment. The second most often cited reason for not working was "made more money from crime and hustling," with child care responsibilities a close third, at 12.3 percent. About 10 percent of the women indicated there was no specific reason or they did not know why they were not working. Just under 9 percent were supported by a spouse or family, while a combined 9 percent felt that no jobs were available or they did not have the training or skills to look for work.

When asked about their sources of support in the year before this incar-

ceration, 37 percent reported "working at a legitimate job," 22 percent reported some form of public support, and 16 percent indicated making money from drug dealing or sales. Another 15 percent reported other illegitimate income, such as prostitution, shoplifting, hustling, and other criminal activities. We also asked about secondary sources of income. Here, crime, especially drug dealing/sales at 31 percent, was mentioned by almost half of the respondents as a secondary support. Approximately one-third of those surveyed indicated that they had been involved in prostitution at some time in their lives.

These detailed figures support the argument that the absence of educational and vocational preparation results in a future with little economic footing. The work data show that about half the women in our survey relied on either public support (22%) or illegitimate incomes from drug dealing, prostitution, and other forms of hustling (31%). With the advent of drug use, which both inhibits one's ability to seek and keep work and requires money to sustain its use, illegitimate activities become a viable survival option.

CONCLUSION

An understanding of the lives of women prior to imprisonment is essential to the story of their lives inside prison walls. This attention to the conditions of women's lives before prison is also critical because many dimensions of these outside experiences are reflected in the culture of the women's prison. Experiences as girls were shaped by growing up with disordered families, early abuse, initial delinquency and criminality. Dimensions of adult experiences include drug use, further physical abuse, increased inability to support one's self and children, and possible further estrangement from conventional roles. For those living the "fast life," an increasing commitment to a deviant identity further accelerates the movement toward imprisonment. These dimensions of their lives before prison sketch clear pathways to imprisonment. These personal experiences combine with an inability to make the "right choice" and structural marginalization. As Rosenbaum (1981) argues in her study of heroin use, these factors combine to create an ever-narrowing funneling of options, often resulting in criminality and imprisonment. This review of the lives before prison leads into a more detailed examination of the ways in which women confront the fact of their imprisonment and struggle to make sense of their lives inside.

Chapter 4

Time and Place

In the simplest sense, a study of prison is about doing time. The term "prison career" has been used by Irwin (1970) to capture a sense of moving through the stages of imprisonment. This chapter discusses the ways in which the prison career of the woman prisoner, and her subsequent immersion in this culture, is shaped by both physical and temporal dimensions. The temporal dimension shapes one's level of attachment to prison culture as one becomes prisonized (Clemmer, 1940) or socialized into the normative prison structure. Like the men described by classic prison studies and by the phases of the prison career suggested by Ward and Kassebaum (1965), the women at CCFW also develop social worlds that are bounded by both the phase of their prison career and the length of their sentence.

As the largest women's prison in the United States, and most probably elsewhere, the physical world of CCWF has specific impact on the social world and the lives of its inhabitants. Opened in October 1990, CCWF has a design capacity of about two thousand women. At the end of my fieldwork, the prison was crowded at almost 200 percent of this initial capacity, with a population of around four thousand. Much like male prisons in the past decade, crowding has become a defining feature of institutional life and affects almost every aspect of daily life at CCWF.[6]

At CCWF, these physical and spatial dimensions shape a woman's prison career. These physical and spatial relationships are structured by the size of the institution, the degree of crowding, living and working arrangements, patterns of inmate movement, and free time activities. For the contemporary prison, any discussion of the social organization of the prison must examine the impact of crowding on the prison culture and the ways women learn to negotiate this world. Huge population increases in California's pris-

ons (Owen & Bloom, 1995a) have created crowded conditions never before experienced in the state. Between 1980 and 1992, the California prison population grew 346 percent, from 24,569 to 109,496. Women prisoners comprise just over 6 percent of the incarcerated population. While California is building prisons at an unprecedented rate, the demand for prison space outstrips both the new construction process and the supply of available beds. In mid-1996, the women's prison population in California stood at almost 10,000 and rising. According to the SCR 33 report, neither population growth nor a rise in the crime rate fully accounts for the huge increase in the incarceration rate. Using historical data, the SCR 33 committee found that while the arrest rate decreased slightly from 1989 to 1991, the rate at which felons were sent to prison increased during that time. The rate of new admissions of women to the state's prison system for felony offenses increased from 2.9 per 100,000 California population in 1980 to 11.3 in 1991, an increase of 289 percent. In contrast, the rate of new admissions for men increased from 44.8 per 100,000 California population in 1980 to 113. 5 in 1991, an increase of 153 percent (SCR 33, 1993/4:A-6).

For both males and females, the proportion of offenders sentenced for violent crime and property crime decreased from 1982 to 1992. In contrast, the number of inmates admitted for drug-related offenses increased for both males and females during that period (SCR 33, 1993/4:A-6). The increase in drug offenders, new legislation requiring mandatory prison terms, and the creation of work and school credits ("good time") have resulted in "the emergence of two new prison profiles, short-term and long-term inmates" (SCR 33, 1993/4:A-8). On one hand, the CDC houses increasing numbers of short-term inmates. In 1991, for example, about 63 percent of the female new commitments served twelve months or less in prison. On the other hand, mandatory sentencing laws have resulted in larger numbers of inmates serving increasingly longer sentences. Overall, the median time served by females in CDC institutions continues to decline, from approximately nineteen months in 1980 to ten months in 1991.

Classification is another feature of the social organization of life in this women's prison. Inmates in CDC institutions are assigned a classification that signifies their level of security risk based on the offenses for which they were committed and their history of prior commitments. With Level I signifying the lowest-risk group and Level IV considered high-risk inmates, over 75 percent of the female population is classified at Levels I and II. Just under 14 percent of the females were classified at Levels III and IV. (The remaining female prisoners were unclassified at the time of the data reporting.) In contrast, 58 percent of the males are classified at Levels I and II, with 42 percent classified at Levels III and IV. The differences in the classification levels of female and male inmates are primarily due to three factors: women are committed to

offenses; women are committed to prison much
while inside prison, women commit fewer and
ctions than men (SCR 33, 1993/4).
tions of the population provide a context for dis-
n in prison. While about half of the women pass
or less, a small core group lives within prison
may never leave. The majority of women in
ents. Of the 9129 in custody during November
me commitments (Department of Corrections,
re parole violators with a new prison term, and
had been returned to custody for a parole vio-
vere typically repeat offenders. For male pris-
compares to a population total of 125,977, with 74,984 (60%) new
admissions, 30,851 (24%) parole violators with a new term, and 13,533 (11%)
parolees returned to custody for a parole violation. During that same time
period, 3,044 women were in custody at CCWF, with 2095 (69%) as first-time
commitments. Regardless of the time spent at CCWF, all women are exposed
to prison culture to varying degrees. Their immersion into this culture comes
through two dimensions: time and place.

TIME

Doing time can be understood from several perspectives. Like the U-
shaped curve described by Garabedian (1963), each prisoner's temporal rela-
tionship is shaped by the phase of her sentence (Ward & Kassebaum, 1965).
At CCWF, sentence length is also critical to this temporal dimension and par-
tially determines the ways women organize their time and their relationship
with prison culture. As Ward and Kassebaum (1965) discuss, the phase of a
woman's criminal career and the number of prior prison terms also contribute
greatly to her temporal relationship. A first-termer, with no prior criminal
record, approaches the prison experience much differently than the woman
who has an extensive record, a commitment to a deviant identity, and prior
prison experience. Prison culture itself experiences shifts in this temporal
dimension. Women will discuss "the good old days" of prison in California,
particularly in terms of the intensity and pervasiveness of the convict code.
This section discusses the ways in which time shapes one's experience with
the prison culture.

County Jail

As the first stop in the process of imprisonment, a woman's initial expo-
sure to prison culture comes at the county jail. While women are awaiting or

undergoing trial, many of them are held in county jail, where they pick up information about prison life. First-termer women are held in jail with parole violators or others who have been to prison previously. In the jail, women often hear stories about prison and what they might expect. The county jail is an initial source of information about how to do time and life in prison. Women who have no prior history of incarceration uniformly report being terrified at their future imprisonment and this terror often begins in the county jail. Vanessa, a young black woman imprisoned for embezzlement, recalls her early days in county jail:

> I was surprised in county because I didn't know what to expect. First thing I thought was, "Please don't lock me in there with those other women." I cried and begged the officers to put me in a cell by myself. They told me I should give myself a chance since this was my first time there, and locking myself in a room by myself would make things worse. No, I figured it would be better to be by yourself, that way the women can't bother you, you will be safe, you will be okay.

For the approximately 40 percent of the women in California prisons from the Los Angeles area, Sybil Brand Institute (SBI), the large detention facility in Los Angeles, is their first exposure to incarceration. Many women described the crowded conditions at Sybil Brand and the difficulty in living in a dorm with several hundred women. The level of violence and the lack of concern exhibited by the officers were reported in almost all the interviews of women who had been held at Sybil Brand. In comparison, CCWF is seen as an improvement over the conditions at SBI. As this woman describes:

> Sybil Brand was rough. This is more better here. The police there are different. They're more militant. These police here are more visible. They're more compassionate. Down there they're not compassionate at all. At Sybil Brand they not take time to know who you are. They just do their job—they might leave a whole dorm full of girls in the dorm for a half a day without coming to see about them. As long as in the morning they have checked you in and got their count right, they're all right. They might leave in the morning not come back until you go to lunch.

Almost all the women claimed to feel much safer at CCWF than at Sybil Brand. Josie, a first-time offender, found that life at SBI was "much rougher." Although she later found that her time at CCWF would be more controlled and less violent, her first exposure to jail life "was a shock":

I had never been to prison before; when a fight would bust out, it would take two to three hours before anyone would get there. I have seen teeth knocked out, I have seen arms broken, I have seen food fights in the dining room, I have seen people being cut at SBI. I would immediately run to the top of my bed . . . and wait until the COs came and broke it up.

CCWF is much more organized. The COs are more responsive. They will run out and break it up. I feel more safer here than at SBI, but the fear still comes on to me. This is a new environment that I am in and it takes a little time to get used to it.

But Vanessa, who was held in a smaller county jail in northern California, felt that CCWF was not as safe as this jail:

County jail was a little better for me, because I like it when there were more police officers there. I feel more protected—here there is more liberty and people are not watched constantly. Here I feel so isolated. I felt safer in the county because there were more officers and we lived in cells.

After women are sentenced to state prison, they are taken to the prison in either a bus or a van. Cari, a young white woman in her late twenties, nearing the end of a five-year term for drug sales, recalls her first days:

I can remember coming in on the bus. The lady driving was a real toughie. She said she didn't want any noise and if we made noise she would take us off this bus and beat our motherfucking ass.

Amanda, listening to this remark, remembers being scared in her first moments at CCWF and "I didn't think I would get out of here alive. I was young, I was seventeen." Another woman listening to these comments exclaims, "Man, that just gave me chills hearing about that."

Coming to Prison

Blue is a twenty-eight-year-old white woman who was interviewed at the end of a nine-year prison term for aiding a sexual assault and kidnapping. When asked to describe her first days in prison at CIW, she recalls:

I remember it was scary. We were driving on the way up there. Everybody was talking and laughing, cracking jokes about going to prison. They were all happy because maybe they had been there before, and I am sitting in the back of the bus, nineteen years old, wondering, "Why

are they so happy that they are going to prison?" Here I am just a baby, and I am going to prison for a long time. This is my first time ever doing anything. I am sitting in the back of the bus. Everybody is telling me these stories what is going to happen to me in prison.

They told me about the homosexuals, the lesbians. Since I am young and new, they were going to take what they wanted, which was me. I was like, nah, they don't do that. And then they say when you go in to shop, there are big trees by the buildings and there is girls in the trees, waiting to jump you and take your canteen. And (they told me) they fight, and use shanks, which is homemade knives, and three or four different girls can jump you.

Many first-termers recall their initial concern about lesbianism, worrying about being "approached," the prison phrase depicting a request for engaging in same-sex behavior. Bonnie tells of her first contact with a lesbian on the bus trip to the prison:

> I was handcuffed on the bus with a lesbian. I would not go to sleep, I was too nervous about what she might do. She told me she was a lesbian . . . had been one for eight years. She has short hair and acts just like a man.

> But once I got here, I was never really approached. At SBI, ladies would tell me I was so pretty and ask me what race I was. I would answer but I would be very firm and very serious. I told them, like, don't try to play with me because I am not that kind of person.

While the experience of coming to prison may be immediate to the memories of newcomers, long-termers are also able to recall their first days at CCWF. Blue recalls leaving CIW and being transferred to CCWF:

> Ohh, it was prison. It was prison. CIW wasn't really prison to me; it was like a camp, because there was so much freedom there. At that time, there was only one fence around it. When I drove up here, it was like, "I am in prison." The way they brought us up here. They got us up at 2 o'clock in the morning, we ate breakfast, strip-searched us, gave us our muumuus and our shoes; when the bus came, they shackled us, our feet, and right then I knew I was going somewhere, it is not going to be like this place at all. When we drove up here, I was tired. And then we did the same routine again. We had to take off the clothes they gave us and strip-search for them, bend over and cough, put on another muumuu.

We come through and walk through the gate and I looked and I went, "Oh my God! This place is so big." It was all dirt. There was only three or four people to a room. It was okay at first, and then they started bringing in all these women. The youngsters, they were so loud and obnoxious, the ones that don't have no respect for nobody when they are sleeping; or have friends in the room, (being) out of bounds. Then your room gets tossed up. I have a lot of things stolen from me, but I am not going to make a big issue out of it because it wasn't worth it. I knew I was going home and I tried to keep my cool.

Prior Prison Terms

Unlike first-termers, repeat offenders have prior experience with the world of the prison. Some of the women interviewed for this study had done time at California Institution for Women (CIW), the oldest prison for women in California and the site of the Ward and Kassebaum (1965) study. A common view was expressed by Evan:

It's so much better at CIW. It's funner. We find ways there to have fun. Lot of dances, baseball games, a lot of activities, food sales. You can get burgers that come from the free world, In and Out burgers, Kentucky Fried Chicken, Winchells, candy, pizza, Jack in the Box. You buy it with the money you get from the free world. Or the money that you earn from the job that you get with a pay slot [a paying prison job].

Divine, who has served several terms, voices an opinion shared by many old-timers:

This place (CCWF) is insanity right here—this is prison, this is awful; CIW was like a women's college, you just couldn't leave. CIW was alright, but Stockton was just small. What you got here is a higher tension level, because of the housing. Having six people in the room, having (security) Level IIIs and IVs here too. People are all mixed in—you get six people in a room and two of them might be lifers and they have to deal with two who are just little violators—with thirty days or sixty days. And then they mix you all together, and that causes conflict big time.

CIW was more settled, more put together. CCWF is bigger, more attitudes, personality. CIW had two to a room—there was more privacy. CCWF is harder time but this teaches me more. I guess CIW didn't teach us a hard enough lesson—when I was there, I forgot that I was in prison and I had to be reminded that I was in prison.

Another level of prison culture is found in the experience of the small number of women at CCWF who were incarcerated in the California Youth Authority (CYA or YA). Patrice, a young black woman who was moved from the YA to the CCWF, liked the programs and lower staff ratio of the Youth Authority and felt that her YA time was more productive because rehabilitative programs were available:

I was arrested at seventeen, sent to YA for robbery and kidnap. I liked being there considering I had to be punished for my crime. They have more programs and more staff who have a little more time to deal with you. I was involved in Free Venture program, trying to get a trade. But at first I was highly medicated all the time—Haldol, Elavil, Miligril, Thorzine, Sinquan, you name it, I took it. I was a monster, I fought staff and inmates.

This was back in '86—I chose to go to YA because I thought I would get less time . . . but then I felt railroaded. I jumped right across the desk when they told me that I had to stay until I was twenty-five. I really flipped out and they had to medicate me. I just had to come off of those pills. . . . If you aren't crazy (already), they make you crazy and forgetful. I had been zonked out on all those pills. It was stress withdrawing from the pills and going through the training at the same time. It was hard to remember all the training stuff—I knew my brain was not going to remember this stuff. I am on the pills now—just to keep me slow, or I will want to fight; I would even fight Charles Manson. Sometimes I still zonk out and get sent to segregation. I came to YA with a twelve-year sentence but was kicked out. I was in SHU in YA—I was in heaven, (my) girl was in the next cell, I was smoking weed and drinking but they pulled me back to court and told me that I was not learning anything so I had to go to CDC. I would have preferred to stay in YA—I was taking courses and gang-banging but it was childish. All the gang stuff and hanky-panky with staff. It was weird with all the boys. They always wanted to get next to you. I liked one boy even though I was a lesbian. I was molested and raped as a child.

The only thing I like about CDC is that you know your date with the day-for-day. If the date changes it's because of me, nobody else. The staff is more into their authority here. In YA, there was Crips and Bloods, and North and South. Some (of the wards) have relatives in the EME or NF. There is really no gang-banging in CCWF. It is part of the childishness at YA. I am glad that it's not here. I would probably be into that [gang activity] because of my friends. There are cliques here but it's not a gang. I play both sides of the fence (to try to get along). People can get an attitude here if they don't like your friends.

In contrast to these early recollections of the first days in prison, the long-termers and lifers offer a different perspective on time. While every woman at CCWF must learn how to "do her own time," the women serving extremely long terms (especially those serving life terms) have a different challenge in composing a life in prison. Randi describes the ways lifers deal with the length of their sentence:

> I have been down almost five years. With me, I can't focus on the time I have. I have to focus day to day. If I think about the time I have, it will drive me insane. The system is not nice to lifers. They treat us like shit. If you come in with a life tail, they go, "Ah hah, we have this one to fuck with for a long time." The staff know the difference; they have access to our C files so they know what you are in for. . . . I have been close B for disciplinary because I refuse to conform. I rebel against the system. I took 13 115s[7] with me to board. They tell me that I am a fuck-up and I tell them, "No, I am not a fuck-up, but I don't conform." Now I am conforming to the life that I want to lead in here. They want me to go by a narrow set of rules that they change daily. Okay, okay, I can follow this rule today, but why should I follow the rule because you will change it?
>
> With lifers and long-termers, we know we are not going home for a while. We have to hold ourselves together and we have to hold everyone around us together when they fall apart. Because we know that we are going to be here and they are going to go home. That is good.

Women serving sentences of ten years or more appear to have a fairly identifiable pattern of early difficulties, but most women reach an accommodation with their sentence, having learned how to do their time. Birdy, a lifer, reflects on her early years fighting with other prisoners:

> I fought because I was really frustrated about how much time I had. I didn't care what I did. Now that I have a [parole] date, I see the light at the end of the tunnel. I have put in enough time, I am doing the right things. I go to school. I do everything they ask because I want to go home. But I still put out a reputation of hardness; that makes [the other women] not tempt me to fight or challenge me to prove anything. With this hardness, I keep my reputation, keep my canteen (commissary purchases) and avoid fights—all without 115s. It is a terrible to say, but nice girls here don't have much.

Toni, another lifer, describes a common pattern of early rebellion prior to "settling down to do time":

I was rebellious the first two years. But that is only normal. They expect a lifer to fuck up the first two years. If you don't fuck up, then they tell you that you are manipulating staff. If you don't make no 115s, then you are manipulating staff. A girl in my dental class has no 115s for eleven years and she was told that she is manipulating staff for eleven years. This girl is just giving them clean time. She doesn't have it in her to fuck up. She made one mistake in her life and that is all she has made. She didn't use, she didn't drink, but when she fucked up, she fucked up for a good reason in her eyes. So why should she change and fuck up for them? She shouldn't have to—she should just be herself.

Lifers also have the unenviable experience of watching women get released and then return:

I have seen people cycle through so many times since I have been down, I will say, "Oh, you are back. How long has it been this time? Here are the clothes you left with me." We lifers see people come and go. And we all wonder, "When am I going to get a chance?"

Mindy, a young lifer, talks about the difficulties of facing a life term while surrounded by so many short-termers:

Can you imagine what it is like being a lifer and sitting in a room with five other people who have three more months they have to sit through before they go home and they can't handle it? They are hysterical because their baby is out there having a birthday without them? I am disgusted with their complaining over nothing.

Mindy, whose earliest possible release date is 2022, continues:

They put us in with people who have eighteen months. Some people can't believe that we don't have a date. Well, my earliest date is 2022. It is hard doing all this time especially when you can look at a bitch that sits there and knows she has AIDS and shares a needle with someone who is doing two years and that is supposed to be okay? They have gotten in trouble all their lives, been in and out of juvenile hall, foster homes, and then they turn around and look at us like *we* are the bad people. Some of us killed someone because we had to, because we might have died if we hadn't. Some of us were in the wrong place at the wrong time. But that doesn't matter. Someone died and someone is going to pay the price.

Birdy tries to share her hard-earned experience of doing time by suggesting:

> I tell people that I want to go home and that they should want that too. It is the free world that is happening. This world is an illusion. I try to tell them what is right. I try to stop them from doing what I feel is not right.

Comparing Male and Female Experiences

Many women also compare their experience of imprisonment to that of men. There is a general consensus that the men show more solidarity than the women, a point shared by some earlier comparisons of male and female allegiance to the "convict code" (Kruttschnitt, 1983). In voicing this consensus, one woman captures the shared feeling that "the men have everything. They stick together. The women are afraid. . . . They don't want to stay here any longer than they have to." This comparison between male and female prisons is also made by staff. A senior administrator provides a staff perspective on these differences:

> The men take answers at face value. When you tell them "no," they go away, but the women want to discuss their particular problem in great detail. When staff are trained at a male institution, they do not know how to deal with it. Women take more time and some staff are not prepared for that.

Other staff see that "men have more of an ego, and they are concerned with who is weak, who gets respect. Here you can mix races and classification levels and not worry about how they get along." In comparing male and female culture, the beliefs of the women at CCWF seem to support Kruttschnitt's (1981) observation that women fail to endorse a uniform code of ethics. Unlike men, women do not appear to hold allegiance to the convict culture. As Chicago, a young black former gang-member, states:

> The men will stick together but women seem to be scared to lose their days, or go to Ad Seg. The women stress on their family stuff and that makes them scared. The women may agree that things need to change but will not come together to do something about it. In 1991, we had a strike, a lay-in, and when the cops started taking people to Ad Seg, everyone gave up.

Kruttschnitt (1981:138) cites Tittle's 1969 study, which found in comparing male and female inmates that females tended to affiliate with either one

best friend or a small group whereas men tended to integrate into the inmate code. Although some women complain about the restrictions inherent in the CCWF environment, others claim that CCWF is a "better place to do time." Teresa, a young Puerto Rican woman who had served time in Louisiana and New York prisons, finds CCWF far superior to her prior experience:

> The food there is worse, less respect from officers; fewer phone calls. They think all women are the same. The New York prisons are also a lot different: a lot more violent; more snitching here in California, that would get you hurt in New York. The New York prisons are harder, more fast-paced. California is more clean—officers take the time to talk to you. You have more room, more space here.

PLACE

The Layout of CCWF

CCWF is a large prison that is physically divided into four separate units. After leaving county jail, a woman is transported, typically by bus, to CCWF. When the bus enters the prison through the sally ports at the rear of the institution, women are brought into a building on the A Yard (also called A Facility) and processed through Receiving and Release (R and R). With few exceptions, all women enter and eventually leave the prison through these doors. A Yard is the most complicated and heterogenous of the four yards in terms of housing units at CCWF. In addition to R and R, the A Yard contains the most secure housing unit (504, a two-tiered celled structure that housed women in Administrative Segregation [Ad Seg], Security Housing [SHU] and Death Row) at the time of the study. A similar two-tiered celled structure holds new arrivals temporarily. Two additional buildings provide housing in rooms designed to hold four persons (also crowded beyond design capacity). The remainder of this chapter describes how "doing time" at CCWF is shaped initially by these physical features and the processing routine.

Receiving and Release

Receiving and Release (R and R) is the first entry into CCWF as prisoners are processed through this small building. Both their physical selves and their property are subjected to a set of procedures designed to receive the woman into the prison, release her into parole, and transfer her to another institution, "out to court," a hospital, or work furlough. Staff in R and R also process property through the institution when women come into the prison, packages are mailed to the prison, or women are removed from the general

population and placed into the Security Housing Unit. R and R also processes cash, checks, and money orders and the documents and files that accompany women into the prison.

Receiving and Release is a busy, often hectic introduction or reacquaintance to prison life. Each woman is accompanied by commitment papers and varying amounts of property. Staff talk of preparing a "body receipt," an objectification that conveys the notions of "processing" and "receiving." Staff members and inmate clerks review these documents and determine if property is allowed into the institution. On extremely busy days, typified by the day the bus arrives from Los Angeles County, women prisoners are placed in the holding cells while others are processed. As R and R also releases women, staff with some time on the post will often recognize women who had been released on parole and are returning to custody, as illustrated in this overheard conversation:

STAFF: You just paroled from here?
PRISONER: Yeah, in March.
STAFF: How much time did you get?
PRISONER: Two years.
INMATE CLERK: It says here two years and eight months.
PRISONER: Where does it say that?

In a world of material scarcity, processing property becomes an important part of the reception process. Property can be defined as any material item, either personal belongings or "state-issue," and is strictly controlled. By definition, anything that is not state-issue or on the list of approved belongings is contraband and subject to confiscation. Officers will determine allowable property and are required to send things home if they are inappropriate or found in the wrong hands. For example, appliances such as hair dryers or electronic items such as television sets must be engraved with one's W number.[8] One officer working in R and R noted the difficulty of limiting personal property, saying, "It is pretty hard to tell these girls, these adults,[9] what they can have and what they can't."

A Facility is the most closely controlled section of the prison. In addition to the "controlled movement" policy, women can't walk around unescorted on A Yard unless in "state-issue," clothing issued by the state. Personal clothing is not allowed outside the unit. Early in the study, Tabby, a young woman from Los Angeles County, was observed walking around the A Yard in a "state-issue" muumuu, tied up on one corner. When asked to describe her look, she replied, "We do these things to hang on to our individuality. Who wants to look like everyone else?" Even within the confines of the rules that require uniform dressing, some women find ways to express their personalities in their clothes.

At intake, the women prisoners are separated out into individual tanks and "everybody is showered." Prisoners are no longer "deloused" as in the past. Clothes not acceptable to institution standards are removed and staff "bag all the stuff they have on." At this point, the institutional clothing of muumuus and underwear are distributed along with "fish kits" that contain minimum hygiene items, such as soap and toothpaste. Women coming from other institutions often have muumuus and identification and can be processed to the other yards without going through the A Yard reception process.

Coming to CCWF is the beginning of one's sentence and the introduction to one's new home. For first-termers, this experience can be frightening and filled with apprehension. Vanessa, a white-collar first-time offender, describes coming to CCWF from a county two hours away:

> They brought me in a little van, all by myself. I was handcuffed and the driver talked to me, cause I knew him cause he usually drove the bus when I had to go down to court. And he was explaining things to me. He said, "When you get in there, you're going to have to protect yourself. Maybe you shouldn't be so pretty, you know. Don't be getting undressed in front of the girls. You have to wait until they go to sleep. Don't make friends. I know you get along with people, but don't take their friendliness too much. Because you'll become a victim in there. These women are not like you, they're hard." He was explaining everything to me. And he was right. I've got a roommate now I don't get along with.

> His telling me things made me more nervous but it kept me on my guard. The whole ride up here was cool, because I was listening to him and I was taking everything in, and I says okay, I was still under the perception that I was going to do a couple of months and leave anyway, because I figured my time out wrong. And it's just when I saw those gates, I said, "Oh my God! I'm going to prison." And it finally set in that I was actually going to be here. And we drove through them and I looked around and I said, "There's no way out of here. They are going to keep me here as long as they want to." And then that woman came up to the van, this black woman—an officer—you could tell exactly what she was. She was loud, and she's like, "First time here?" I said, "Yes ma'am." "Well, that's good, they'll break you from this. You're a new fish."[10]

> I had never heard the term "fish" before. I don't think she should've said that to me. All I could picture was how the TV movies portray the guards and everything and how the people were females, and I just figured she's one of them. And she just looks like a man. It's just the way she was.

Being processed was like an assembly line. Each person had a job to do. You go in there, you weren't a person anymore, you weren't human anymore, they could care less. About forty-two of us came in together. They threw us all in the same room, and we, four of us, shower together, it was awful. We were in orange jump suits, with no underwear. For some girls it was that time of the month. One girl had to keep a pad on with a jump suit with no panties on. That's just the way it was. And they don't care. The phrase is always, "Welcome to the real world." And they don't care, and I was not raised for women to be that rough. That uncaring. I couldn't believe that—and I'm naive to a certain point, yes, I got in trouble, but I still believe in certain things women are like, certain ways. Nothing matters, they just throw you in one room, haul you out, throw you in another room, and they made four of us shower together. I am not talking to anyone.

I'm just sitting there looking at them. I don't know these people. And there was no reason for me to talk to them and the way some of them were looking when they came in, you don't know what they have. All I could think of was that book by Sidney Sheldon, *If Tomorrow Comes*, when the docs line the females up and use the same speculum on all of them, and I was like they are going to put me in lockup cause I'm going to lose it. And that's all I could think of. They're going to use the same thing on all of us. Cause I didn't know what to think. And then somebody orders us to the next step. Even the inmates, they were acting like the officers.

Yeah, I mean they had a job to do, but they thought they were officers, and they were talking just as snotty as the officers were. And I'm like, they had to come in the same way we did.

After women pass through the reception process, they are walked to their initial housing unit. Here they are assigned to two-person cells and introduced to the routine of the housing unit. Sometimes, the new arrivals are given an orientation by staff. Other times, guidance is provided by inmates who have lived in the unit for some time. As Lindy explains:

And then, like, an inmate gave us our orientation, and we were expected to know everything. We were told to ask questions if we had questions, but she was too busy throwing her hair to answer any questions a person had. That's all she did, she threw her hair at every other phrase. And she didn't know the answer to any question you had to ask. And I never forget when we first got in, I said, "Hey, they didn't tell us we had boys in prison with us." Cause there was this girl sitting at the table with us, I thought it was a

boy. She looked exactly like a boy. And one of the girls told me that was a girl. I said, "That's not a girl." We actually passed words back and forth cause I just knew it wasn't a girl. And they call her boy.

I was afraid. It was um, oh my God they are going to gang-rape me. And then the next morning a girl came up to me and she touched my arm and she said, "You're cold, here, take my jacket." And she just gave it to me. And I'm standing there with her jacket in my hand, like, if I take this, she's going to take me. (I thought) What should I do, what should I do. I guess I'll give it back to her, but I'm cold. And I'm like, what do you do? Do you go outside and you freeze, but then, I figured she might want me to owe her something or give her something back. I was cold, so I went back to her and I said, "You know, you're so nice but I'm not really cold. I'm a warm weather person," and I gave it to her. And she was mad at me ever since. She got smart with me every chance she got. And she tried to hook me up with another woman, and I ain't going for that either, so they didn't speak to me. A lot of people alienated me, they say, I thought I was a oo-ee bitch that wouldn't get involved.

I now know you never get any real pressure, just social pressure. (They tell you) you're going to be here long enough, you're going to do it anyway. Time does not dictate my sexuality. And they are just telling me how it's going to be when you get old. They told me I was either going to have to fight, or fuck.

I was like, I don't fight, so if I get over there they are going to beat me to death, cause it's just—that's not me. They act like that, you know, if you're going to be here doing any amount of time you're going to change, you're going to be that way.

But I now know there are some women who aren't. I knew some women who weren't, but they are now. And I don't know if they change because they feel that's what they are supposed to do in here, or if they really wanted to try it out or something.

Daisy, attuned to the ebb and flow of these relationships, notes that "a lot of short-timers come in confused, wanting to be with somebody because they are scared and alone here. No one is turned out by force." The nature of these relationships is described in the next chapter.

Ninety-Day Observation, Parole Violators, and "Dry-Outs"

In addition to the new commitments, A Yard also houses women in various statuses. Parole violators, returned for very short stays, may do all their

time on A Yard. RTCs (return to custody's) may also be sent to CCWF for a thirty-day dry-out, involving a short detention designed to provide a detoxification period for substance-using parole violators. A unique type of commitment is the ninety-day observation case. In this instance, testing and observations are made to determine, in the words of staff and inmates, "if a woman is prison material." Isabel, a twenty-seven-year-old Hispanic woman beginning her ninety-day observation, comments:

> I have been here twelve days. They want to find out if you are prison material, if you can adjust to the surroundings and act like everybody else. I have no idea what prison material means. I guess if you adjust you are in trouble, I don't see how anyone can adjust to this lifestyle. How can anyone adjust to prison—the use of profanity here, the liberty to smoke and talk? The officers seem to be more aware of good manners. There are lots of lesbians in here—I can't cope with this. I feel it is against nature. I was brought up to be very religious, very conservative atmosphere. But even after this short time, I am starting to say "he" in referring to some of the women.
>
> I don't feel in any risk or danger—I am very determined to do what is right. But when I am depressed, I go to my room and cry. You get to a point where you can't take it anymore and you have to let it out somehow. There is no privacy here—I need some time to myself. My roommate talks all the time. I will tell her to just give me a few minutes, because I need time to pray and read my Bible. She respects me and gives me that time. I can get some respect by practicing my religion; people will leave me alone [they will say], "Don't mess with her, she reads the Bible." People will leave me alone. But this place is horrible— the girls who act like men. It is really difficult to not have privacy in going to the bathroom, especially when my roommate is there.

Another woman, ending her observation period, says she feels "optimistic. If you don't hurt yourself and don't act violent with other inmates, then you will get a good recommendation. I feel hopeful that I won't come back."

The typical processing time in A Yard can range from two weeks to several months, depending on crowding, the speed of the classification process, and bed availability. The ninety-day observation cases, by definition, spend about three months in the reception housing unit. During this time, women begin to learn about doing time and discover the need to develop activities and ways to "do" time within the limited programming activity available in the A Yard. This is often the initial phase of negotiating the prison and a first step in developing a woman's style of doing time.

The controlled movement in A Facility, while allowing more mobility than most inmates had in their county jails, is much more restricted than that of the general population units. First-timers hear about the increased mobility in general population, and most are anxious to complete the reception process and begin to "program," which includes job or school assignments, more permanent housing, opportunities to contact family and friends through phone calls, and increased recreational activities. Women returning to CCWF or those transferring from other facilities are equally anxious to return to a more open environment. Laura, a returning prisoner, says:

> A Yard is the hardest time. There are small cells and little movement. Nobody has anything. You can only shop at half of what you can in general population. The canteen is more limited and you don't get a package until you are classified. This time is a lot harder because there is more supervision, more controlled movement.

The contrast between A Facility and the general population units is so great that the general population yards are known as the "free world" or "going over the wall." These ironic phrases, usually applied to the free community and escapes, show the shift in perspective as one becomes socialized into this world of women in prison.

Women must have passes issued by staff to move outside the units, unless the unit is "programming." Programming involves leaving the housing units, one tier at a time, walking around the oval expanse of grass on asphalt walkways. Valerie, an old-timer working as an inmate clerk in the A Yard administration offices, says, "The women coming from county jails need to get fresh air, especially those coming from LA County. Here they can walk around, go to canteen. This period gives them a chance to get situated before they go to general population." The processing on A Yard includes classification, visits to the counselors, medical clearances, psychiatric and education evaluations, and other procedures designed to place women into the appropriate program or institution. In CDC, women are assigned or "endorsed" to either the CCWF main yard or other institutions within the system. As women become more comfortable with their surroundings, they find that CCWF includes women from all walks of life. Ruthie, a middle-class woman serving time for a white-collar offense, notes that "not only is the trash of the streets in here, but there are other people who are alright, people that you might be able to establish a conversation with."

Daisy, with a long history of drug use and imprisonment, was interviewed during the reception process. She offers these observations of the newcomer experience:

The first-termers, the alcoholics, the shoplifters, they are devastated when they get here. They don't know anybody. They don't know what to do about the phone, how to get their money. I try to take them under my wing. They are shaking and need somebody to talk to. I tell them, "You know what, you are here, you need to learn how to live here." I can see their defenses, their fear, even if they are acting tough.

Making a New Home

In order to gain some understanding of the reception process, I followed a group of women leaving their first housing unit to two non-celled buildings where they will live in rooms housing six women. The officers announce these moves by calling out the "last two" numbers of their five-digit identification number. Upon hearing their name and number called, the women come out of their cells with their belongings and blankets collected ("rolled up," in the prison vernacular). Once assembled, the women are told by the officer to "take it to the pavement" (move to the asphalt outside). During my observations, some women were still in their cells and were hurried out. While it is clear most women know that they are leaving this unit, some women are hesitant until told individually that it is time to move. If a woman does not speak English, then others translate for her. I spoke with two women, Paula and Anne, explaining my interest in this activity and asking their permission to observe these events. Both women are young and have violated their probation, resulting in a commitment to state prison. As they look around their new housing unit, they comment that "these units were nicer." Compared to the two-tiered cell block[11] of their first stop, the more open floor plan with a well-lighted day room does appear nicer. Light flows through the windows and there is a greater feeling of both movement and space. The women congregate in the open areas waiting for a room assignment.

As the women wait, they talk about their worries and concerns as they begin the next stage of their prison career. Paula, serving a sixteen-month sentence for a probation violation, is concerned that "I'll have a difficult cell mate; a stud broad or a murderer." Other women are concerned about learning the unit schedules and wonder when their halftime starts. As the officer makes bed assignments, calling out names, Anne tells me, "We are all wondering what will happen next." She continues:

It is just not knowing what is what; you don't know how to get toilet paper, Tampax, whether someone is going to hit up on you. That doesn't bother me. I have no problems with gay women. But meeting people here is scary. We are unsure of the other women. You don't know

how other women will react to you . . . if they will like the way you look. We don't have any control over the environment. I feel like I am here, without freedom, without friends.

Paula reflects a feeling that CCWF is not as bad as she thought it would be:

I thought prison would be a lot worse, like you would have to stay in a little room, get fed under the door. I thought it would be ugly, that maybe we would get beat. Now I see that it is pretty nice. Most of the girls are just like us. They all want to go home, get back to their families. Everybody wants to go home to a loved one. [When I first came], I was tripping hard. I would just stand still and try to be tough. I know that I am tough, but come to find out that you don't have to be tough. You just have to be yourself. The majority of people here respect you. Even the girls with shitty attitudes will have respect for you if you just are yourself. Girls, and staff even, with shitty attitudes snap at you, or expect you to know things that you have no way of knowing. Others will tell you, "I didn't bring you here to raise," when you are new and don't know anything, but it is important to know people from your county, that you come with. It is important to stick together. But it is sad when you see people you know from your hometown.

Even in these early days, women learn about the need to stay out of trouble and avoid "losing time." As women become more savvy about prison culture, they learn specifically about "the mix" and its connotation of trouble, more fully described in chapter 6. Anne, a thirty-year-old white probation violator serving time for a drug possession, says, "I now know I have to keep to myself and do my own time. Don't let the time do you."

The officer provides a brief description of the rules in the new unit, some of which include instructions about the lock and unlock times, smoking policy (smoking is only allowed outside their rooms), the availability of items such as cleaning supplies, paperwork, forms, and games, the principle of "out of bounds," the prohibition against "going down the hall" (trespassing into other halls), mail and canteen schedules, the "one table at a time" seating policy in the dining hall, the indigent and cell search policies, and the volunteer job arrangements. The officer concludes his instruction, saying, "The rules here are basically the same as your last housing unit" and offers this caution:

I have to warn you against fights. You will be sent to Ad Seg and you will lose (good) time if you get involved in fights. With six women in

each room, you will have a hard time with all the turnover. The best way to do your time here is to think of it as Reception. You will only be here a short while. So do your time and you will be alright.

The women have many questions: "Where do we put in for jobs?" "How long until we see a counselor?" "When can we see an MTA (medical assistant)?" The officer answers their questions and tells the women to be patient: "Just go to your rooms, take a breather and don't do anything to lose time." The women continue their questions, asking when they will go to open line, how long until they go the main yard, and what "Ad Seg" means. The women continue to look around, staying close together and talking quietly among themselves. They discuss the rumor that "the main yard is better." As Paula says, "I hear you get more privileges, more phone calls, but I also hear that you have more weird people." The women agree that having showers in their rooms is a big improvement over the conditions in the celled-housing unit. A young black first-termer says:

> I am still fearful of the inmates here. I am especially scared at shower time. These women are rough in the line. I am always scared that you can lose your place in line. Naturally, you let them go in front of you if they are bigger than you. I have to learn to stand up for myself and not let people walk on me.

The women who come to prison with a friend from county jail or a homegirl from the streets express positive feelings about this. As Anne says:

> I am glad to be going through process with a friend from county. The judge told me that he sees a cycle (with drugs and crime), that he hopes prison will break the cycle. The only thing that helps me here is being with people I knew from the county. I have some pity when I see a new girl come in. . . . You can always tell new folks, they look around, they have these scared looks on their faces. And they don't know anybody.

Staff Perspective on A Yard Life

Another way of understanding life on the A Yard comes from interviews and observations of staff in the reception units. This interview was conducted with a black male officer who seemed to understand the complexities of life in his unit and the female prison population. This seasoned officer understands the difficulties women have when they come to prison and recognizes that women meet these difficulties in a variety of ways. He begins by explaining the routine in his unit:

The first order of business is handing out bed rolls to the new arrivals: blanket, towel, two sheets, and pillowcase. We then explain procedures of the dorm: things like the "no smoking" rule and the requirement to make beds. At that point we call names and assign rooms. Beds are assigned through central control. A pregnant inmate will get a lower bunk, and those with health needs receive a "lower bed chrono," which means they also are assigned a lower bunk.

We keep problem cases in 503 for closer observation: women who have seven-year or longer sentence, "N" numbers, and ninety-day observation cases. We "program" one tier at a time. A lot of the women don't want to leave their rooms. . . . There is a feeling sometimes that the women on the yard may be looking for trouble and they want to avoid it. This is the best unit—the celled design allows better surveillance; and a more controlled environment with stricter standards. The women will follow the rules if you take the time to explain them.

We will also keep workers in this unit. Women who volunteer will get phone calls, extra privileges in exchange for their work. We can't give halftime here until they are assigned on the main yard. The workers are no trouble—they do their time.

We do have problem-children that have to be watched more carefully. You have to keep an eye on the ninety-day observation cases: these cases are court-ordered; to determine "suitability" for prison, never convicted before. The judge is thinking about giving them time; counselors will give a reading as to their being "prison material"; and they see the psych here. Probation can be recommended at the end of the observation period. Another problem are those who talk to themselves and those who have poor hygiene. We send them to psych. The officers have to look for these problems and observe. It is our job to ask questions to determine the state of inmates.

I don't think the CO is out to treat them bad: we are here to keep control and fill their needs. This unit is not a playground. Here we prepare them for the main yard—the rest of the place is a madhouse. Some yards are scandalous, wild . . . the inmates can game and work staff; the officers set the tone and make it a good yard or bad. Here we run a more controlled program: the women cannot go to the main yard; can't wear makeup, no personal clothing, or jewelry. A person is much more liable to have more trouble on the main yard.

I see a real difference between the first-timers and the old-timers. The first-timers will ask many questions, because they don't know what is

going to happen to them, either long term or short term. They want to
know when can they shop, clean up, smoke, they always want to know
when. First-timers will ask other inmates what will happen next. They
are moved out in a week—to 501 or 502 if they program well—unless
they have longer than a seven-year sentence; programming well means
doing what staff says, not too many arguments. They learn about the
routine here and begin to learn how to act in prison.

This officer notes a difference in attitude between the new prisoners and
those returning for another term:

The old-timers have a "don't care" attitude, like "there is nothing
you can do to me that I haven't done to myself." I can kid with
them—newcomers don't know what to think. I have seen a real dif-
ference in male and female first-timers: the men will not ask any
questions of staff- a fear of looking like a snitch—whereas the
women will approach the officers when they want to know some-
thing. That is a big difference between men and women—the way
they see informing. The women will tell, they don't have to worry
about being stuck in the chest like men. That is a big thing with the
men—not to snitch. The women have more feelings, and they can be
hurt with talk. The women inmates are much more likely to approach
me as a male officer than they will a female officer. With my being
black, the black women may approach me more, but I talk to every-
body. Race is just not a big thing here, but sometimes it comes up in
housing.

Another difference is in the RTC (return to custody) populations: the
parole violators are different; they try to game us. They have been to the
main yard and know how to get over. I see the women as they keep com-
ing back. They can't cope with the outside: they hang around with the
same homegirls; they have nowhere to live, no one to live with. They
have a negative attitude—you try to tell them that there is a chance, but
then they tell you that they can't stand their old man, the family is
against me.

You also see a difference with the older and younger ones. On the
streets, the younger ones expect things to be handed to them—they
would rather sell drugs than work in K-Mart. More women are coming
to prison because there are fewer constraints, less morals and values on
the streets these days. The drugs, divorces, kids—all that leads to more
crime. More women are involved with drugs . . . and that is why we
have so many here.

TIME AND PLACE IN GENERAL POPULATION

Women new to the prison world experience different levels of culture shock. As they move through the initial processing, concerns about their safety, their sexuality, and their ability to "do time" become less pronounced as they gradually adjust to the prison routine, develop their own program for getting through the day, and become acculturated to the prison world. As the weeks and months pass, women start to compose a life inside the walls. Once classified and assigned to CCWF, the women are moved to one of three general population units (B, C, and D Facilities), where they begin their "program," which includes more permanent housing and a job or school assignment. By the time women have been processed through the A Yard, they have received an informal indoctrination about life in general population. With the exception of B Yard, which contains a specialized medical unit, the yards are similar in both design and culture. The general population yards are managed by a unit team, composed of a program administrator, counselors, a correctional complement (usually headed by a lieutenant), medical staff, and various support staff. While prisoners eat in a dining hall across the yard from the housing units, the primary food service, as well as other mechanical and physical plant services, are located behind the housing units. Educational and vocational training, as well as Prison Industry buildings, are also located behind the housing units.

Each of the three general population yards is organized along the same plan. Each yard is self-contained, with four housing units, a dining hall, administrative offices, and medical space. Each yard holds around 1000 prisoners, with the capacity to hold 256 women in each building. (The institution also has a separate medical facility that serves all the units.) The buildings are connected by asphalt walkways and surround an open oval of grass. When the prison was initially opened, this expanse was dirt. The grass is a great improvement in terms of esthetics and cleanliness. Some units have made an extra landscaping effort with flowers and other ornamental plants. Each yard is entered through a gate or doors leading into the administration buildings. These gates are kept shut, except during the scheduled unlock times (typically a fifteen-minute period between five minutes to and ten minutes past the hour), giving each unit the capacity to be managed separately. At CCWF, women are prohibited from entering housing units they are not assigned to, but they can interact with all the general population prisoners in the public spaces, such as the yard, the library, or the gym.

The Housing Unit

Each housing unit is centered around an open area, known as the dayroom. The single door into the unit is usually locked, except during a fifteen-minute unlock period and at work or mealtimes. In the center of each dayroom

is an enclosed structure known as the bubble or "cop shop" where the officers work, maintaining records and conducting unit business. The structure is enclosed by glass about three feet from the floor. The day room is anchored by two television sets at its opposite ends. Chairs and couches, in the universal institutional green, are arranged in rows in front of these televisions and line the perimeter of the dayroom.

The housing units are constructed of cinder block and have windows covered by steel bars that allow light into the unit. Four telephone stations are placed along the perimeter of the room. The units have a small enclosed game room, an office for the unit counselor, two restrooms, and two other small rooms. One restroom is designated as the staff restroom and has a solid door. The inmate restroom is distinguished by a medium-sized window that affords minimum privacy and inspection at the same time.

Radiating off the dayroom, in a spoke-like design, are four hallways leading to the rooms. With eight rooms, four on either side, each hallway holds around sixty-four women under the eight-bed housing configuration. Each room is about 22 feet by 20 feet, with a door that has a small window, a large window facing the hall, and a small window facing the outside. The room contains as many as eight beds, although it was designed originally for four beds. Two sinks and lockers line the outside walls. The single toilet and shower are located in the corner with doors that provide some privacy, but are nevertheless open on the bottom and at shoulder height. These "modesty panels" are designed to give some privacy while allowing visual inspection. Like all prisons, security is a primary concern, even while acknowledging the privacy needs of women prisoners.

When women are transferred into the general population housing units, they are escorted in groups to their new homes. Small groups of six to ten women, each carrying a few personal items of clothing and bedding, enter the new unit. Newcomers are typically hesitant, while returning prisoners look around more boldly, scanning for friendly faces. Women sitting in the dayroom return these looks at the incoming women. Some of the unit residents call out to incoming prisoners. Sometimes the calls are friendly; sometimes they are like catcalls. The greetings to new "fish" among male prisoners are much more intense and oftentimes threatening (Irwin, 1980). I have observed some catcalls of a sexual nature as new women enter the units, but cries of "Welcome to prison," shouted in a derisive way, are more typical. More often, no comments are made at all. When a relative or returning homegirl arrives in the unit, personal greetings are made and occasionally accompanied with a rush and a hug toward the friend or relative.

The Schedule in the Unit

The day begins early at CCWF. Staff announce the time ("It's 6:30, time to get up") and flash the lights. Some officers "blast the music over the PA.

They do it even on Saturdays when we don't have to get up." Women are required to get out of bed, clean their rooms, and make their beds by 7 A.M. Randi, a lifer, says, however, that "there are ways to go around getting up. I sleep on top of my bed and never get under these covers. That way my bed stays made twenty-four (hours), seven (days a week), year round." Women note that every shift is different and that staff actions "depend on your room. If you don't have an attitude and cause them problems, and if you are quiet, then the staff won't give you problems."

Most morning activities in the unit take place within the rooms, as the women prepare for their job or school assignments. During the day, the unit is typically populated by a small number of women, typically those who are unassigned, ill, work or go to school at other hours, or whose work or job assignment has been cancelled. A smaller number of women work in the unit as porters. From 7 A.M. until late afternoon, the dayroom is relatively peaceful and slow-paced. Some women return to the unit to eat lunch around 11:00 A.M., but usually the dayroom is quiet during weekday work hours. The importance of a job or school assignment to the development of one's program cannot be underestimated. These activities allow the woman prisoner to occupy her time in (hopefully) constructive activity, move about the institution, and thus structure her day.

Around 3 P.M., the pace of the dayroom picks up, as women filter in from their programming activities throughout the prison. Some women socialize in the dayroom, others pass the time between work and the evening meal in their rooms. Before women are released to the dining hall, a count is conducted while women wait in their rooms. After dinner, women may return to the unit, again socializing or watching television in the public dayroom. Most women, it appears, return to their rooms for the evening. Other women may have school, self-help programs, or other activities that take them outside the unit. Still others may walk out to the main yard, meeting friends from other units or engaging in recreational activities such as weight-lifting or walking.

Public and Private Life at CCWF

The need for privacy at CCWF shapes many activities. The prison design works against privacy, for security reasons if nothing else, and increased crowding makes privacy an ever decreasing, and greatly desired, resource. The room is the primary opportunity for privacy within the prison. Over 60 percent of the women reported spending the majority of their free time in their rooms (Owen & Bloom, 1995b). With four women in a room, obtaining privacy was more attainable. With eight women in the room, privacy became increasingly scarce. Some prisoners enter the public life of the prison, either through sanctioned activities such as the Women's Advisory

Council, the choir, or other legitimate and visible program activities or through illicit or subterranean activities that bring trouble. Known among the women as "the mix," dimensions of the trouble vary. As described in the final chapter, the mix parallels the risky and potentially damaging behaviors that brought many women into the prison. The majority of prisoners, however, opt out of any public life and begin to retreat into the concentric levels of privacy afforded through institutional structure, daily routine, and individual effort.

The main yard is the most public area in the prison. Here, women are exposed to scrutiny by other prisoners and staff alike. Women from all three general population yards may go to the yard, creating a common, public place. As a woman enters and exits the main yard, her presence and movements are visible to everyone. Activities on the yard include legitimate activities such as organized sports; walking; weight-lifting; visits to the library, the gym, the hobby rooms, or the chapel; and sitting on the ground alone, in dyads, or in small conversation groups. The yard is, however, also a place of illegitimate activities, including drug dealing and interpersonal conflict. The yard is described further later in this chapter.

The dayroom is another area of public life. Noise is the distinguishing feature of the dayroom. Concrete walls, steel doors and window coverings, and hard, linoleum floors combine with the sounds of televisions, conversations, and public address system announcements. Until late 1994, women were allowed to smoke in the dayroom. The loudness of this area and the public nature of the activities deter some women from visiting the dayroom. Tory says, "Everyone knows your business on the yard and in the dayroom. Who needs it?" The noise in the unit often interferes with the phone calls women make from the dayroom. Many women report that they spend little time in the dayroom, emerging from their rooms only to make a phone call or view a video movie on the weekends. Mindy, a lifer serving time for a drug-related murder, suggests:

> Each of us has our own way of going about things. We all do our certain things in the day—and what we do with our excess time is on us but it is all basically the same. We socialize with certain people, or we will just sit in the dayroom and catch the gossip and see what is going on. But nine times out of ten, unless I am doing something like playing cards, I will be in my room.

Tory chimes in, saying, "You might as well call us hermits because we are in our room every chance we get. I go to work. I come home. There is nothing for me out in the yard." With the doubling up of the housing units, privacy becomes scarcer still. Under crowded conditions, the room is the last possibility for privacy at CCWF. The dynamics of prison social life are all played out within the confines of this small space.

The Room

The room is the basic building block in the web of relations that reproduces prison culture among the women and therefore is one of the most significant social units at CCWF. Newcomers are assigned to rooms based on available space and efforts to create ethnic balance. Particularly for those new to CCWF, coming to the room can be a cause of trepidation. While almost all women were processed through A Yard and have some idea about their living accommodations, arriving at their new permanent home may require some adjustment. The first step in this adjustment is an introduction to the dynamics of the assigned room. I conducted a group interview arranged by Divine with several women at the start of my fieldwork. The interview began with about eight women, but other women joined and left as the day progressed. The women who participated included a good representation of women at CCWF: black, brown, and white women; women who had been in prison for a long time and those who had "just drove up." Articulate and shy women joined in the conversation. At the end of the day, I had met about twenty new women, many of whom became the core of an interview group that included Randi, Tracy, Tootie, and Rory. (The first group interview was conducted at a time when the crowded conditions had expanded the prison's occupancy from a planned capacity of four women to the room to an operating capacity of six to a room. By the next summer, eight women to the room became the norm.) I first asked what kind of introduction would be given to a new person just moving into a room. Tootie offers this description:

> I would wait until we were all there and I would introduce everyone. I would introduce myself and I would tell a little bit about each of us; maybe something about our funny little attitudes. Some people give the whole spiel. We are all in program when someone new comes in because they usually come in the middle of the day. But we knew we were going to get a roommate because we had an empty bed but we did not know who she was until the 4 o'clock count. I would run it down to her, explain that we all get along to a certain extent in here; we like to laugh and joke. But at times we have our little arguments but it be all fine after that.

> The best thing you can do when you get a new roommate is to run everything down to them. Tell them the rules: okay, everything we talk about stays in this room; we have a TV and radio, if you want to listen to them it is no problem. Do NOT go into my locker, do NOT touch my radio, do NOT go in my drawers . . . that is really it. If you need anything, ask.

Listening to this, Rory adds:

> On the first day and the first couple of days, we more or less just watch (to see what kind of person they are). I am the one that usually tries to make someone feel comfortable. I would ask them if they would like to watch TV; if they need something. Or I would tell them what time dinner is, or how something works around here. I am that kind of person. But then pretty much I just leave them alone and let them come to me. And let it develop from there.
>
> I only give advice if I am asked for it. The biggest thing that I will tell them is to keep to yourself. And to stay out of everybody else's mess. You have to do your own time, you came here alone and you will go home alone. The only way you are going to get home is to take care of yourself. You are number one. And a lot of people, especially youngsters in here, get involved with other bitches, other this and other that and they are not thinking about themselves.

In another interview, Blue, reflecting on the end of her long sentence, points out the ways time takes on different meanings among a diverse set of incarcerated women. She says, "Your state of mind is different if you are a short-termer. Your mind is more out there [in the free world] than in here. If you get sixteen months, or two years, that is not that much time." When asked to describe the kind of advice she might give to newcomers, Blue offered:

> Stay out of the mix. If you hear something and it is about somebody you know, don't say nothing. For what? You are going to tell this person and this person is going to go back and say so and so told me that you called me a bitch. Or that I was tramp or a whore. That I go with this girl and that girl. It will start something. Just stay out of the mix. Stay to yourself. Stay to your program. Program every day. Regardless if you have four or eight years. There is a gym out there, you can walk to track, play softball or racquetball. There is a lot of things you can do instead of sitting in here and gossiping. The majority—85 percent—of the fights around here are around "he say, she say." And for what? It ain't going to lead you anywhere, except take ninety more days and send you to Ad Seg.

Learning to get along is the warp and weave of prison life. Amanda, in the last year of the five she will spend here, suggests that developing a friendship with just one person is her key to managing prison life:

Like me, I only talk to one person and that person only; that is my closest friend and my only friend. Now our room is beautiful. Her room is good too. I am real close to my roommates, but I am the closest to her. She has never been to prison before and I have been in prison since 1984. But I am not hard, I haven't gotten hard. I am not going to let myself get like that. This is my fourth term. I was an N number from 86 to 89, and then I picked up this W number. I go home in July of 94. I got a nine-year sentence and this is end.

As the primary unit of social organization, the room ideally is a safe place. Women want to be able to relax and trust the other women in the room. Chicago states that:

> you should be able to talk about anything in your room and have the confidence that it will not leave there. But it is not always that way. You have to realize that everybody has a different personality, so you have to feel a person out to see where they are coming from. Then you can pinpoint the kind of person they are. We have a lot of snitches in here. A lot of people who is under the police and tries to get this and that [by informing]. . . . We have a lot of people that use (drugs) in this institution so if they can tell the police and get them off their back, they will. We have all kinds here.

Sissy adds:

> You also have to tell about the cleaning procedures—how we clean up our room and stuff. How everybody has their own day to clean and then on inspection day where we all clean together. A lot of people don't know how to clean. Sinks, toilet, shower, bathroom, windows, table.

But some rooms continue to have a problem with cleaning, and "some rooms have to make specific rules; in some rooms they have to make little signs and put them up to get people to clean shit." Tootie recalls a problem with a roommate who did not pull her share of work:

> Like we had a problem with Suzy. She would get up in the morning, throw a little water on her hair, and she was out the door. We would all be jumping up and cleaning it, and that was on inspection day. She would fly off and be down the street and we would stand at the door and holler at her, "Wait a minute, don't you live in 22 too? Come on back." She had a fucked-up attitude but you have to let her know that we all live here and we all have to help clean up. She still has that bad habit—

the other day I asked her to clean the shower; she said yeah and soon as I left the room, she left too. I asked my roommate and she told me she didn't clean the shower at all. I saw the same dirt as before. She is going to clean it tomorrow.

Another problem involves roommates who are unassigned or without a program during the day. The burden of cleaning the room often falls on women without work or school assignments. As Sissy suggests, "We have another new roommate that doesn't program and what is not done falls on her and that is not fair. She should not have to do all the work." But Tootie disagrees:

They don't do anything all day. She doesn't have a job and just moved over from A Yard. That is how our room is, half of the room programmed and half of the room didn't. It was to the point that I was the only one not programming and I was the only one cleaning up in there all week. And I didn't have a problem with it because I lived in there too. So I did it by myself. But we had one roommate that doesn't do nothing and we have to confront her and ask her to do every little thing. Or we will just leave it there and see if she will catch on. She gets an attitude. I ain't seen her lift a rag, nothing. You watch them to see if they know what to do. They are trained on A Yard as to how to clean their rooms, so she knows the procedure. A Yard trains you for over here.

Crowding in the room can create conflict when eight women are trying to get ready for work in the early morning hours. Women work out formal schedules, based on one's work arrival time, to accommodate the needs of eight women with one shower. For Randi, the lifer, the crowded conditions in her room are her biggest concern:

How are we going to put all of our things into this little locker? Our clothes, our food? Especially long-termers—we are the youngest of the lifers. The twenty-, twenty-one-year olds. We just came and we are going to be here for a long time. How are we supposed to live here?

One aspect of privacy involves revealing (or, more accurately, not revealing) the nature of one's offense. Divine offers the old-timer perspective, saying, "When you are introducing a new roommate around, you never talk about offenses. That is up to the individual person to decide if they want to discuss it. If you want to share it, then you can share it, but that is none of our business. It's like, 'I don't care what you did. Just don't do it to me. That is it.'" Privacy concerning the nature of one's commitment offense is important

for another reason: certain offenses, generally those relating to killing or hurting children, or parents, are seen as the ultimate taboo in the women's prison. While not subject to the same physical threats as in the male prison, "baby-killers" are typically looked upon with disfavor in this community.

Conflict

Minor conflict can result from verbal arguments, personality conflicts, or having a bad day. Major conflicts occur among emotional intimates or as a result of illegal activities, primarily drug dealing. In the close confines of the room, conflicts among roommates are particularly noticeable. Tootie describes how two roommates might handle a conflict situation between themselves:

> You won't speak when you are in the room. If you are not going to fight, you just don't speak. You act like she is not even there. That is how we do it. For a few days, but sometimes it does not even last that long. Everybody has pride and doesn't want to look like a sissy. You want to keep (the pride) what you got. And then some people are easy and some aren't.

She further describes the reaction of the other occupants:

> We don't do anything. We will talk to both of you guys. We ain't in the fight, we ain't in it. Sometimes it happens that the one will be mad because you talk to the other one, but that is out of line. Normally you would just keep it between them. You might tell me what happened and she might tell me what happened but I would just say, "Whatever." That is your problem. See, nobody wants more problems than they already have.

Another prisoner describes this example:

> We had a problem with a roommate that was forty-seven years old. We tried to give her that respect because she was the oldest in the room. And her and Marta fell out. I had went to work and when I got back the old lady was there and she told me what happened. I listened to everything she said. So when Marta came back, I said we need to talk about this and her and the old lady kept going at it and at it and at it. This went on for about a month—in these small quarters. Once during an argument, she told Marta that was why she was never getting out—she could not get along with anybody and that was why she would be here the rest

of her life. You do not say that to a lifer. It will make them do something very terrible. I saw her eyes get very big and I went to the police on it because it was getting out of control.

Another area of conflict involves smoking. From the beginning, prisoners were prohibited from smoking in their rooms. Although some rooms with nonsmoking roommates developed informal rules, such as no smoking at all or limiting the number of smokers to one or two at any one time, the rule was not effective. Initially, women were permitted to smoke in the dayroom. When the prison officially became a smoke-free environment in 1994, smoking in the room became more problematic but did not end. Several women reported serious conflicts between smokers who wanted to violate the ban, smokers who wanted to heed the rule, and nonsmokers.

With increasing population pressures, privacy becomes a rare and valued commodity among the women at CCWF. With eight women in the room, time alone becomes uncommon, and women develop strategies to find this solitude. In her search for privacy, Zoom develops time alone this way:

Sometimes your roommates might have different work hours. And then you might work out that some of your roommates might go out into the yard, and when your roommates go you can go into your room and kick it by yourself. Finding privacy, the way this institution is set up, is very hard. Cause you have seven roommates, it's kind of hard.

Other women told me they use earphones for their music or radios to block out noise, or lose themselves in a book, hobby, or letter-writing. Patsy, a middle-class woman serving time for assaulting her abusive husband, reported that she climbs up on her bunk and pretends it is a "condo" away from everybody else. Many women walk the track alone or colonize their workspace to find this much-sought-after privacy.

In addition to the need for solitude, women often seek private time to be alone with their intimate partner. Ward and Kassebaum (1965) describe these arrangements in their study of CIW. But with the architecture of CCWF, and with eight women to a room, closing the door and covering up the "wicket" (window) does not work as it did at CIW. When I ask how one finds privacy, Tootie chides me by saying, "Imagine how you find time with your man when your mama doesn't want you to be with him. You'd find a way and so do we." While some women are successful at getting paired in the room with their partner (and others develop partnerships with assigned roommates), others rely on favors or reciprocity to have the room to themselves. Usually, a woman will ask her roommates if she can have the room to herself. The women I interviewed agreed that this was respectful and the best way to keep

peace in the room. Tory stated, "It would depend on how much respect they have for themselves and you. The roommates would be upset if you disrespected them. Or infringed on what they had to do in their daily lives; like go to work or watch TV. Most people are respectful." Some women report, however, that not everyone is this respectful, resulting in uncomfortable situations where intimate activity is pursued in the company of others. Partners may make a tent out of blankets or enter the shower together. Most of the women I interviewed said they were disgusted by this behavior, but felt they could do nothing when a roommate insisted on acting "in such a vulgar and disrespectful way."

The room and the unit are thus the basis for much of the social life in the women's prison. As Tory claims:

> It never fails to amaze you. Something is always going on in this unit. . . . It is not boring, I will tell you that.

Work and School

Another key element for the organization of women's lives at CCWF is formal "programming," typically a work, school, or other training assignment. Under California law, prisoners can receive "good time" credit, more accurately called "work-time" credits that reduce their prison sentence in two ways. First, under "day for day," prisoners can cut their sentence in half by working, going to school, or attending a job training program. Almost 70 percent of the survey sample reported earning these "halftime" credits. Of those earning halftime credits, the majority worked in job assignments, with the remainder in education or training programs. Of those with jobs, about half reported earning money at their assignment ("having a pay slot"). Our survey found that women are most likely to have a job in food service or landscape, or as orderlies or porters.

Like in the free world, jobs are stratified according to desirability. High-status assignments are those that require skills, allow for autonomy, responsibility, and creativity, or provide an opportunity for access to a desired commodity and a "pay slot." Often, work conducted on the job or interactions with powerful staff can lead to a "juice card" (a slang term for having informal pull with staff or increased status or maneuverability for the prisoner herself). Work is necessary to "make the time pass" and to become involved in activities that are somewhat constructive. While generally the source of "juice," jobs are also pivotal in the construction of a satisfying day-to-day existence. Work assignments can be obtained in two basic ways: assignment by unit teams or through personal initiative. An informal referral system also exists when a woman leaving a position looks for a suitable replacement.

"Programming" is the process of developing a personal accommodation to one's situation of imprisonment. Learning how to "get with the program" is the first step in learning how to do time. For the women in this prison, programming involves more than just settling one's living and working situation. Successful programming also involves settling down and developing a routine that provides satisfying—and nonproblematic—personal relationships and routine activities that offer constructive stimulation and protection from the dangers of the prison environment.

At the other end of the programming spectrum is the prisoner who refuses to "program" and spends her time circumventing expectations, often resulting in lost jobs, time spent in detention, and loss of "good time" credits. For this prisoner, prison activities extend, as one woman says, "the bad habits that brought you here." Programming, then, involves arranging a satisfying living and work routine that both structures the day and provides some measure of satisfaction. The routine is the structure that provides for the passage of time and, often, some meaningful reflection. Blue, considering her past nine years of imprisonment, comments:

> You have got your program that you do every day. Programming means to me that I get up every morning, shower, brush my teeth, and get ready for work. I come to work, do my work. I go home for lunch, I come back. I get off, go home, shower and kick back. Either I read a book, or I kick back with some of my friends and bullshit. I stay in my room sometimes, but I go into the dayroom. It depends on the kind of mood I am in. I got in a fight once and lost my privileges for thirty days. This changed my whole attitude . . . as far as getting in trouble, going off on people. I have been able to come to myself, to sit in my room and think about my goals and stuff in life.

In addition to shaping the day and making the time pass more easily, the small amount of money earned in "pay slots" allows women to provide for some of their personal needs. Many women want to "find a good-paying job" in the limited economy of the prison. Our survey found that women earned amounts ranging from $10.00 per month, to a high of $140.00 for the few women who worked in Prison Industries. On average, women reported earning about $20.00 per month (Owen & Bloom, 1995b). Although the majority of women indicated receiving some support from their families, many also reported that they wanted to work and provide for some of their needs (Owen & Bloom, 1995b). As Trisha states, "You have to look for pay slots; you cannot always ask your family for things."

In addition to being a source of material rewards, a work assignment can be a source of nonmaterial satisfaction. In making time pass quickly, a

challenging and satisfying work environment can be a source of positive rela-
tionships and activities. One result of a constructive work environment can be
the strengthening of feelings of self-worth and the rewards any worker reaps
from a productive workday. Several studies of the relationships between staff
and their prisoners (Sykes, 1958; Owen, 1988) suggest work relationships
between these two diverse groups within the prison community create unex-
pected respect between inmate workers and prison staff. Contact with prison
staff contributes to the nonmaterial rewards through creating mutual respect
between worker and prisoner (Owen, 1988). Tracy, serving a long sentence
for drug-related crimes, says:

> I worked in the (lieutenant's) watch office first year here and had con-
> tact with four different lieutenants, and a gang of sergeants. I worked
> with them every day. I did their paperwork. I did their overtime with
> them. Everything they needed, I finished. That gave me play here and
> there. When I wasn't happy with a situation, I had people moved. Some-
> times all you have to do is make a pot of coffee for them, and they love
> you for life because you go out of your way do to something that is not
> your job, or you bust your ass (by working hard). I had been called at 4
> o'clock in the morning to do certain paperwork and they appreciate that.

A repeat drug offender, Valerie, a clerk for a program administrator, thinks she
has the best institution job:

> I created that job because the white girl that had it before me didn't
> know anything and she did not do near the things I can do. When I first
> got that job, she thought she was teaching me that job, but I didn't want
> to front her off and show her boss how stupid she was. I just let her think
> she knew something. When she went home, I just showed them what I
> could do and they were amazed.

> My philosophy is, because I am older and I have been in prison before,
> I want to help anybody I can. It don't matter who they are, staff or
> inmates.

Valerie also tells of her loyalty to her boss and her feeling that she has a "real"
job:

> My boss is very detailed, demanding, and fair. He does not have a prej-
> udiced bone in his body. He sees it like it is and he never changes. He
> makes me want to do a good job. When I come over from D Yard, it
> makes me feel like I am coming to a real job. Some jobs have too many

women on their crew. . . . They sit around and watch TV, or talk all day or do nothing. The clerks have real jobs—we have stuff that we have to do, stuff that has to go to Sacramento and look right. We have real deadlines and real responsibilities. A good job is determined by the way the job is, the way the boss is, and the way the inmate is.

She also tells me that having a constructive atmosphere on a work assignment is important:

We all get along in my office. All the clerks respect each other. They are old enough to be my kids. We talk about their problems. We don't have no active dope fiends, no thieves. Most of the workers here are more responsible about their time. When I go home, I will look for somebody who is to replace me. [I will look for someone] who is trainable, who does not have an attitude, or who feels like they have something coming. If they can type, or if they are willing to learn. All you have to do is ask. You can get what you want if it is legal here.

Perspectives on the content of a job differ among inmates. Contrast these two versions of working on the yard crew. Tami sees that:

Yard crew is the worst, because they work you to death in the hot sun, in the rain. You plant one week and then you pull it up the next week. It is terrible. There is nothing to do, you are just playing in the dirt every week. There are too many people here. You have to report to work at 6:30 A.M. It be dark-thirty and there is ice on the ground. You have to get up at 5:30 to get ready.

Juanita, on the other hand, feels that the yard crew is a good job because of her relationship with the "boss":

I feel that this is a good job. I like it. But I feel the boss makes the job. Our boss is cool. As long as we do our work and we don't get him in trouble, or make him look bad, he is not on our back. You get in trouble by talking back, not doing our work. It makes him mad. If you got a good boss, you are going to do what he asks you to, you are not going to be fronting him off. You can't be fronting him off in front of the other officers.

He is the same way all the time. Even if he is with the other cops, he is the same way. He don't change, his attitude makes us feel like working. Because he is not on our ass all the time, looking over our shoulder all

the time. In the morning, he tells us what part to mow; we do it and he don't be hounding us, yelling at us. . . . If he has something to say to us, or if you are in trouble, he will take you aside and tell us. He doesn't try to front us off either.

For women who have carved out a good job, the nature of the work assignment contributes not only to their ability to program, but also to their sense of well-being. Celia says that:

Having this office job is the best thing about being here. I can stay here and work and go eat in A Facility. My roommates cannot really deal with me now. I am a short-timer. You never have any privacy in the room—never alone in room. I can always find plenty of work here. I would much rather work than sit in the noisy dayroom or my crowded room.

Participation in educational and vocational programs is another way that women earn halftime credits. Just under a quarter of the women in our survey said they were involved with school or vocational programs. Educational classes range from early education to GED courses. Vocational programs are also available, providing a wide range of both traditional and non-traditional job training. (See Owen & Bloom, 1995b, for a complete discussion of programs available in the CDC system.) Even though they acknowledge the need for school or vocational training, many women prefer work or Prison Industry assignments so they can earn some money during their time in prison. The institution also offers pre-release classes, substance abuse education, and other forms of instruction. Fran recognizes the need to put some effort into her program, saying, "If you want to learn something in school here, you can. But you are not pushed to do anything. You are just there." Other women report a different view, and feel that the educational and vocational classes are preparing them for their release. Substance abuse treatment courses and pre-release classes receive compliments for "giving me something to think about so maybe I won't go back to my old ways."

Pregnant, Ill, and Disabled Prisoners

Although most of the housing units do not differ along any single dimension, B Yard houses inmates with diagnosed medical needs in one unit. Pregnant, ill, and disabled inmates live in a unit modified somewhat to accommodate wheelchairs and those with special sleeping needs. As stated in the introductory chapter, this book excludes a specific investigation of a small, but significant part of this population: HIV-positive women and those with

AIDS. The complexity of their world and medical condition cannot be adequately addressed without intense study. These sections attempt a brief description of some of the unique circumstances of two subsets of women prisoners.

Pregnant inmates.

> [When I delivered my baby] the ambulance came quick. An officer goes with you and stays with you—you are on the ward with other women but they don't put anybody from the [free] world in with you. You are not allowed visitors. You can keep the baby in the room but you are lucky to have twelve hours with the baby—usually you have between six to eight hours. I still have the feeling of being empty: must be the baby blues. I can remember walking out of his room, turning around and looking at him—knowing that I was leaving him. Even though my mom and [the baby's] dad picked him up, I still don't know where he will live. I don't know who will take care of him.

Although their numbers are small, the presence of pregnant women in the CCWF population is a potent reminder. Because most of the women in prison are mothers, pregnant women remind them of their loss and reinforce their feelings of separation and guilt at leaving their children. Relationships with children are sacred among the women at CCWF and provide a basis for attachment to the outside world not always found among male prisoners. As reported in national studies (Bureau of Justice Statistics, 1992; American Correctional Association, 1990), about 6 percent of the prison inmates and 4 percent of the jail inmates were pregnant at the time of their admission. As far as I could determine, the unit did not provide specialized treatment services or trained staff. It appears that women are housed in this unit because of its proximity to the institution's medical facility, located just outside the B Yard fence. Most women in this unit do not program; instead, they are "medically unassigned" and do not earn the halftime work/school credits off their sentence. Pregnant women stay in the unit up until the time of delivery. At delivery, women are taken to a community hospital under escort by the correctional staff. After the baby is born, the inmate stays in the hospital only one or two days. Some women make arrangements for a relative, usually a mother or sister, to pick up the baby. If there are no prior arrangements, the county social service agency provides foster care for the child.

The pain of a prison pregnancy takes several forms. First, most women reported that being pregnant in prison was an "ugly feeling." Second, not having a place to send one's child was very painful. As Kimi Sue, a young pregnant woman, stated:

It is hard when you are pregnant here. You are so full of life and then
you have the life taken away. You are depressed (wondering) if CPS will
care for the baby.

Third, many women said that returning to prison after giving birth was
extremely difficult. On their return, other prisoners attempt to provide some
solace for the new mother:

When you return from the hospital, everyone here is pretty nice to you.
All of us know this feeling because the majority of us have children. My
roommates were supportive. They talk to me when I need it so I won't
feel too hurt about leaving my son. But they also give me time to myself
because they know I am down. They look after me. They tell me, "Don't
worry, Marisa, you might be apart now, but you have your whole life
ahead with him."

Disabled inmates. Women in wheelchairs have specific problems in the prison
world such as mobility, obtaining specialized care, developing a satisfactory
program, and establishing satisfactory relationships with other prisoners.
Judy, who was injured in the course of her crime, describes the problem of
mobility within the prison:

If the officer is late on the unlock, you don't have time to get where you
are going. When you are locked into your room—your cell—and the
staff is late, you won't have enough time. You go out the door in your
wheelchair, you wheel yourself from 505, which is all the way at the
end, to the gate at the sergeant's office and you get down there and they
click the gate on you and say, "Well, sorry, you didn't get here on time."
There is no recognition that it takes me longer to get there.

Judy describes the reactions of other prisoners and the staff to her disability:

Normal human beings are afraid of the unknown. Since I have been in
a wheelchair, I have gotten to see that from a different light. People do
stare at you . . . they (officers and inmates) don't understand individual
problems. To me, because you are handicapped, that doesn't mean that
you can't program and work. But they make it so hard for you to pro-
gram and work because they don't understand the disabilities.

Another prisoner feels that:

disabled inmates are discriminated against in the workforce. There was
a girl in here that had crippling in her fingers and she could type, she

taught herself to type with one hand. She wanted a job desperately. She finally did get a job as a teacher's aid and got a recommendation for that, but it was a hard fight to get that job. She fought almost the whole time she was here. She worked the last four months and got a good recommendation from the teacher.

As discussed in earlier sections of this chapter, the majority of women shape the day around a job, vocational training, or a school assignment. In explaining the difficulties in filling her day with activities, Sally, who is confined to a wheelchair, says:

If you don't program, you have nothing to fill your day. I go over to the library, broaden my spectrum on legal things, but most of the girls sit in this unit. If you are medically disabled, which means you are getting your halftime, or medically unassigned which is third time. Once you become on either one of those statuses, you don't program.

Material Life

A critical part of doing time involves the material life at CCWF. State-issue property includes blue denim pants, muumuus, underwear and bras, "baseball"-style long-sleeved cotton T-shirts, and state-issue shoes. Women are also permitted some limited amount of personal property, such as clothes and "personal appliances," such as a small television set, a radio, a cassette player with recording capacity removed, and a hair dryer. Legitimate sources of material goods are the prison commissary (where the term "shop" is used to denote commissary purchases), quarterly packages (known as a "box") sent from the free community, and approved catalogues. Personal property is controlled at CCWF and women are not officially permitted to bargain or trade their items. Personal appliances, such as televisions or radios, are engraved with one's prison identification number, and possessing an item with someone else's number is a fairly serious rule infraction.

Women legitimately obtain funds for commissary purchases through work or through money sent from the streets. In identifying the major source of commissary money, almost half (47%) of those interviewed for the survey indicated that parents or other relatives contributed money to their "books" (prison account of personal funds). Another 15 percent reported receiving money from a partner on the streets. Thirteen percent received money from friends, with only one percent receiving money from their children. Just under 15 percent reported supporting themselves through their prison income. In our survey, just about half of the women reported earning money through their job at CCWF. Another 4 percent supported themselves through their own funds

previously earned or obtained outside the prison and about 6 percent reported never shopping. Almost 90 percent of the women interviewed reported "shopping" or going to the prison canteen at least once during the month. But only about one-quarter spent the full amount allowed ($140.00 at the time of the fieldwork).

Goods can also enter the prison through quarterly packages. Women at CCWF are allowed to receive quarterly packages from friends and family on the outside. Almost three-quarters of the women interviewed in the survey said they received at least one package a year. Almost half the women indicated they received packages every quarter. Fifteen percent of those surveyed said they were "indigent," having received no money from a job or the streets in a certain period of time.

Tootie remarks that many women have burned their bridges with their family and thus do not expect any support while in prison:

> It is very sad. Very. But then after you think about it, you hear people talk about they got six brothers and a mother and a husband out there, and you ask why are you indigent, you know. There's something wrong out there because if you got a husband out there and six brothers, where did you all's love go?

> You know, a lot of people, like you say, burn their bridges. You know, if you steal from your brother, why would you expect him come here? He's probably glad as hell you're gone.

Receiving a box signals a time of plenty. Food is shared and new clothes are sometimes displayed. Norene offers a cynical view of the temporary status of new clothes:

> A lot of the young girls think that when they get their boxes or they shop, they think they are the whole thing: "Well bitch, my mama sent me this and I shop $140 and whoop de whoop." You know how they talk. Well, so what? So you get a box! . . . You are still in prison. Why do you want to get dressed, and put a miniskirt and nylons on and walk out? You are still in prison. You are not going to Hollywood and Vine, you are not going to no dance club. It is not as if you can go somewhere. They just dress up to dress up, to try to impress other people. Yeah, this is what my mom got me. I'm sharp. Me, I am into jeans, T-shirts, and sweats. Why am I going to dress up? I am not going nowhere.

Some women get by on small amounts of money sent from their family or friends. Tracy says she "makes do":

My family sends me about $40.00 a month. I live on that because I don't have a pay number. I gave up my pay slot to learn a trade. You can live on that, not very well, but you can smoke and drink coffee and that is about it.

For those women without outside material support, or without a pay slot, a few options exist outside the conventional prison economy. Illicit economic activity includes drug dealing inside the prison or other kinds of "protection" rackets that extract material goods in exchange for not threatening other prisoners. I was unable to determine the amount of drug dealing, but did find that protection rackets among the women were rare.

More common are forms of hustles that either exploit other prisoners or provide services to prisoners who have more comfortable incomes while in prison. Blue tells of her early economic exploitation by prisoners and how she learned to handle it:

People would come to me because they knew I had people [on the outside] taking care of me. They would say, "Blue, could you shop $20 for me? My money didn't make it." And I'd say yeah, and I would shop and I would never see it again. Then I met up with girl named KJ, a lifer. I call her my play mom. She has raised me from the day I met her until now. She still sticks by me. She has taught me so much. She is younger than me, a year younger than me. She got busted when she was sixteen, so it is like she grew up in prison. But she had knowledge. She used to tell me, "Now Blue, that is not good. People are going to try to step over you and once they see they can get over on you, they are going to keep doing it." I watched and I looked and tried to figure out where they are coming from. I have learned a lot.

In addition to prison hustles, several informal economic options exist. One option involves providing personal services for material compensation. Women will provide services such as laundry, ironing, or obtaining ice (a valued commodity, especially in the hot summer months at CCWF) to women who are "well-taken care of," a phrase denoting significant support from the outside world. Fran describes these informal jobs:

I don't have people in the free world to take care of me. I am a laundry girl, so I do laundry for someone who is "well-taken care of." An ice girl will sell ice or someone else will be ironing.

"Getting a box" or "buying a label" is another informal economic option. Women who do not use one of their four package privileges may "sell"

their package opportunity to another woman (who has received her single package for the quarter) for compensation that can include "wiring money" (putting funds on one's prison account), "splitting a box" (which involves sharing predetermined portions of the contents), or receiving requested items. A pair of blue jeans is a typical price for selling a box or a label. Exchange of actual currency is uncommon, with the conventional form of exchange in the form of goods from the prison commissary. "Shopping" for someone else refers to an exchange whereby one prisoner repays a debt to another prisoner by purchasing goods from the prison commissary in a specified amount. As an example, if Maria owes Arie $20.00, Arie would give Maria a list the specific goods in that amount available from the prison commissary. Maria then "shops" the commissary, and purchases those items with funds withdrawn from her own account and gives the items to Arie.

Although women are not allowed to trade personal property, some degree of exchange occurs. Women who leave the prison often pass on their property to those who stay behind. Sometimes women can be heard to say, "Keep my TV for me until I come back," a joking but often prophetic farewell. Women who get too "big" for their clothes can swap or trade. Selling or trading items, particularly valuable items such as appliances or jewelry, can also occur in exchange for less benign purposes, such as drug debts. As in the male prison, cigarettes can be used as currency as well as commissary shopping.

Food

As in all cultures, food plays a significant role in the prison world. A popular magazine, *Prison Life*, publishes a regular column on food and prison-modified recipes. At CCWF, like most places, food provides more than sustenance and is an important part of the social fabric. Prisoners with any kind of material support often avoid the dining hall and provide their own meals in the housing units. The ingredients for these meals come from the quarterly packages sent from the outside, canteen purchases, or food smuggled from the kitchen. Tuck describes her reluctance to go to the main dining hall for meals and her preference for "home cooking":

> When I shared a room with my wife, she would cook for me. But when my wife ain't living with me, I'll have to carry it outside. I try to eat in her room or with my homegirls. I only go to the dining room very seldom, like when we have chicken, or roast beef, or something else good. The food in the dining hall is kind of fat. Who wants to go and get beans? Who want to go and get a hot dog when I can fix up a crab salad or fix up some rice and different things?

Although the dining hall appears full at each meal, most women dislike going to the dining hall and avoid eating every meal there if possible. Some women said they check the offered menu and "only go on certain menu item days." Canteen and box food allows creative cooking. Women described ways of making a wide variety of dishes, including something called "Chowchilla rolls," a speciality of the house approximating the California sushi roll. When a box contains special food items, it may be the foundation for a celebration. Randi reports:

> My family will all pitch in for my birthday, for Christmas and Easter—that will hold me for four boxes. My grandmother brought me all my hygienes, my makeup . . . my mom threw in exercise clothes and my aunt sent some shoes. That was my Christmas and it was wonderful. My mom sent me a food box before Christmas in somebody else's name—you pay somebody for that. I paid her a carton of cigs and a can of coffee because that was all she wanted. I got my food box on Christmas Day. We had a party—my whole room had a party. I cooked for everybody for three days.

The ability to avoid the dining hall is a mark of status and standing. Divine says:

> I ain't been to the dining room in three years. See this stinger? I can make anything with this. With an empty coffee can, you can boil water; you can broil, you can fry, make rice. Of course, the cops smell it but we're allowed to cook. We just can't have a hot plate. Or a crock pot. That would be nice. But you can make your own hot plate by flipping it over. See, you boil water underneath and the steam heats the top.

Randi agrees, adding:

> We have some of the most screaming food go through here you would not believe. It's try this, try that. I had something the other night that could have come out of a Chinese restaurant. Our whole world revolves around boiled water. If you can't boil water in here, you are in trouble. And if you don't have a stinger, then you are fucked. Anything you can cook in the free world, we can cook in here.

Women share food with their family members, roommates, and other close friends. Rory says she always cooks for Divine:

> Whenever I cook, I cook for her. When she buys, I cook it for us. That is just how it is. For us. One of our ex-bunkies used to cook with her; now it is my turn.

But because food is scarce, informal rules exist about sharing. Those who do not—or perhaps are unable to—reciprocate may not be included in these food events. As Randi explains:

> We will offer food to other bunkies. If there is enough, we will offer. If there is not, we won't. If somebody happens to be hungry and we know it, we will offer. I can't feed everybody out there. There is a point where it gets a little strained. It depends on who the person is and their own situation. If they are indigent, okay, I can understand that. But not if you have stuff in your closet and you are eating up all mine.

Tootie adds:

> If you are taking care of somebody else . . . now if you are taking care of your broad, we ain't going to do it like that. We are not going to feed you when you are off taking care of somebody else.

Many women practice reciprocity in their food preparation. As Tracy describes:

> It is different in every room, but this is a good room. We share almost everything. Now, there are six of us. If everybody pitches in just one thing. Like if somebody just got a food box and in there she got beans and tortilla shells and chilies. So I threw in the chili beans and rice, and Judy threw in the cheese and something else and we all cooked and everybody ate. We even fed Randi and she doesn't live there. Because there was enough food.

Health and cosmetic items (known as hygienes) play an important role in the material world of CCWF. Women who have their material goods organized often act as suppliers to women who are less prepared. As Tory says:

> I am the local pharmacy—if anyone needs a cold pill, Motrin, tape for their hand, I have it. They don't even give us cold set ups here. If I was to get a cold today, and went to see the doctor tomorrow, by the time I got my medication, the cold would be gone.

Mutual Aid

Roommates are often the first sources of mutual aid systems (Irwin, 1980), as Randi illustrates:

If you are here about a month, you usually get your first box (package from the streets) and get your money together. If you don't have nobody, then we try to help. If someone comes from CIW, they might have absolutely nothing when they get here, but the same muumuu they wear for a week. That is how I came. The only way you are going to make it is if someone helps you. It is the only way you can. What else are you going to do?

Other times, Robin says:

You might have a "homegirl" or relatives locked up here. They will help you. If you hear that someone has been sentenced to prison and they are coming to CCWF, you will sometimes start putting stuff together for them, depends on if they need it. You will hear that someone just arrived and they need something and you will help them out. People share. [You have to realize] that some people are way out of their territory here, and they need help.

This system of mutual aid was observed throughout the prison in many forms. Often called the welcome wagon or care packages, women will assemble necessities for the new arrivals. This system extends to the very small microworld of the death row prisoners, who take great care in assembling goods for the rare new arrival. Roommates are the main source of this aid, but other relationships contribute as well. Having a "homegirl" or a relative is a second source of mutual aid. However, these systems of mutual aid are not available to all members of this prison community. For those with no resources within or outside the prison, a special category of "indigent" exists to provide some personal hygiene items. About 40 percent of the survey sample indicated being indigent at one time or another. Socially, signing up for the indigent list is a low-status event.

The Yard

As the most public place in the prison, the yard is defined as a place of trouble and, with some exceptions, a place to be avoided. As Esperanza says, there is little to do on the yard:

There is really nothing to do out there. In the free world we would go to the movies, go to the park. Go to my gramma's house, my auntie's. But they are no benches to sit on. We are just going to walk around and get our shoes wet and be Messy Marvin from the ankles on down.

Carmen adds:

> At first you are all excited to go to the main yard. After being in A Yard,
> you think you are going to the free world. But the freedom of D Yard
> wore off. I might as well be in Ad Seg because I stay up in the unit. I
> don't go to the yard. It is messy—the drugs, drinks. The cops search you
> for no reason. The whole time you are in there, you have to keep your
> eye out because you never know what is going to happen. A person is
> likely to throw a syringe at your foot. You can be in the wrong place at
> the wrong time and you are apt to go to Ad Seg for nothing.

In hearing this, Divine and Tory laugh out loud, with Tory adding:

> I am a homebody (laughs). We never go out. I even hate the dayroom. I
> won't even use the phone. I get enough of people at work. I call my
> room my cave—let me go back into my cave and stay out of every-
> body's business.

In describing the yard as a place of trouble, Tracy says:

> When you realize how many people are in this prison—three thousand
> people—and you look at the yard, you see that hardly anybody goes
> there because everybody is afraid of the same thing. I just want to stay
> in my own unit. I am attached to people there and I know them. I feel
> like it is your own apartment complex—in this hallway we run from this
> room to that room.

Randi states that she makes only brief trips to the yard:

> I go from here to the library and directly back. Do not pass go, do not
> collect $200.00, and DO NOT go to jail. I don't fuck around with nothing
> in the middle. I cannot afford to.

Some women, however, do go to the yard. They may go to meet a friend
from another housing unit, walk the track, or sit on the grassy expanse of this
public place. The yard, as a public place, is often the place for celebrations
such as birthdays or "weddings" that involve women from different housing
units. In the course of this study, I was shown invitations to these events and
facsimiles of marriage licenses produced surreptitiously. The yard is also used
for organized sporting events, team sports, or individual workouts.

Spring weather may also bring out many women to enjoy the sunshine
and the fresh air. Women may play music or sit in conversational groups. But
Tootie agrees with the feeling that the yard is a place of trouble when she says:

Last Saturday night I went outside with my friend, Chicago, for a minute, right? I was in here on the next unlock. When I was out there it looked like the night of the living dead. It was cold and everyone was walking around bunched up. I told my friend, let's go, these people are walking around like zombies. If you are out there in the rain, the cold, you know why they are out there. It's the drugs and the trouble. Do you know what I mean by the mix? Those people in the mix, they will be out there faithfully.

Snitches and Baby-Killers

While this world of women is somewhat more tolerant than the prison culture among men, two categories of deviant behavior are disdained at CCWF. Informants, or snitches, are undesirable. "Child offenses," including child homicides, violent crimes, and any sexual offenses against children, are seen as highly repulsive. Unlike male prison culture, however, women in prison seem to be more tolerant of these offenders. In male prisons, informants, child molesters, rapists, and those committing any violence against children often need to fear for their personal safety within the prison population. "Snitches" and "rats" also are in jeopardy in male prisons. In some situations, these offenders may seek protective custody, isolating themselves from the general population, living in secure housing units. This does not appear to be the case at CCWF. While snitches and "baby-killers" are certainly looked down upon, few are actively excluded from daily life. As Lorreta says, "Snitches are treated differently. They are to be avoided. But we can't do nothing about them." Defining the snitch, however, is problematic. Randi says the gossip and the "he said, she said" of CCWF often paints an inaccurate picture:

> Sometimes you get jackets [a bad reputation] without even doing anything. If people don't like you, they will say, "Oh, she told on me about this." And just because she got busted for that, somebody will believe that you told on them. You have to sort it out for yourself whether you believe that they are lying. If you decide not to associate with someone because of what somebody said, you are no better than the person who is lying about them. You have to judge it for yourself. In here, so many people would lie—about big things and petty things—who has the iron, who has the broom, that kind of thing.

Other women state that the nature of their job, which may require them to type an incident report or mark a woman absent for a missed day in school, causes others to think they are "with the po-lice."

Although a woman with a "child-case" is shunned, there is a informal prohibition against asking one to identify her offense. Because "there is nothing we can do about it," most women do not want to know the nature of other women's offenses. Those who have such an undesirable status are afraid of others finding out about their offense category. In fact, it is seen as quite rude to ask another prisoner about her offense. As Zoom states:

> The worst offenders here are baby-killers. Child offenders. Child abusers. They don't tell us what they are in for. But we don't ask them. Mostly, you may know the person from the county and we may know what they are in for. But I prefer not to know why someone is here. What if she is a baby-killer? It is just easier not to know.

> A long time ago you could get cut [stabbed] for being a baby-killer. We had a riot at CIW over that. But now they are in with us. They walk around like it is the thing to be doing.

The emphasis on privacy in this culture inhibits questions about offenses among those who fully embrace the "convict code." Some women, however, engage in the rude behavior of asking "why are you here." While the women are relatively tolerant of a wide range of rule-breaking behavior (as they say, "we have all been there"), a few offenses remain anathema to the sensibilities of this population. Even though most women do not ask about another woman's offense, women who are convicted of a "child-case" are extremely wary of any questions, as this woman, convicted of child endangerment, tells me:

> All women want to know why you are here. That is something I don't want to discuss. I try not to listen to the women in here. The only ones I listen to are the ones that are in charge of me, the ones taking care of me while I am in here. I only trust the officers. . . . If I tell the ladies why I am here, then it will be all over.

ADMINISTRATIVE SEGREGATION, SECURITY HOUSING UNIT, AND DEATH ROW

These special populations on A Yard have a unique social organization, outside the mainstream life in the general population units. In addition to the reception population, A Facility also houses three distinct special populations. In this prison, the security housing is divided into two separate areas: Administrative Segregation (Ad Seg) and the Security Housing Unit (SHU). Ad Seg functions as a shorter-term secure facility, whereas SHU contains women held

for significantly longer terms. Building 504, like the more secure reception building (503), is based on the "270" design, a more typical two-tiered modern cellblock, generally found in male institutions. Both buildings contain two-person cells and a fenced recreation yard. In 503, women are allowed to "program" outside the unit (usually one tier at a time); women housed in 504 have no unescorted movement outside the unit. 504 also has a solid wall down the middle of the unit, dividing the building into its separate functions. Unlike male prisons, CCWF does not require large units for disruptive prisoners. To the left as one enters the sally port is the Administrative Segregation Unit. Ad Seg functions much like a jail in the outside community. Women are moved to Ad Seg when they are under investigation for infractions of prison rules or more serious offenses, under suspicion of involvement in such behaviors, or immediately after any incident in other parts of the institution. Upon investigation, women can also be held in Ad Seg for short periods of time as punishment for minor offenses.

The Security Housing Unit (SHU) is designed for the few women offenders whose behavior represents a danger to themselves or others in the institution. (At the time of the fieldwork, CCWF did not typically hold women with severe psychiatric problems. Once diagnosed, such prisoners are transferred to a secure mental health unit at CIW.) SHU can be thought of as the prison within the prison. An even smaller number of women, four at the time of the fieldwork, were confined to a six cell-wide area, known as Death Row. The few women sentenced to death are confined in this section of SHU, due to the need to separate these women from general population. The larger number of men on Death Row (389 in May 1996) are housed in a wholly separate housing unit at San Quentin. The comparatively few women on Death Row do not warrant such a separate unit and thus live within 504 on the SHU side.

While research still suggests that male prisons are organized around violent, predatory behavior (see McCorkle, 1993, for a recent review), little attention has been given to violence among women in prison. In the free community, women are often the victims of violent acts; in the women's prison, they can be the perpetrators as well.

Women are typically confined to Ad Seg for three major reasons. Fighting (called physical altercations with other inmates, a charge somewhat less serious than assault) is the most common reason for admission to Ad Seg. Typically, these fights involve co-participants. Drug-related offenses (possession of narcotics, drug trafficking, and conspiracy to smuggle narcotics) are the second most common behaviors. "Assaults on staff," a somewhat serious charge, although the actual incident may not involve violence, was the third highest reason. I looked at a sample of records that documented admissions to SHU for a six-month period, finding that women in Ad Seg typically serve terms shorter than one month, with "physical altercation" as the most frequent

offense category. Among SHU inmates, "staff assault" is the most frequent offense category, with SHU programs lasting more than six months and often longer. If found guilty of a serious offense, women will be assigned to a SHU program and may serve several months and sometimes years in the right side of the building in the Secure Housing Unit. By far, assault on staff is the most common reason for a SHU assignment (also called a SHU program). Assaults on inmates, weapon possession, serious drug misconduct, and other fairly serious behavior problems result in a SHU term. These decisions are made by an institutional review team as a result of an investigation. Going to Ad Seg or SHU is much like going to jail or prison from the streets. Tuck, under investigation for drug possession in the prison, tells us:

> When you first get here, it's just like taking you from the free world and putting you in jail. Because you can't smoke, you can't eat all the things you want, you can't drink Pepsis cause they don't allow cans back here. And you can't have too much property, for security because you have people who might want to cut their wrists. You miss your loved ones [in the prison population], people that you've been around, you miss your freedom, your space, because you go from a big old yard to a shoebox. You know, it's hard when you're an active person, like to move around and all of that—when I first got here it's like, stressed for a minute, and think about the yard, think about this and think about that, wrapped up here and get my little personal hygienes and you can't come in—you might not have all the personal things you really want and then you'd be missing that—you get used to it, you adapt.

Daily Routine

In 504, women are not held to the same schedule and are not required to get out of bed at any given time. LaDonna describes the daily routine:

> Unless you want breakfast, you don't have to get up. If you got your light off that means you don't want breakfast. You can keep your light out all day. If you don't want to eat, you can get up when you want to. I am used to making my own food in the (general population) unit. I have to force myself. It's like you don't got it so you have to adapt to the food.

When the breakfast cart comes around, staff typically announces, "It's time, ladies, to get up, turn your light on if you want breakfast." Many women choose not to get up, and spend the day sleeping on and off, or keeping busy in the cell reading or writing letters. Tuck describes her routine in the unit:

After breakfast is over I usually stand at my door and watch the police move around. I just watch to see somebody move around. I think how I would like to be able to move around too. We don't have much room in there. I might stand here an hour, just see what is going on. I watch the cops take women out of their cells, they might be taking them to the doctor, they might be taking them to court, it's not a shower day so there's no showers—so it's just kind of like watching main street.

With little face-to-face interaction possible in this unit, the social life in 504 takes a form found in lock-down units in all prisons. The women held in 504 often engage in loud conversations, either with one other woman specifically or in large groups. Women also make conversation with "vent partners," immediate neighbors with whom they share a heating vent. Most verbal interaction, however, is public interaction. Conversations between two women, shouted across the concrete expanse of the Seg unit, potentially become a group discussion. During my fieldwork, I observed several incidents of this type of interaction. In one of my first interviews in the Ad Seg side of 504, the noise outside the unit was so loud that I could not hear my respondent. The sergeant generously offered her office, where I recorded all my interviews over the next several weeks. While in the office, I heard shouting and clapping and I asked my respondent, Tuck, to explain this event:

Yeah, they are clapping. Somebody said something stupid. It's like their entertainment. And the main thing back here is a lot of people have a program, sleep all day and stay up all night. Cause the days is the hardest, you know.

She continues in describing a typical interaction in the SHU unit:

Well, after breakfast, you can sit up and freeze and cuss people out for entertainment or you can get back into bed, which most people do. Some days, just like animals would communicate, you know, somebody starts it off. And if she starts it off and it's her friend, then she's going to join in. It's just like studying animal behavior. Very rarely would you see somebody stand up and defend someone else—no way. No way, they would be cussed out theirself.

If you are trying to have a private conversation, even though you are yelling, your tone lets a person know they're invited or not. Like, now you can hear my girlfriend yelling at me. She is trying to start something with me. She is mad cause I don't want her anymore, okay? She's not my type and I'm sick of being with her, I've been with her for four

months. We're back here on the same charge, we're co-defendants. She's the same age as me, but she has no concept of responsibility, I mean nothin'. I just don't want to be with her.

Staff and prisoners report that the unit is most lively in the evenings and at night. LaDonna provides her perspective on the nighttime activities in the unit:

Sometimes these women start cussing out the police. Like last night. So they pulled out all the girls last night because they cussed the police out. And I watched them pull them out, and I watched the inmates make a damn fool of themselves. Why do they want to be in a little cage? Last night I sat here on my skinny little bed and I watched them cuss the police out. They don't think that yelling at the police like that is going to make it much harder for them back here? When they need a roll of toilet paper, the police will take their time to bring it to them.

I guess they do it to impress the inmates. I used to be like that. I'm not into impressing these inmates—I'm trying to now be more responsible for me. Have more control of me. Because if I'm going to cuss out the police so the inmates can laugh, and cheer me on, then I feel like I'm a damn fool.

What bothers me most back here is these stinking ass women. They come to the door and they do some of the stupidest shit. Like last night they woke me up at 2:30 and I stayed woke from 2:30 to 4:00 listening to them cuss an officer. I mean the officer wasn't bothering them or anything. So what was the purpose?

There are people who might sleep all day and stay up all night. See, at night there are two officers here, one up here and one on the floor. So last night everybody decided they were just going to pick on this officer. It don't make no sense.

Routine activities in the Security Unit include showers three times a week, weekly laundry exchange, and yard recreation. Women in these units do not have access to their personal property (which is "rolled up," or boxed up and placed in R and R for storage while an individual is housed in 504). Women are given "state-issue" clothes, pants, shirts, and muumuus. Some women customize their clothes for comfort and individuality. For example, the jersey baseball shirt can be turned upside down and used as sweatpants, with the arms of the shirt used as pant legs or the body of the shirt used as a skirt. Although laundry is exchanged once a week, women often wash their

clothes in the cell sink. They may desire clean clothes prior to the weekly exchange, or they may have received clothes that they particularly like and do not want to send them to the general laundry.

Death Row

At the time of my fieldwork, four women were on Death Row. Unlike the men awaiting the death penalty, the small number of women do not justify a separate housing unit. The condemned women are housed in the lower tier of the SHU. I had several informal interviews with the four women in the middle of my fieldwork, but was asked by these women not to report on these data due to the sensitivity of their cases and the need to control all information that could be used in their appeals.

CONCLUSION

Women manage their prison sentences by carving out a life that provides for some measure of privacy and safety, a range of activity, a satisfying program, a living situation that is fairly comfortable, and a degree of material comfort. As I discuss in the next two chapters, one's immersion in prison culture and the nature of one's relations with others in the prison community shape the ways women learn to do time. Arranging and ordering one's life in prison is the first step to surviving. But not all women learn this skill of arranging a life and some "go through some changes" before developing these survival skills. These comments from a group interview show the critical importance of surviving the prison world as one learns how to do time:

DIVINE: You have to learn to survive here.

TOOTIE: There are a lot of people who are here that are not surviving.

RANDI: They are backsliding. . . . I spent the first two years banging my head against the wall.

TRACY: You learn to get out of that . . . you learn that you get nowhere with it.

TORY: That does not do you any good. You learn that you have to deal with it . . . or you hurt yourself.

RANDI: You accept where you're at and then you move on. You try and do the best you got with what they give you. If you can't do the best with what they give you, you say, oh well, I tried. We are getting in a lot of youngsters, a lot of young ones now, with a lot of time. They are bitter—I mean, real bitter. They have not had a chance to live and it is hard to help them get over the bitter because that is how they think they are supposed to feel.

DIVINE: They think they are supposed to be tough. You are supposed to be tough, and not cry and beat everybody up. Well, that is not what it is about. It is about living and making a stable place for yourself here where you are going to be for a while.

The next two chapters expand on these themes, describing the ways women at CCWF carve out their lives through relationships with other members of the prison community and the prison culture.

Chapter 5

Relationships Inside and Out

> *Women "do time" differently from how men
> do time. Men concentrate on "doing their own
> time," relying on feelings of inner strength,
> and their ability to withstand outside pres-
> sures to get themselves through their time in
> prison. Women, on the other hand, remain
> interwoven in the lives of significant others,
> primarily their children and their own moth-
> ers, who usually take on the care of the chil-
> dren. Yet, the inmate continues a significant
> care-giving role even while incarcerated.*
> —Lord, 1995:266

While the physical and temporal worlds of CCWF provide a foundation for the culture of the prison, interpersonal relationships are the anchors of prison culture. This chapter describes three categories of relationships that define and reflect prison culture: relationships with children and family on the streets, relationships with other women prisoners, and relationships with staff. I found that gender differences exist in male and female connections to the outside world, particularly through contacts with families and significant others, and are expressed in prison culture through close, personal relationships, in either intense emotional relationships or through the pseudo- or play family arrangements. Relationships with staff are developed and maintained by prison culture, again in ways different from those developed by male prisoners.

RELATIONSHIPS WITH CHILDREN AND FAMILY

While some evidence in the literature on male prisons suggests that incarcerated men have the ability to "cut loose" their family ties (Fishman,

1990; Hairston, 1988, 1989; Koban, 1983), the women in this study main-
tained these ties in a variety of ways. While incarcerated, they make efforts to
maintain contacts with their children and family. These contacts have a sig-
nificant influence on prison culture because children hold a primary role in the
lives of women before prison as well as during their prison experience (Bloom
& Steinhart, 1993).

Children are part of the prison culture in two distinct ways. First,
women maintained ties with their children through a variety of means: phone
calls and letters were the most common, with regular visits and family visits
(known as FLU visits, abbreviation for family living units) the least common.
Second, for many women, reuniting with their children becomes a primary
goal and acts as a form of informal social control during their days in prison.
Reunification immediately upon release was the goal of almost half of the
women interviewed in our profile survey, but this desire often conflicts with
the reality of raising a child under the restricted circumstances of their release.

In 1990, an American Correctional Association survey asked women
prisoners to name "the most important person in your life right now." The
ACA reported that 52 percent of the women interviewed responded that their
child (or children) was most important to them. Another 18 percent identified
their mothers as most important to them. Just over 10 percent replied that a
husband or significant other held this status (1990:54). In individual conver-
sations with female prisoners and in narrative descriptions of the value system
of women's prisons, children emerge as the most significant factor in the lives
of women in prison. This makes sense. Since 80 percent of the women in our
survey sample reported having children, it is not surprising that motherhood
and children are highly valued. Of these children, 30 percent were under the
age of six at the time of the interview, 45 percent were between the ages of
seven and seventeen, and 24 percent were over the age of eighteen. Our sur-
vey asked the women the living status of their children during their incarcer-
ation. As other studies report (Bloom & Steinhart, 1993; Baunach, 1985;
Datesman & Cale, 1983), the majority of women indicated that their children
are with the prisoner's mother (30%) or with her relatives (10%).

The primacy of these relationships has an impact on the values shaping
prison culture in several ways, such as making conversations about children
sacred, acknowledging the intensity and grief attached to these relationships,
sanctioning those with histories of hurting children, and other child-specific
cultural beliefs or behaviors. Finally, family relationships form the foundation
for the play family or the pseudo-family. These "prison families" reflect sig-
nificant roles present in family dynamics in the outside world. They are a pri-
mary social unit in the organization of the prison culture.

Throughout interviews and participant-observation, almost all women
voiced the extreme importance of children in their lives. As one pregnant pris-

oner remarked, "I may have been a lot of bad things, but I was a good mother." On countless occasions, women would speak of the pain of being removed from their children and the tragedy of separation. The desire to "just be home with my kids" and the need to "be a good mother" were echoed in numerous interviews. Women repeatedly spoke of their concerns about their children and their worry over the effects of this separation on their children's well-being. Pictures of children, letters to and from children, and phone calls or visits with children are a critical axis around which many women organize prison culture. Social support for these sentiments was equally strong. Other women listened to conversations about children empathetically and attentively, sharing experiences and concerns. In the value system of the prison, similar to that of men, prisoners with a "child-case" are shunned and scorned. By every indication, reunification with children is seen as the primary goal of the prisoner mothers. Indeed, much of the literature (Bloom & Steinhart, 1993; Baunach, 1985; Datesman & Cale, 1983) supports this claim, with recent work on the woman prisoner focusing on her status as mother. There are relatively few studies of the male prisoner as father (Parker & Lanier, 1992).

But this emphasis on the importance of motherhood while incarcerated does not always reflect the reality of their lives outside prison. In our survey, just under one-third of the sampled women reported living with all their children prior to incarceration, with another 10 percent living with "some" of their children. About 28 percent of the women did not live with their children in the year prior to this imprisonment. The remainder reported having children who were grown, incarcerated, or otherwise "on their own."

Constance, a lifer in prison for killing a man who abused her and her children, illustrates the complications of the tangled relationships many women prisoners have with their own mothers and the effect their incarceration has on their children:

> Some of the things that I am going through with my mother make me wonder if my children are going through the same thing with me. Like this love–hate thing. It's like, I love you because you are my mother, but I hate you because you have been gone all my life.

These family situations immediately prior to incarceration illustrate the fragmented nature of their own early lives. This pattern of disordered families is repeated in their adult lives. About 35 percent of the women we interviewed in our survey had custody of all their children, with another 7 percent maintaining custody of some of their offspring. Thirty percent did not have custody, with the remainder having grown children (or no children). Candy, a white female offender serving five years for drug sales, reports that her par-

ents "take care of my kids while I am locked up so I don't expect them to take care of me." As a whole, women agreed that their kids needed to come first and that they did not expect any financial or other material support. Tootie, scheduled for released at the time of this interview, describes these expectations:

> Although I did the county jail thing for ten years, this is my first time in prison. My mama been there for me during my prison time. She has been there for me but at the same time she will say, "I ain't got no money to be sending you." And I have to understand that because I have two kids that I done fucked up and they are in the system and she has custody of them and she has to do for them off what the welfare is giving them. So I have to make other precautions (arrangements). Like I ask my other buddies on the street for help. So I ask them to pitch in and do it. Sometimes they just drop money off there. My mama will tell me, well, so and so sent you this, or I have a brother who has been doing his little thing and he will send money to the house. My mom will tell me you got some money here, and I will ask her from where? Your brother sent it and I will say okay, cool, just send me my money now. Before you decide to pay a bill with it.

Some of the women report that their "street" families continue to be an important source of support while they are imprisoned. Tracy, serving a long sentence for a drug-related violent crime, tells of her attachment to her biological, or "street" family:

> My support system here is my street family. My mother, my father, my grandparents. Everybody. When I got arrested for first-degree murder, it blew my whole family away. From the gate, my mother told me that she would believe whatever I tell her and it was that trust that got me through fifteen months in the county and the two years that I have been here and the three more I have to do. They do what they can for me. More than anything, more than the money, the boxes, they give me the love and the respect that I need that I cannot get in here. You can get as close to somebody as you want (in here), but if you don't have the backing when you get out there, it is twice as hard.

> For me, it is going to be easy to go home. I am going to have my family and my support system. A lot of these women are not going to have that. A lot of these women don't have that from the beginning; that is why they are in here. They are homeless, people with abusive parents, husbands and all that. I did not have any of that. I left on my own and

did my own thing. I had a reputation out there. I did business the way I thought business was supposed to be done and I was good at my job (drug dealing). But when I stepped in to the incarceration bit, I dropped all that. When I need it, I will pick it up. If I need a favor done on the outside, I will pick up the phone and call my partner and say, look I need this done. I won't ask for money. I don't want to be in debt. I have my family for that. I would not be able to survive without them.

Patty, who has served multiple prison terms, talks about the reaction of her family to her prison term:

I think my mom is happier when I am in prison. When I had my son, my mom and my aunt took the baby home. On the streets, I was into drugs more than I was into my family. I knew my baby would be better off with my family than with me. It's been so long since I have seen my kids. I feel like my heart has been ripped out, even though I know I brought myself here. It makes me angry with myself. It still hurts, even if I know my daughter is being well taken care of. I was fighting with my husband in the streets; it was my troubles on the street that brought me here.

Tory, who does not plan to live with her teenage children when she is released, remarks on the difficulty of answering children's questions about her release: "My kids are always asking me, 'When are you coming home, Ma? What day?' They don't understand that I can't think about going home right now."

The physical separation of imprisonment is often accompanied by emotional estrangement from their children as well. Daisy, a thirty-five-year-old white woman with a long history of drug use and a husband serving a life term at San Quentin, describes her estranged relationship with her children:

I have a fourteen-year-old son. I want him to finish school or go in the service, so he can get what he wants out of life. My kids seem to think it is alright that I am in prison. That is all they have ever known about me.

I don't go see him. My sister cannot stand me. My sister took my boys when my mom died. Last time I was arrested, for weapons possession, she wrote me and told me not to come around her house when I was released last time. When my mom died, she sent me a picture of my mom in a casket and said, "I hope you are happy."

While many women see their "real" family as their support throughout their imprisonment, some women report negative relations with their family on the streets. Often the families of women react strongly to their arrest and subsequent imprisonment. Randi, a young white woman serving a life term, says, "Two days after I got arrested, my mother said don't call me, don't talk to me, I don't want to have anything to do with you. I hate your guts." Most of the women interviewed have complicated relationships with their families, complications that are aggravated by their incarceration. Other women report that they feel abandoned by their families, as Randi states: "I don't expect anything from my parents but their love and their support. And for that two years when I heard nothing from my mother—not a letter, not nothing. That is when I started tripping and I thought why do I care? That is when I really starting going wild in here." While this can be a reaction to the immediate arrest, this "cutting loose" can result from a long history of disappointments. Tootie describes her relationship with her mother:

> I done did so much wrong to my mother. I have stole from her and all that. I have done things that have degraded myself and she knew about it and she still saying she would come see me when she knew I was going to prison. I knew [my current charge] was heavy then because she all of a sudden had a change of heart. She came to see me and brought one of my kids to see me. And she ain't been to see me in all the years I was going to jail. But she came to see me [when I was sentenced to prison]. She supported me when I was at CIW. Writing me, sending me money. But then times got tighter and so I don't expect her to send me much. I don't want her to send me much.

Tracy echoes these feelings:

> One of the hardest things for all of us in here is that we have people that we care about out there. My father has brain cancer and if that man were to die, I would fall apart. He forgets when I am coming home. I got eleven years, so I will do six. I get FLU visits about every six months . . . my mom and my dad. They are a mainstay for me. My dad is on 100 percent disability and they don't have any money, but they manage to send me about $40.00 a month.

Tootie sums up the importance of her family by saying, "I hate to say this but if my mama was to cut me loose, I would be gone mentally. I would die. If anything was to happen to my mama today, I would be gone."

Oftentimes, parents see prison as a salvation. Many women supported the idea that their parents "liked knowing that I am in prison; at least they

know where I am." This drug offender adds, "When I am here, she doesn't have to worry about me, so the longer I am here, the happier she is." Imprisonment, for some, opens the door to a reconciliation between the prisoner and her parents or her spouse. Jane, a white woman serving a short sentence for probation violation, provides an example:

> My mom has come around now. She has both my kids; she has both my boys now. My husband and I were fighting custody—he wants to reconcile since I am back in here now. He wants to see if we can work things out. And he is willing to help me the rest of the time now. My mom has my oldest son, my husband has my youngest son and he is going to let the youngest go with my mom so he can be together with his brother. Everything is starting to come together. But it didn't the last year and a half when I was on the streets.

Divine talks about the difficulty in establishing a relationship that has been marked by drug use and repeated imprisonment:

> My son was in prison and I now am in prison again. I wasn't in a position to help him. That is why I want to go to work furlough so bad, so me and him can get it together. There are a lot of mothers in here with kids in prison. A lot.

Among the women with children in trouble themselves, there is a feeling of hopelessness and resignation. Divine continues:

> My son will probably go back to prison. I just hope that I am out there (then) to help him because I know what he is going to go through. I don't care if he is Charles Manson, I am going to help him.

One aspect of these family ties is a need to help younger relatives avoid the troubles experienced by the prisoner. Blue describes her feeling about her nieces who are beginning to use drugs:

> I tell my nieces when I talk to them on the phone that if they keep doing what they are doing, they are going to end up getting hooked. One of them hangs around these girls that smoke PCP. I tell her, "You keep hanging around her and one of these days they are going to get crazy and go rob somebody and you are going to be there. What is going to happen? You are only thirteen years old. At least, give yourself that chance to grow up before you get involved in a gang or put tattoos all over you."

My niece came to visit me and told me that she was getting a tattoo. I pulled her by her hair and took her out of the visiting room and told her, "Now listen." I showed her mine and said, "Do you see this? What does this look like? What really does this look like to you?" And she looked at me and said, " Aunt Jan, it doesn't look too good. It is a lot of writing and scribbles." So I go, "Yeah, how would it look if you had a scribble on you? Come on, Missy, you are only thirteen years old. I have been in prison half of my life. This was because I have been in prison, not because I have been out there hanging around a gang. Believe me, if I was still out there, I would not have these tattoos."

Connections to the outside world also create problems for a woman trying to live her life within the prison world. She may be torn between "doing her own time" and thinking about her family on the streets. Difficulties on the streets and the problems of their children frequently enter women's prison world through letters or phone calls. As Daisy says:

There is lots of bad news on the phone. Some women don't like to get on the phone because they are afraid of what they will hear. If I hear my family is not doing well, I will not call that often. I can have a flashback to the time that I was called over the intercom to learn that my baby son had been killed in a fire on Christmas Day.

"Losing family" was described as being one of the hardest things about serving a prison term. Almost all members of the prison community, prisoners and staff alike, show empathy toward a woman whose child dies during her imprisonment. Daisy tells me of her recurring sadness that is reinforced every Christmas season. Her friends, and some of the staff, know this history and are especially supportive around the holidays. Blue tells of losing both her son and her father during her prison term:

I lost my son in 1990. He was five. I know it is going to be hard because I am used to my baby. He was only seven months old when I got busted. So really, my sister raised him. But he was still mine. I birthed him.

And then I lost my father last November. It is going to be hard with my father because me and my father never had a relationship. A couple of months before he passed away he sent me a box, which was really shocking because I hadn't seen my father. He kept telling me he sent a visiting form, which he didn't. He lied. When I called him about two weeks before he passed away, he just told me that he loves me and he will always love me. It felt kind of good because it was the first time

that I can remember that he loved me . . . he knew he was dying and had a family get-together and told my brothers and sisters when he died, not to let me come to the funeral because he thought I might do something crazy. So they waited until two days after they buried him to tell me. It was hard. It was hard.

While many women report that being separated from their children is the hardest part about doing time, not all women want their children to visit while they are in prison. An interview with two first-timers illustrates many of the issues involving children. Maria is thirty-six years old and has three children, between twelve and seventeen years old. She has been at CCWF for fifteen months, with ten months remaining to serve. Arie has two girls, ages five and seven. She is twenty-three years old and is doing a three-year term. Her children are cared for by her mother; her husband is in a California prison.

MARIA: Missing them is the hardest. I have not seen them since I have been locked up because I do not trust anyone to bring my children here. But it would be too hard to see them here. I have letters and pictures to keep me going. The first fifteen months were hard, but the next ten will be easy because I know I will get out to the gate and see them.

ARIE: They ask me what it is like here and I tell them that it is not really that bad, but it is not something that I want to repeat. This is my first time in prison and it will be my last. My children are young, but real smart— when I talk to them they tell me that they miss me and love me. They say they want to learn to write so they can write me letters. [They tell me on the phone], "Well, Mama, since you are in there, I hope you have learned your lesson." But she also said, "I am there with you." She said she will work hard in school so she can make me proud. She will be nine or ten when I get out—I have a six-year term so I'll do three flat. When she told me, "I will never forget you while you are doing your time," that made me so happy. Knowing your kids are okay makes it easier to do time.

Maria is concerned about her son's reaction to her imprisonment:

My oldest son had a lot of anger toward me because of my offense. But he has said, "But then we knew what you were doing and what the consequences were. . . . Instead of turning my back on you, I should be standing beside you."

She comments further about the logistical and emotional difficulties of having visits:

While I am doing my time, I am not really expecting any visits but I send them the visiting forms. They say they would visit but it is really hard from the San Fernando Valley. They send me a box and stuff and I told them cool. . . . I told them not to take the trouble to come all the way up here for a visit of an hour and a half and then to drive the five hours back. I told them, you're looking after my kids and that is good enough. I can call and talk to you on the telephone and write you. That is saving gas money that can go (be spent) on them. And then if the kids come up, that will hurt me to see them walk out the door and I can't go with them. And that is the main reason I told them not to come.

When they visit, to see them coming from the free world, dressed all nice and cute and visiting me in state clothes is too hard (laughs). You do have warmth when you are laughing and talking with your family members, but then when it is time for them to get up and go, you have to go back to your cell. When they are going back to the free world and it don't feel so nice. To see them have to walk out of a door and you can't walk with them. It is almost not worth it to have them visit.

Many women reiterated this feeling that families who were taking care of their children should not feel obligated to visit or send money or packages. Maria discusses the nature of family support:

I would feel guilty taking money from them. My parents are taking care of my kids so I don't expect them to take care of me.

In order to get some sense of how much contact women in prison have with their family and friends on the street, we asked a variety of questions in the profile survey. About two-thirds of the 294 women interviewed noted that they did not have trouble keeping in touch with their children. Just about half of the women reported calling their children on the telephone every two weeks or more often. In fact, 34 percent of the women polled indicated telephone contact with their children between one and three times a week. At the other end of the spectrum, one-quarter of the women indicated that they had no contact with their children during this incarceration. Almost 75 percent of the women said they wrote letters to their children at least once a month. In contrast, 70 percent of the women indicated that they had never received visits from their children during this prison term. Less than 11 percent of the women stated they had visits with their children once a month or more often.

Likewise, very few of the women interviewed in our survey indicated they had FLU visits with their children: eighty-two percent indicated no FLU visits during their incarceration, with less than 5 percent receiving visits from

their children every three months or more often. Distance and care-givers' reluctance to bring children to the prison were most often cited as reasons why their children did not visit them. Around 10 percent of the women indicated that they did not want their children visiting them in the prison.

While there are few comparable studies of visiting patterns among male prisoners (Parker & Lanier, 1992; Fishman, 1990), my observations of visits at CCWF and male prisons over the past decade suggest a simple difference between men and women prisoners. Men, in general, tend to be visited by female partners, whereas women are much more likely to be visited by family members and caretakers of their children.

Connections with the free world are, then, a double bind for most women, especially those who have a significant amount of time to serve. While most women value their relationships with their free world family, particularly their children, many women interviewed at CCWF, like male prisoners elsewhere, see that family relationships can "make it harder to do your time." For women with children, awareness of the life that goes on without them makes their prison time doubly difficult. Divine reflects a common sentiment:

> You cannot do your time in here and out on the streets at the same time. That makes you do hard time. You just have to block that out of your mind. You can't think about what is going on out there and try to do your five, ten [or] whatever in here. You will just drive yourself crazy.

These connections to the streets are also apparent when a woman starts thinking about going home and making plans for life outside prison. As an extreme example, Blue tells how she started thinking of the outside world after she had done nine years and was being released the week of this interview:

> I started thinking about the outside last year, in May, when my best friend paroled. I knew that if I stayed right up free, that I could get my days back and I could go home. When she paroled, it was like, "She is going home to her family, like I need to go home to my family." She started writing to me, telling me to be please be good (in here) because she wants me to come home and stay out of trouble.

> I don't know why it took me so long to get myself together. (Knowing) this is what you need, like a GED to get a job on the streets. They are going to look at me and say, "Well, you have been down so long, how do we know that you are not going to rob us?" I think about that. I think about the doors being slammed in my face. But I am just going to have to deal with it.

My mother moved out of state when I got busted because she couldn't handle her baby being in prison so long. It is probably better for me to move to another state too because I don't know nobody. I don't know nothing out there. Here I know everybody.

Now, my sister lives (where) there is gangs and a lot of drugs. And even though drugs are not my problem, that worries me. What if I can't get a job? This is how my mind is. What if I can't get a job, and somebody right here next to me is saying, "Well, here, Blue, here is $500.00 worth of dope. Go sell it." Knowing I don't have no money and can't take care of myself right now, that is the first thing I am going to do. Grab it and say, "Okay, I'll be back" . . . and sell it.

So now I go to church and I know that I can beat that temptation. Like I told my sister, if I have to lock myself in a room for thirteen months to get off this parole, that is what I will do. I am only twenty-seven and it is not easy seeing all these youngsters come in and out of prison, and coming back. Maybe some people don't have family and don't know how to live on the streets. Maybe prison is all they got.

In addition to the emotional and social importance of letters, phone calls, and visiting, contact with family members and friends has an important economic dimension. As we saw in chapter 3, the majority of women at CCWF receive material support through "putting money on the books" or quarterly packages from family members. Women without economic support from family have three options: relying on in-prison hustles to supply their material needs, obtaining gainful employment through "pay numbers," paying work assignments (as 14 percent of our survey sample did), or connecting with other people on the street, known as tricks and runners.

TRICKS AND RUNNERS

Some women do not have family or friends to provide for them while they are in prison and thus rely on "runners" or "tricks" for material support. Tricks and runners are usually older males that the prisoners either knew prior to the incarceration, meet through mutual friends, or contacted through magazine or other publications soliciting pen pals. "Running drag" on a person is another term used to describe these exploitative relationships, usually with an unattached male on the outside. An extreme form of this hustle is a type of con game, where the mark is made to believe that his help is needed to save the woman from some terrible event, such as needing money to pay for an operation, to pay off some life-threatening debt, or to pay off an official to secure a release. Milder forms of

the hustle include developing or expanding a personal relationship with someone on the outside willing to provide money or services during one's imprisonment. Like any mark in a con game, the person reeled in through these methods is denigrated as a "trick," similar to a prostitute's John, and is seen only as a source of money or other support. In some cases, a woman's runner may in fact be a former prostitution client. In cases with a preexisting relationship, mutual exploitation is possible. Sometimes these outside persons are friends or acquaintances from the streets, and sometimes they are found through magazines or "trick books" in which women advertise or answer ads placed by both men and women from the free world. Carmen, a long-term prisoner who has served several drug-related sentences, describes finding a trick:

> You can get money from tricks, guys that think we are paroling to them. You give them the wrong date, tell them you live somewhere you don't. Then you just split. You can get money from tricks by telling them that you broke somebody's TV and they are pressuring you or that you need to pull a 115, or you need commissary. You just use you mac, your macaroni, your bullshit line, to get what you want. A trick is usually old guys who you would never talk to, even meet on the streets. It can be old men or women as well.

Randi describes the relationship when asked how people survive without family economic support:

> They latch onto their people. They get runners, they get tricks. If they worked the streets, they pull in a couple of their old tricks to run for them and mount up a debt that they have to pay off when they get out. I have seen that done. . . . (If you were a hooker on the streets) you have one, maybe two tricks, maybe three real good tricks that you see constantly. They are your sugar daddies. If you come to prison, then they run for you, (which means) they get you your boxes, they send you money, stationery, stamps, clothing, cigarettes. Sometimes they will visit you, write letters.

> [The nature of the repayment] depends on the kind of person or what kind of relationship you had. It all depends. Sometimes you owe them your body and soul. They think you owe them everything. Some people have five or six that they are running drag on.

Lorraine chimes in:

> Some runners don't feel you owe them anything, but there are very few of them. I have one. I have my best friend. I was in a psych unit for

sixty-eight days two years ago because I had a nervous breakdown. Somebody I met there—we had been friends and he came to see me in Orange County Jail before I got transferred to CIW. He knew I was having trouble with my mom because she was having a hard time dealing with me coming to prison. She said you are on your own—you did it to yourself, you are doing it yourself. He said he would send me my money, my boxes and I didn't owe him a thing. He said he would be there at the gate the day I was released to take me home.

Others say their runners can be depended on. Randi tells us:

That is what one of mine's is doing—taking care of all of my obligations out there so I can just think about me while I am here. He has been one of my tricks out in the free world for ten years and I know I can count on him.

Still other women are skeptical of this relationship and voice suspicion about the runner's motives:

People who send you money and send you boxes are runners. Women (who have runners) are just users. All these women are just users. They are out for what they can get. So I am always asking, like what is your motive? What do you want? There is no body but [my friend in here] who does anything for me and never want nothing in return. I don't trust anybody else. I only let people in so far. I have been wondering if I am going to be like these when I go home. How is that adjustment going to be? When I am out in the big world now, in society now and I can't be like I am in here. Not trusting. It's like I have to go back like I was before. I don't think I can ever go back to that. I don't think I'll ever be able to be open and friendly and trusting and naive. You always say that you are not going to let prison change you. But it does. It changes you. You have to let it change you in order to survive.

Other women claim to have caring feelings for persons with whom they develop relationships in the outside world:

Well, this guy is my visitor now, but he was visiting my friend at CIW. When she died, he told me that she had said I was her close friend and that he should visit me. She told him that if anything ever happened to her, that he should look out for me. He said that he was here to be my friend. He has been visiting me ever since. I told him that I need a friend, that he had to be my friend and I was not ready

for anything else. I said I wasn't going to tell him that I would fall in love with him. Or tell him that I love him, or that I am paroling to his house.

Now women here have these things called tricks. Older men that come and visit them. They promise them the world, these men take care of them and the women dump them when they don't need them anymore. No. I told him that I was going to be totally honest with him. Yes, I am doing life, this is why I am doing life. This is how my lifestyle is and I am not paroling to you. I am not planning a future with you.

He is an interesting man. We have very interesting conversations. I thought he was going to be boring and all. That this was going to be a drag. I didn't want to hurt this man's feelings (by) telling him not to visit me anymore. But it is interesting to hear about his lifestyle and the life he led, the places he has been. He is just a trip and a very nice man.

I told him not to write me nasty letters, not to send me nasty cards. That would turn me off. I told him that if he wanted somebody to treat him like a trick, I could introduce him to some of the girls out on the yard.

Sometimes, women hope that their street friends will send them money or help with their children. But women also acknowledge that their friends on the street are often unreliable. Most of their street friends, they tell us, are "drug friends" who are often undependable. Tootie describes this relationship:

Say, for instance, my bunch of supposedly friends at home. Maybe every other month, one sends me some money or they take some money over to my mother's house. They do what they can, but still I get on their case because I know what they are doing on the streets. They are out there in the drug thing and I know they got a little money. But they do what they can for me since I have been down and I have been down a year. They might drop some money at my mama's, or I talk to my mother (and ask her) to hook me up to them (and) I'll send my sister to go get the money and she will go get it from them. It works like that. See, (if my kids have a birthday), they help. I missed both my kids' birthdays, but they both had nice parties, because my girlfriends was there helping them. And I respect them, you know what I am saying?

While these outside relationships have a significant impact on the thoughts, plans for the future, and material status of the women at CCWF, relationships inside the prison shape the majority of their day-to-day experiences and their penetration into prison culture.

RELATIONSHIPS INSIDE

Much of the literature describes two broad categories of relationships among women in prison. The first, play families, has been described by Selling (1931), Heffernan (1972), Giallombardo (1966), and others. The second, "homosexual relationships," called "same-sex" relationships in this study, have been a staple of the literature, discussed in theoretical detail by Ward and Kassebaum (1965) and Propper (1981, 1982). Propper provides an important distinction when she states that the concepts of play families and homosexuality have been confused methodologically and conceptually. In her comparative study of co-ed and all-female institutions, she found that asexual pairing formed the basis of most make-believe families and that participation in these families was not associated with a greater likelihood of homosexual experience (Propper, 1982:128). The play family or the role as "homosexual partner" has been described as the basis for a woman's role and status within prison culture.

Data collected during my fieldwork show a complicated pattern of personal relationships that have at their base emotional, practical, and material connections as well as sexual and familial ties. Some of these relationships are highly transient, while others are long-term, lasting through years of imprisonment and freedom. Regardless of its form, the play family is an enduring feature of women's prison culture. Somewhat related to the family, but not necessarily tied to it, is the existence of the romantic dyad, or couple. Finally, women in prison form deep attachments to others that may or may not be sexual in nature and endure as friendships rather than romance.

The prison family, like families on the street, may be small or large, and may last a significant period of time or dissolve and transform. The family structure reflects the dominant role played by women in the free world and continues to find expression in prison life. While the basis of some families may be the romantic dyad or couple, families can also be formed by individual women developing close ties and taking on family relations. Typically, an older woman will take on the role of the mother, with a "youngster" taking on the role of the "kid." Women who are taking on the "butch" or the aggressive role may be a dad, a son, or a brother, but these designations are often fluid. Ro, a woman committed to the prison world, offers this description, which introduces some of the relationship roles played by women:

> The family is when you come to prison, and you get close to someone, if it is a stud-broad, that's your dad or your brother—I got a lot of them here. If its a femme, then that is your sister. Someone who is just a new commitment, you try to school them into doing things right, that is your pup. But if somebody is a three-termer, and doing a lot of time like I have, then that is your dog, road dog—prison dog. I am this way on the

streets. I am not a stud or a femme. I am just an aggressive person. I prefer not being with a stud because I am too aggressive for them. You can switch: you can be brother and sister. It just depends on what you call them, and how they act. Like, all of a sudden you just start calling them that, "Hey, brother what's up?" It just comes out of your mouth.

Tuck, serving her second prison term, describes the nature of her prison family:

Well, let's see, I have a mom, I have a dad, a brother, a sister, a sister-in-law. I have a little nephew, I have aunties, I have cousins, that is very rare. Mostly you have mothers, aunts, brothers, and sisters. Now my wife would be my brother's sister-in-law. The family thing is just being close.

One of the most common forms of "familying" is the "kid" and the mom or the dad. As Randi and Tracy describe it:

RANDI: A kid is someone you take care of and then her friend would be your "kid-in-law." Now this is my mom, even though she is younger than me and this is my girlfriend. She is Mom because she always picks me up off the ground when everybody else knocks me down and walks all over me—she has always picked me up and dusted me off and said okay.

TRACY: I am the "mom." I slap her on the butt and tell her to get back out there and deal with the real world again. Kids are different than friends partly because this one here doesn't have family [on the streets] and she needs to feel that closeness.

RANDI: I do have family but my family is real chaotic. I can't count on them.

TRACY: I am here for whatever she needs—be it consoling, comforting, food. Whatever she needs I am going to give it to her. She is just my kid—I feel protective of her. If somebody was to come to her and get in her face, I would be the first person to step in.

RANDI: Now I am also a mother of a youngster in here. And when I can't deal with her, then I will say here go to your grandmother (Tracy).

TRACY: Although I am younger than her, mentally I am not twenty-three. I grew up real fast, I did a lot of things that I should not have done and I lived a very dangerous life—to me, street smarts counts more for age. It is what you know and how you handle yourself—what you say and do compared to what you don't say and do. When Randi gets into fights, I will tell her to sit her ass down. Just sit down. No bitch in this penitentiary is worth three years of your time and you are not going to do anything. She may be worth ninety days of mine but she is not worth

three years of yours. It is nothing different here to take care of people older than me. She depends on me. I am her sanity. And most times, her insanity as well. When she needs to vent anger I can take it and give her back constructive criticism in the process. It is how you say it. I don't put her down but when she needs to be put in her place, I will do it. Just like she does to me. She will tell me, no, you are acting up, stop it, I will say what the fuck are you talking about and she will tell me.

Another woman listening to this conversation states that she does not have a prison family; instead, "I am close to one girl in here and then my roommates I am close to and that is it."

Divine, who is very well respected by the prison population, partly because she was formerly a lifer and "everybody knows what she has done," partly because she has a very prestigious job, and partly because she "takes many youngsters under her wing," is Mom to many people. But she also says that she was "Moms" to people on the streets:

> There are about five women here who called me Moms on the streets (and she names them). I would say that this is my play family. Almost everybody is involved in them one way or another. It could be just two people or a bunch. It is just like the family on the streets—you start depending on them. You treat them like family. You can tell them anything. Then there is the loose-knit family. That is just what you call each other, but you don't really care that much about each other. All families do not have women who play the male role—some based on couples, others on friendships. I think it is about half and half.

This long-termer, Birdy, is a member of a typical prison family. She has a steady partner, with whom she has had an ongoing relationship for eight years, and claims responsibility for four prison kids:

> I have four kids. Most of the time they are young, or act like a kid. They can wear my clothes. They can get [from me] whatever they need—cigarettes or whatever. I protect them if I like them. I won't let anything happen to them. Now in the past, I used to go to jail (Ad Seg) for my kids, if they were fighting, I would fight. But not anymore. Now I am thinking more about myself.

> My woman is the dad—she has the same obligations to the kids as I do. If a kid crosses me, then they are out. Like just try to get involved with my woman, or do something against me, then you are out—out with an ass-kicking.

Families have reciprocal social and material responsibilities. Tuck, serving a long term in the SHU, states that it is up to her wife to "make sure all my stuff gets packed right and that the police got all my stuff into R and R. They have to write me back here and keep in contact with me until I can get back out on the yard." When asked if she worries about her relationships surviving this separation, she answered:

> You have to block out all that when you are in this situation, because you will do very hard time. If I was doing thirty days, I would be stressed because I would know I'm getting out. Right now I'm in a situation where I don't know when I'm getting out, you know, it might be, I might be here another four months. So I cannot worry about something that is already happening now. You know, if she loves me, she will be there for me. You know, right now it's the time and place where I will find out for real if she is just with me when I've got it or just using me for sex, or a good time, or whatever.

The prison family replaces the "tips and cliques" (Irwin, 1980) in the male prison and may also overlap with the "homegirl" networks, loose friendship groups made up of friends and acquaintances from the community, county jail time, or prior prison sentences. This study found very little evidence of the racially and geographically based gangs that structure the male prison. While many of the younger women "claim" gang membership on the streets, these interviews found very little social support for typical gang membership inside CCWF. As discussed more completely later in this chapter, racial issues play some part in the culture and everyday life of the prison, but not to the extent found among male prisoners. There is significant evidence at CCWF that suggests prison families and emotional dyads can and do cross racial and ethnic lines.

Dyads

Same-sex relationships are a constant feature of women's prisons and have been the subject of academic research as well as more sensationalist speculation. Lesbian relationships are known as "homo-secting," in the prison argot. Interest in the sexual activity of female prisoners has shaped research into the female prison to a much greater extent than research in the male prison. This can be partially explained by attention in the outside world to the sexuality of females, traditional expectations of women in terms of sexual behavior, and the morally based theoretical explanations of female delinquency and criminality. Additional impetus for this focus, in contrast to male prison behavior, is that such same-sex behavior is more open, less sanctioned,

and more observable in the female prison population. From early descriptions in the classic literature to present observations, such behavior appears consensual and socially accepted by both participants and nonparticipants. Estimates of the proportion of women engaging in these relationships are unreliable at best. Some prisoners—and staff—argue that "everybody is involved," with conservative estimates ranging from 30 percent to 60 percent participation. Some women initially see such involvement as unnatural, but change their perspective over time. Other women steadfastly "don't play that shit." Zoom, in discussing the transition from being a heterosexual on the streets to becoming attracted to another woman in prison, develops these themes:

> It depends on who the other person is. Cause it is like that with me, it's like you don't want to make a conscious decision that I am going to be with that woman. And you think especially, not being gay, that is gross and I would never do that. Cause I was one of the people who said, "Ughh, two women? That is just not right." The person I met was a friend first. But in a close environment like this, it is a woman's bond. Women are very emotional and we build little families and what have you. And one thing leads to another. You know, it is not force. There is no rapes and all that shit they have in the movies. None of that is true in female prisons. In men's, yeah. But not here. If you are not gay when you come in, you cannot be gay when you leave. It is not something, a lifestyle that is forced on you. It is something that you make a choice.

Discussing her past same-sex involvement, she recalls:

> It was like the girl was irresistible. The girl was like cute. She is here now. She's a body builder. And she is really buff, you know, but she is not hard looking or manly. Like a lot of them are. They're like men . . . they walk like men. She has not forgotten the fact that she is a woman. She is still very feminine but she is big and that was a turn on to me. That relationship is over and has been for a long time. But we are the best of friends. And she will not let anybody get close to me or let me get involved in another relationship. She runs anybody off that acts like they like me. This is what I want because I do not want to be in that.

Many of the women interviewed claim to have avoided any sexual behavior, stating they could never feel "that way" about a woman. Still others claim a lesbian identity on the streets as well as in prison, while other "street" or "real" lesbians avoid any sexual or emotional entanglements while imprisoned.

For some women, the prison same-sex relationship is a truly romantic one; as one woman suggested, "Your eyes meet in a certain way." The authen-

ticity or sincerity (as well as the longevity) of these relationships varies tremendously. Some women, like Misti and J.C., have forged a long-standing relationship over twenty years, moving back and forth between the prison world and the outside society together. At the other end of the relationship continuum are relationships that are undertaken for purely material gain. Known as "canteen whores" or "box whores," these women are the gold-diggers of the prison, approaching a "well-taken-care-of" prisoner (often young and inexperienced) with offers of friendship. These exploitative relationships are described below.

A third form of relationship is the close tie, based on emotional attachments. Some of these relationships are based on gender identities and family structure and some are similar to mentoring roles. Jeanne, a young black woman who has done time both in the California Youth Authority and in adult prison, feels she has few close friends at CCWF:

> There are no homegirls here. You really do not have any friends here. Even your friends could turn on you here. But I have a best friend—her secrets are my secrets—she'll jump on someone if I was fighting, but even she could turn on me sometime. But I know I have to depend on myself and no one else. I know that I won't turn me in or tell on me.

As Randi suggests, the "dog" relationship is based more on equality and reciprocity, and is fundamentally characterized by its dependability:

> You can go from friend to friend, but you always have that one to fall back on . . . the one you always go back to. This is your dog. Other terms you might use would be kid, your partner, crime partner, bud, buddy, mom. If they are younger, you might say room poodle—ha, that is an old one, or pooch, your crumb snatcher. It is usually the younger inmates, but it depends on the situation.

Friends in this case perform the same function as those on the outside:

> You have people who just need someone to talk to. You have them that got all this time and they don't feel that they can talk to anybody. You have to come to them and let them know that they can talk to you about anything. I have to ask, "What is going on with you?" If I see you tripping, I will ask you, "What are you feeling?" That is the way we have to communicate.

But Marta cautions against becoming too dependent on these friendships:

You get hardened in this place; you get where you become tough so people don't walk all over you so you have to stand up for yourself. If you care about people, mostly they end up back stabbing you but there is people that can get along.

The close emotional relationships can evolve from several types of interaction. Occasionally, women may "know someone from streets" and further develop a friendship inside. Sometimes they may have "run in the same circles," or "done county time together." Zoom describes her close, nonsexual friendship with another long-termer:

We are really close, we are like sisters. Her and I lived the same lifestyle on the streets. Ran in the same circles but did not know it. We have even been in some of the same places at the same time. I tell her, "Suzy," I said, "you and I had to have crossed paths before, but because we didn't know each other, we never tripped (noticed) each other." I might have seen her and thought, " I wonder who that bitch is. She probably thinks she is fine." She has probably said the same thing about me because that is what you do.

Maybe we are close because we didn't know each other out there. I knew of her in county jail. We were there at the same time. The staff used to dog her and the inmates used to dog her and that would make me mad. I fought behind (because of) somebody picking on her. And I didn't even know her. It wasn't until prison that I knew her.

I know we will always be friends. She likes me. You know what they say, a friend is somebody who knows all about you and still likes you. She knows a lot of my bad. I have talked to her about a lot of things— not everything, but a lot of it. And she likes me anyway. She is still my friend. Same thing with her.

But in this environment, our friendship is conditional in this particular environment. With each other as well as other people here. You have to be on the same level, to be into the same things I am in here. You cannot be my friend and be using drugs and fighting and being off into that scene. I am not into that. It's like I tell the youngsters all the time. A friend is not somebody who tells you, "Come on, let's go get in trouble." That is not a friend.

Most people think my best friend is my girlfriend. We have been friends so long that many people have accused us of it. I used to have a girlfriend here but that is in the past.

There also exists a small minority of women who claim to be "gay on the streets." Some of these women state they remain faithful to their woman partners on the outside, some develop new relationships with new partners inside, and a few claim to be celibate while inside. A few are serving time with their partner. One woman who professes to be "gay on the street" explains that she stays away from entanglements inside the prison because "No bitch is worth ninety days," referring to the lost "good time" for rule infractions regarding sexual activity. Although some of the women interviewed in this study claimed to be "gay on the streets," this prior sexual orientation does not always translate into their relationships at CCWF. Morgan, who describes herself as an assertive lesbian on the streets, offers these observations on prison relationships:

> I learned to stay out of the mix—to not be involved with women emotionally. Now I care about me for the first time. My relationships on the street have been stable and loving. The relationships here are different from lesbian life on the streets. There is no gay life here—it is just fun and pleasure. It is playing, it's very promiscuous and based on what she can get me—501s (blue jeans), noodles, cigarettes. The "males" get stuff bought for them. The women are used to taking care of their man; even under conditions of abuse. If someone sees something that looks like a man, fits her image of a man, she is going to chase her down. Its much more obvious here than at CIW. These little boys here plant these things in their own minds. They dress like boys because that's what they think SHE wants. It is all a game, it's not real and they know it.

Laura, ending a five-year sentence, describes her relationship with a younger first-termer:

> It is a big game for some people, but I am Sally's best friend. She has never been in trouble before and I need to protect her. People will take advantage of her; they just might want her for canteen. Some people have girlfriends on each yard. They will try to control the girl and they will tell you, "Don't go out on the yard. I'll be out there with my other lady." Sally is different because she is not con-wise. She does not even know the prison rules and I have to be on her. She doesn't know that there are things you can write in your letters or say on the phone that can make you be under investigation. She has learned to be more careful in approaching people, in being kind. We are really more like sisters and I look after her.

> She told her family about me. Her dad went off (got mad) but her mom said okay. Her mom sent me money for Christmas. We plan to get together when we get out, but I can't get my hopes up about out there. She likes men and I don't.

Although a significant number of women in the prison seem to be involved in these same-sex relationships, there are many women at CCWF who "do not play," that is, become involved with another prisoner in a physically intimate relationship. Those not involved in these relationships can be divided into two groups: those who profess a general tolerance for such activities and those who are repulsed by them. These positions are flexible, like most things personal and emotional. As Birdy suggests, "When I first came here, I was really grossed out by the thought of two women being together. Everyone told me I would get over it and pretty soon come to be like them. Well, they were right." Vanessa, a young newcomer, describes flirting behavior:

They will tell you have such pretty eyes, such nice skin. And comment on the way you walk. I don't get as sick as I used to, but I don't understand how they can kiss each other, hold each other. I watched my roommates do each other. I saw them in the shower together and not just standing. We were locked in, and I had gone to the sink to wash my hands and you couldn't help but hear it. You're gonna look when you only see one person standing. And then, they made a game out of it, "Come on, let's go watch, let's go watch." And it was no big deal to them.

The officers try to prohibit it by walking up and down the hall, but they have someone standing in the room to watch and tell them. They have no shame. No, it was no big deal, one of the girls said, "You can watch, I don't care." And it was like, it didn't mean anything to them, it was no big deal.

They will try to share a bed. But sometimes like certain guards will come with flashlights. They don't catch a lot of things around here. So much goes on in here, and I think some of the staff like it.

Now there is a girl in 502, she's beautiful. I'm not one of those type of people who can't give a female a compliment. She is pretty, but she tried to talk to me, and like I'm not like that. She says, "I know but everyone else here is." So she figures with the two of us together we could alienate ourselves from everyone else.

Male roles

In prison as well as in the outside world, gender is a social construction, flexible in both appearance and behavior. The most extreme example of this flexibility is found in the "little boy" role. While not all assertive or aggressive women take on an outward male appearance, some women "become"

men, taking on male ways of walking, behaving, and looking. There also exists a feeling among some women that the male-identified female is "faking it" and using this persona to manipulate others.

Women who take on male roles are referred to by a variety of terms: "stud-broad," husband, butch, and little boy. Within these gradations of gender roles, there are several characteristics that serve to mark the prisoner taking on the range of male identifiers. Physical signs include clothes and hairstyle. Women adopting male identities and roles almost always wear pants and avoid the state-issue muumuus. When forced to wear a muumuu, these prisoners will make every effort to wear their blue jeans under the dress. Those adopting the "little boy" role tend to "sag" their pants, wearing their pants low on the hips, duplicating a popular "gang" style of dressing. They also may mimic the male habit of grabbing one's crotch. As this woman says, "I got a roommate now, she's grabbing down between her legs and to this day I don't know what she thinks she has down there. She's sitting there with her hand in her pants, just like a guy." Underwear is another key item of apparel that makes these gender distinctions. Women in the overt male role tend to wear men's boxer shorts (that may show when pants are worn low, like the current street fashion) and avoid bras where possible. Sports bras and male undershirts ("slingshots" in the male prison vernacular) are also part of this wardrobe. Those adopting the male posture also favor the hard work boots provided by the state, but other women wear them as well.

Hairstyles and jewelry may also denote identification with male roles. Extremely short hair, as close to shaved as possible, or shaved sides with long hair behind the ears and at the nape of the neck are common. Again, other styles, such as "punk" hairstyles, may also account for this display. Constance, a long-termer, offers this description:

> In my relationship, my wife is the wife. Here, the wife/wife thing is two aggressive femmes. Now I am not a femme, I am the aggressor. I am the butch and I was butch on the street. I am not a penitentiary lesbian. Here all the women play, just about all of them, but only a handful were gay on the streets. You can tell the difference—by the way they carry themselves, the way they dress, the way they talk. Even though we all wear the same stuff, you can still tell. If you wanted to look butch you would have to be yourself and not wear no makeup and maybe sag pants. You could even keep your hair, but you will have to take your big old earrings out your ears. You would be an aggressive femme if you kept your earrings. A butch is very hard core, no lipstick, no nails, no makeup, short hair. An aggressive femme wears her nails, her lipstick, her eyeliner—we called them mermaids on the streets.

Trixi unequivocally states:

> I like my girls to look like boys. I have had femmes (for partners) but I
> like them to wear clothes like boys if they are going to be with me. I see
> these girls who turn into boys once they get here. I call them trans-
> formers because they switch back and forth.

A second category of gender identifiers involves names. Women may
modify their first names, turning a feminine form, such as Kathleen, into the
male Charlie. Nicknames, quite common within both male and female prison
culture, may be used to denote maleness (such as Tuck and Chicago). Women
in the male role may prefer to use the initials of their last names as a form of
address that distances them from the female identifier. This woman describes
her views on "little boys" and her sexual orientation:

> Here, the "little boys" are desired because they look like men, so all the
> little girls are going to be chasing them. Truthfully, I don't know why
> they get chased. I am gay, I have been gay since I was fourteen. My
> mother knows about it; she doesn't like it very much. My brother really
> doesn't like it. He tried to break my legs. But as far as being in here, I
> try not to have an intimate relationship with anybody or have a real deep
> relationship with anybody, because they ends up to fights and then they
> are going to say, "I don't go home until next year, babe, why don't you
> go get a 115 and stay here with me?" Why? Why do you want me to stay
> here with you when I can do better for you out there? I don't understand.
> I have not had a relationship for a while. But I look at these girls and
> they fight. One day they fight and they go to jail for ten days, they get
> ninety days taken away, and then the next time you see them they are
> back together. And then it happens over and over again.

The complex web of relationships is fueled by both interaction and dis-
cussion of this interaction. Fran describes these dynamics:

> Here everybody knows everybody's business, why she's back here,
> what she's doin', who's tellin', who's doin', who's zoomin' who—you
> know, the homosexual stuff. Everything here revolves around—most
> things in here revolve around homosexuality. But here everything is a
> fantasy. You understand—it goes with the fantasy of being with your
> man. Say, if I'm not a homosexual when I came into the system, and I
> am a product of that system now. Girls come here and they look at dif-
> ferent women, and they see fragments of their man. And that's what
> they want.

Some women, observing this flexibility in gender, remark that women are confused, as a woman with a strong outside orientation and short sentence remarks:

> I think people here mistake loneliness for love. I had one roommate, she was involved with this girl, and you'd see her, her T-shirt would be all messy, her blue jeans would be pulled down and everything, and she was just a normal little boy. That same day that the girl left for Stockton, she was in a mirror putting on makeup, she rolled her hair, and her pants became tighter than mine. She completely changed.

Although the prison family includes a significant number of women in these flexible and informal webs, not all women take part in them. Same-gender relationships are not necessary to memberships in the families, although a core dyad—husband/wife or wife/wife—is typically at the center of the family. The prison family can also be based on a matrilineal structure. In such families, an older and definitely "prison-wise" woman takes the role of a "mom," with younger, or at least naive women taking on the roles of daughters, or in cases where the woman takes on a male identity, sons. As Zelda, a young black woman with a violent history, explains, these relationships are grounded in the sex role stereotyping of the wider society:

> You don't have to do all that mother and stuff. You don't have to be in a family to have a close relationship. I have a relationship here with another woman. You see, women in society are different. We're more emotional feminine—you know, all those things come into play more than a man. So men organize themselves around territory, fighting race stuff. And it comes from the way you are raised. What do we do to the boys that are coming up? We fight them, we don't want them to be sissies, punks, or whatever, so that the girls, you put them in dresses, and you make them feel, and you have them with a doll so they associate with them, so that's different.

She further explains that, even among women, "toughness" is part of learning how to survive in prison:

> Definitely. You would consider me tough if you look at my "C" file, because I have a lot of violence, a lot of assault, but I'm really not that violent. If you could see the reason [I did these things], the act and look at the reaction then you would know that I'm only dealing from an emotional stand because of something that happened with me and the girl. Maybe the girl I was involved with did something. Maybe I caught

her sleeping or kissing with somebody else and I set her on fire. So they still say I'm violent. Even though I was working on my emotion.

Janice offers a cynical perspective on the role of play families. She states quite plainly:

I think the play families are just bullshit. If I am with you, you are my woman. I think all that "daddy," "sissy," shit is just a way to get over. I think they just want to get next to my woman.

Marlene sees that flexibility in sexual orientation is a prison-based event:

The majority of the girls who come here, they are not gay. They see these girls that look like men, and they are going to say, well, I am going to try it with her because she looks like a man. She will do until she goes home and get a real man. That is how the majority of these women see it. Just to do it until it is time for them to go home.

When in conflict, these same-sex relationships are the source of much of the trouble that creates "the mix" among the women at CCWF. Jealousy seems to be at the base of many of the conflicts, as Blue muses:

I think I am always a little bit jealous. When me and Jeanie got to jail, we used to fight a lot. I used to wonder why we used to fight so much. I thought we should be just be friends. I came to terms after I came back from court and I found out Jeanie lied to me. And it hurt my feelings and then I just wanted to fight for a long time. For a while we didn't hang together. We're friends now. I wouldn't call her my dog no more. But we're friends, we're still close friends.

I would say about two-thirds of the girls here are involved with other girls. You can't tell by looking. Would you look at me and think I was? There's girls that get off that bus that are just like me, femmes. Pretty femmes. It's hard for me to find out sometimes. You can always tell the stud-broads but not the femmes. Sometimes you can because my sister is. And I just left her, we were in the same room together. Oh God, I haven't seen her in two years. But I never knew she was like that until I saw her getting off the Madera bus and she had her little girl and they both had their hair permed and she was all hanging all over her. I was like, "Get away from her! Move. Don't let her rub up against you!" She ignored me. I try to deal with it because I am imperfect but I mean, sometimes I just I can't deal with all of it.

The fear of same-sex advances was voiced by many of the women as they described their concerns over coming to prison. Throughout this study, the women and staff interviewed agreed that force was rarely used in recruiting individuals for relationships. The standard disclaimer "I don't play" or "I don't use" was sufficient declaration of one's desire to stay out of these arrangements. Evan, a young white woman, says she has never used those terms and that she prefers a stronger expression of her disapproval of these same-sex relationships:

> I never say "Hey, I don't play" but when I first started they said, "Just tell them you don't use and you don't play." Bitch, get away from me. And that's trying to be nice because I really don't like it, I mean it . . . they didn't make Adam and Eve for nothing. Now they will act like you are insulting them. Usually they will say, "What bitch, you think you're too good?" When they say something like that to me that becomes a fight.

Women involved in these intense dyads may feel the need to perform marriages, sanctifying their union. Like marriages "on the outside," these ceremonies take many forms, some small and intimate, others large social affairs. Jewel, a young woman, describes her marriage on the main yard of the prison:

> The motivation is love, honor, and obey. My wedding was nice and big and juicy. It was sweet. I am the husband. I cried during the whole thing. My wife is the wife. I am not a femme, I am the aggressor. I am the butch.

Sometimes these relationships cause trouble. Morgan, serving a SHU term for violence against her partner inside, sees that trouble can come from the relationships one develops inside the prison:

> You can only create a comfort zone for yourself by centering yourself around the things what makes you comfortable—your programming— and basically hibernate and basically you pick the people that you—you be very selective, very selective. You want to hang around with the duds, you know the uh—you know, the people that are only interested in going home. The people that are not interested in looking good in prison, having an old lady, selling dope, making money, slicking the cops, you know.

The importance of the family and the dyad relationship endures as the basis of prison culture for the women who are enmeshed in their prison life.

A significant minority of women at CCWF, however, do not participate in these social arrangements and maintain an identity that is not embedded in the prison culture. Members of this minority, made up of short-termers, middle-class women with little investment in a criminal identity, and those who have moved away from participation in the prison culture, may have little connection to "familying" and emotional relationships with other women.

Exploitative Relationships

Within this relationship structure, some women take on an exploitative role vis-à-vis other women. These women take on the male role for economic gain or emotional dominance in the prison community. In this world of material scarcity, populated by those who "have" (women who are "well-taken-care-of" by family or tricks and runners, those with hustles that create material comforts, and those with jobs) and those who "have not," opportunities for exploitative relationships among the women exist. Three general categories of exploitative relationships can be described. The first category typically begins with a nonpayment of a friendly loan of food or cigarettes, is less specific, and does not involve any ongoing emotional bond. Some women who carefully budget their resources act as a bank for others who may be waiting for a money order from home. Tory describes her role in the inmate economy:

> There are a couple of people out on the unit that I loan things to every single month. I am like a bank. They know they can come get it from me, and they pay me back every single month. The first month it was one pack of cigarettes, and then the second month I trusted them with two. And now it is up to six, with coffee. You hate asking for it. If you don't have to ask for it, that makes it even better. The best way is when they just come and give it to you. If you just shop and come right off and give it to you and say, "Here, this is what I owe you," the next time, nine times out of ten, you have it coming. Especially if you say, I am shopping, is there anything that you need? But if I have to hunt you down, you ain't got nothing coming from that day forward.

> If they give you excuses, you just have to tell them "Save it" or "I don't want to hear it." Then you start doubling on them. Then they get you your stuff. Everybody knows about "doubling"; it is an open rule. Sometimes they try to tell you that she says she doesn't owe me (the doubles), she only owes me two packs.

Some women avoid this informal loaning, and are seen by others as being selfish:

You know what everybody's got in their locker. You see them when they are shopping and they bring it into the room. If you ask them for something, and they tell you they don't have anything—that hurts more when you ask someone when you don't have and you'll say you'll return it and they won't give it because they are stingy, that hurts the most. You know they have it and that you will pay them back. That is when you want to smack someone.

But, outside friendship groups with their unspoken rules of reciprocity, loaned goods are often not repaid. Sissy, a newcomer trying to learn the prison ropes, describes this uneven exchange:

But wait, you have to draw a line between giving people things. Some of these girls have been burned too bad because they have given to other people and they never see it again. Some people will burn you. I don't care if it is your roommate or not. I loaned out. I got my box (from home) and five boxes of cigarettes. I loaned out three cartons the first three days and one girl still owes me one. And she won't even look at me—she puts her head right down and walks right by. I asked her for them and she said she doesn't have any. But she is smoking, her girlfriend and all her friends are smoking, and I can't have any cigarettes. That is why I draw the line. I don't have a problem with loaning to my roommates because I know where they all live. I know none of us are going anywhere.

Listening to this exchange, Tootie, a more savvy prisoner, adds:

But I told her not to loan things to people. When she told me she didn't get them back, I went over there and discussed it with the person too. I went over there and said, "Why didn't you pay her back?" She said, "Well, I didn't have it." And I said, "Huh, when I see zoos and wham whams (candy bars and the like)." No, you pay your bills first. We all try to warn people about loaning out unless they know what they are doing.

The second category of exploitative relationships can be seen as emotionally exploitative. These relationships are known by such terms as "box whore," "canteen whore," or "hoovers," which indicate a relationship undertaken solely for exploitative purposes. Although no one interviewed described herself as participating in the arrangement, many women described the situation as one in which an exploitative woman initiates a relationship with a woman who is somewhat naive and has significant material resources. In one

version of this arrangement, the exploitative relationship may take on the male role and have several relationships simultaneously. Much like the "gold-digger" on the street, these relationships are undertaken with the sole purpose of economic advantage. Stories are told about women who lose their outside support and their prison partner at the same time. This arrangement was described thusly:

> The relationships are very serious. We have over four thousand women in here, and then someone else comes along, it is tempting. It is hard to make a relationship work. If you are strong and sincere, then it will work. It is just like your man. If you really cared about that man, you wouldn't be looking nowhere. But a lot of these broads act like they are in a candy store. A lot of them are canteen "ho's" and box "ho's" and money ho's. You would want to be with her because she has lots of stuff. What is really sad is that these broads know that it is happening. These broads know that these people just want them for their canteen and they let it happen. They don't care, they still give them all their canteen. I guess just to have somebody. I really don't understand it. They know they are being used. Some of them is headhunters—you can pay them. They like to say, this is my woman. It is sad but true. You see the same thing on the street.

> You shop your $140 and she is standing there with you. But first, you have to go get your slip and ask your woman what she wants. "Baby, you tell me what you want and I will write it down." I am going to stand there with you and help you bring the groceries home. I am going to carry them in the house, and then we are going to divide this. And of course she gets more, because she is the aggressive and they eat more and they get what they want. That is okay, baby, you can have this. That is how it goes, man. And then you cook me something to eat.

The third category of exploitative relationship involves outright extortion. Usually carried out by a "toughie," this activity has no basis in any relationship. Instead, a woman with little social support in the prison, one who is thought to be "weak" or a "punk," may be pressured into surrendering her goods to another prisoner, either in a one-time confrontation or ongoing extortion. There was little evidence, in the interviews and observations, of any organized extortion or protection rings, like those sometimes found among male prisoners. Likewise, I did not observe any open prostitution as has been described among male prisoners. Ro, a woman serving a brief sentence for parole violation but with a long history of prison terms, describes this relationship:

After being in prison for so many years, you get to carry a reputation. You (learn you) can mess more with this person, you can't mess with that one. You can run over this one—take her fucking shit and make her look like shit, make her look like a punk bitch. But this one over here you can't mess with because she ain't going to let you punk her out like this one over here would. Like I walk up to a broad and say, "Hey motherfucker, I want that watch," and she gets all scared and I take it and say, "Thank you, you fucking punk bitch."

Or if I want those earrings, I would say, "Hey, I want those earrings." If she said no, I would take them anyways, that is just me. We would fight if you chose that. It doesn't matter if you don't want to give them to me. This is prison. What you want is not what you get. If you don't like the combination, then you should not come to prison.

Now if you wanted my earrings? Are you big enough to take them? It is a matter of if you are going to stand your ground. You can stand it verbally: like if I say, "Give me your earrings," and you say "I don't want to give you my earrings," and I say, "Give me an excuse," then you'd say, "Bitch, I don't owe you no excuse, I don't even know you." That is how you come off to me. Don't go, Ohh ok. You say, "Bitch I don't even know you. What the fuck you want my shit for? Go over there. I don't sell my shit, I buy it." That is what I tell them.

Race

A critical distinction between male and female prison culture lies in the degree to which race is emphasized. Among the women at CCWF, race is deemphasized in the everyday life of the prison and is not critical to prison culture. In contrast, contemporary descriptions of male prison culture suggest that both race and geographic identity are the basis for prison social organization, a social process that began in the 1960s and culminated in the formation of race/ethnicity-based prison gangs. Irwin (1980) traces the rise of the race-based gangs to the early days of the prisoner rights movement and the "Black Pride" and Chicano movements, describing the ways in which racial divisions shape the social order of the contemporary prison. In *Prisons in Turmoil*, Irwin (1980) details the levels of distrust and open hatred among black, brown, and white prisoners. Carroll (1974) uses the concept of "ordered segmentation" to describe the informal segregation among prisoners in a Rhode Island prison. The prison identity and social interaction of Chicano prisoners, according to Davidson (1974), are based almost exclusively on their ethnicity. Jacobs (1977) details the development of prison gangs in Illinois through the increased imprisonment of street gang members. More recently, Carroll

(1996) has argued that gang and other race-related violence has subsided in prisons nationwide.

Observations in this study agree with the sparse literature on race and ethnic relations among women prisoners. Carroll, in summarizing this literature, suggests that "from what is known, however, race relations appear to be devoid of the hostility and conflict found in the male prison" (Carroll, 1996:381). Citing the work of Giallombardo (1966), Carter (1973), and Kruttschnitt (1983), Carroll (1996) agrees that the basic social structure of families and dyads tend to be interracial. He suggests that racial tension in the women's prison is found primarily between staff and prisoners, rather than among prisoners themselves. For example, Kruttschnitt's 1983 study of race relations among women prisoners found that racial conflict was not a predominant aspect of prison culture among the women she studied in Minnesota.

At CCWF, race and ethnic issues form a subtext that mediates relations among the women and between the workers, but is not a primary element of prison social organization. Race and ethnicity, then, form one aspect of prison identity and social interaction, playing some role in the formation of prison culture. Unlike male prisons, where race is the primary basis for prison social order, race and ethnicity play a somewhat different role. Contradictory perspectives on race can be found in these three seemingly opposite statements. This young black woman suggests, "Women don't get involved in race or gangs. We think with the heart, we are sensitive to people as individuals, not what color they are." Birdy offers an opposing sentiment: "Race is important here. I try to get along, but if I thought I was in a room with a prejudiced person, I would do everything I could to be 'black'-boisterous, bodacious, act like a clown, go off (be wild). Whites here are prejudiced but afraid to show it." Still a third black woman adds that "race is not really an issue here, but if you get mad enough, then you will throw it in someone's face. It becomes something to use against them if you have to."

Like the women in Kruttschnitt's 1983 study, most of the women interviewed at CCWF claimed that race had little bearing on their day-to-day activities. Many claimed that the "ethnically balanced" rule, requiring a mixture of ethnicities in a given room or job assignment was a good idea, but often separated friends and forced women to live with "people we don't know." Ongoing observation of the common areas such as the dayroom, the yard, and the gym (prior to its conversion into dormitory living units) found little overt segregation. While watching television, sitting in conversation groups, or observing athletic events on the yard, the women prisoners mingled in mixed race groups, talking and kidding, with women of all races and ethnicities. Families and emotional dyads were also intermixed. Repeatedly,

women voiced a common perspective that race "doesn't really matter in here." Particularly telling was the formation of mixed groups that gathered during the many open-interview sessions of this study. Women of all ethnicities would gather together to participate in the rather freewheeling discussions that characterized these interviews. Blue, a white prisoner, reflects on the racial problems in previous eras:

> I was jumped by six white girls at CIW, because I hung around with blacks. I think there was more racial stuff in the eighties than now. Here, they are all together. You see homosexuals, black and white couples, Mexican and black, Mexican and white. It is not like over there, back in the eighties when I was there. I didn't understand why. But I let them do it; I wasn't going to tell on them because I knew that I'd get in more trouble. So I just let it go and then they put me in a room with a white girl. They called her "the crazy white girl" and she was into lightening bolts, white supreme power and all that. I thought, oh my God, it was terrible. I feel that everybody is a person; we are the same. But some people don't see it like that.

Tootie contrasts the attitude of women prisoners with that of male prisoners:

> We are not like the men, because we learn to live with each other. We communicate. It is not a racial thing in here. If it is a racial thing in here, we don't know nothing about it because it is not shown. Neither is it spoke upon. We all stick together. Like if the white people are down because one of the CO's is doing something against them, we stand for them. If we are down, they stand for us. It's called togetherness, it is teamwork. Now the men, they don't do that. They are hard heads.

A "prison-wise" lifer, Margaret, suggests that some of the tension found at CCWF is not necessarily based on ethnic or racial conflict, but instead on the differences in attachment to a code of behavior. This comment implies that living by "a code" is more important than race:

> A lot of people did not grow up around people of other races. A lot of people had codes on the street and they did not have to live with people unlike themselves, who don't follow your code. But I don't think it has to do with race. Now you have to live with people you would never talk to on the streets—especially baby-killers, child molesters, rats, and informants. The people who should be in protective custody are running around the general population.

Race, however, did not disappear in the lives of the women at CCWF. As a subtext, race and ethnic issues were likely to emerge during times of specific confrontations, such as interpersonal conflict or competition over a scare resource, or in cultural expressions (songs, movies, or slang) where racial content was brought out from its background. Elise, interviewed in SHU, suggests that race is only brought up when you want to make somebody really mad: "Then you can accuse them of being prejudiced and boy, does the fur fly." Vanessa, an upper-middle-class woman of mixed heritage with an white-collar offense, talks about interpersonal conflicts as they reflect the difficulties and complexities of race in this environment:

> I don't think I am prejudiced. It's just that I wasn't brought up around a lot of things, like I went to an all-girls school and I think there maybe was one or two other black girls there, but both of my best friends were mixed, they're all mulatto, that's always how it's been. Here, they tell me I don't know what I am. And like in jail, I hung around with a Mexican girl. The black girls asked me why I was buying so much stuff in the canteen. I said I got homegirls here. I want to make sure they have things, cause I knew that they didn't have the money and that type of stuff. I think my homegirls are people I knew from the county jail. So I make sure that they have their coffee and sugar and things like that. And this girl she says, "Those aren't your homegirls, your homegirls are me," and she pointed to her hand [indicating her skin color].
>
> And I said, "No, those are my homegirls." Cause there is this Mexican girl who helped when I came into county. I had nothing, they had just shopped. She had nothing but people had sent her care packages and she turned around and gave it to me. And they are my homegirls, not because they are white, or because they are Mexican, but because they accept me. And they will accept me before my so-called kind will. I mean, you'll be on the streets and a white girl will say, "That's a beautiful outfit. Where did you get it?" I will say the name of the store and a black girl will say, "Uhh—it would look better on me than it would on you." And, your own kind, so to speak, will bring you down before anyone else will. And that's the truth about how it is.

Conflict over some types of resources is a second area where racial issues emerge. Some minority prisoners felt that jobs were unfairly distributed in the prison. This black woman, Chicago, feels that the best jobs, those in Prison Industries, are not evenly distributed:

> It is white people that get those jobs. There are no blacks at all. Everything is supposed to be (racially balanced), two blacks , two Mexicans,

but you have some rooms that are all black or all white. Those white girls say, "Oog, she got to get out of my room." Some of these white girls are KKK and won't room with blacks.

It is just the opposite of men's prisons. They are segregated but here they want us balanced. The white girls get the good jobs. There are not that many jobs in Prison Industry and the white girls get them. That is the only job that you can live off, if you don't have a runner. You can make about $100, $120 a month.

As the fieldwork progressed, CCWF experienced the overwhelming crowding that characterizes female institutions throughout the country. In 1991, the beginning of the investigation, the prison population was less than two thousand. In the summer of 1995, the population at CCWF reached over four thousand. This doubling of the population, without any appreciable increase in physical space, staffing, or other resources, may increase racial divisions among the women at CCWF. Some women felt that racial tension was present at CCWF, unlike other prisons.

They segregate you at Stockton. Right? You are housed with your own race. Here there is a lot of tension behind prejudice—a lot of prejudice. They stick to their own. Everybody sticks to their own. When it comes down to it, there is a lot of friction.

Finally, cultural expressions constitute a third area of racial conflict. "Thunderbolts" and other white-oriented tattoos are quite common among male white inmates and denote allegiance to a white supremist ideology. Tattoos or other graphic "white power" symbols may provoke comment at CCWF. This young white woman, who claimed "not to be prejudiced," recounts this reaction to a letter with symbols indicating a white racial identification:

White people are peckerwoods, featherwoods. White girls are featherwoods. Women are featherwoods, men are peckerwoods. Well, the black people are Crips and Bloods and the Mexicans have the Mexican Mafia. It is the same thing. I have another roommate who is a white girl, she is a featherwood. So she got this thing in the mail from her pen pal that had peckerwood written in it. And this black girl wanted to look at her mail, which she had no business doing in the first place. So my black roommate said all that peckerwood stuff is KKK this, KKK that— so she made remarks three different times and it made me mad.

It is kind of touchy, so I asked her if she had a problem with it. Then, let's get it out in the open right here and right now. And she said,

"Yeah, I got a problem with it," and I said, "It is no different than you guys [who] got the Crips and the Bloods, the 'cuz' and all that, and the Mexicans have the Southern and the Northern. So we have the pecker-woods and featherwoods. There isn't no difference." Anyway, there was a little conflict there but she calmed down after I explained it to her. She was mad about it. But we talked about it. That is something you would never see in the men's prison. It wasn't easy but we didn't box about it. I brought it up. It is a touchy subject. Especially when you got two or three blacks in your room. I have three of them in my room. The other ones weren't tripping on it—just her. Just her, because she is prejudiced.

Cultural events, such as talent shows, music selection, television programs featuring a single style of music, or movies, may provide a second arena for racial and ethnic conflict. Because rap music is primarily identified with black street culture, some white women may publicly express their displeasure when it is played. Television programs that feature heavy metal or white dancers (such as "American Bandstand") may draw only a white audience in the dayroom. Spanish television programs or music selections may attract only Latinas or those who speak Spanish. While the weekend movie is typically a big event in the life of the unit, movies with narrow racial appeal may not draw an integrated crowd.

These observations also agree with Kruttschnitt's finding that racial conflict can originate in the attitude and behavior of staff, often more so than within the prisoner culture (Kruttschnitt, 1983:583). Chicago, a former gang-member, tells us:

The COs are more of a racial problem. They instigate a lot of it. They do it like this. Say, for instance, they see me and her (a white woman) talking. And one of the officers would pull her aside and tell her the other night I was talking about her. They are messy and they start fights.

Tory, a white woman listening to this comment, agrees:

Like she said, if one of the officers don't like somebody and they see them talking, they are going to get them back someway. They will call them aside and start telling them all kinds of shit and you will get all pissed off and go off on that person and end off in a big argument. Sometimes you realize it too late because they had already written you up for the fight. And you are sitting in 504 for racial misunderstandings, or engaging in a riot or racial noncommunication. You can get written up and have time taken away from you.

Race relations among prisoners and staff have received limited attention. There is some evidence in the studies of male prisons (Irwin, 1980; Carroll, 1974, Jacobs, 1977; Owen, 1988) that white staff exhibit prejudice toward minority prisoners and staff. Chicago, intensely identified with the values of prison culture, offers this observation:

> This place is more prejudiced, especially with the staff. I never saw such prejudice until I came here. As far as the white people staff, I think they are KKK. I have white friends [among the prisoners] but here the staff will call you niggers. They do it and get away with it. There is a lot of shit that goes on here that Sacramento does not know about. The prison is fucked up and the staff is fucked up. I am an ex-gang member, ma'am, and I don't know about those big words, all I know is the slang words and this place is fucked up.

> Like I said, babe, there is a lot of prejudice that goes on in here. Their attitudes, you can tell when a person doesn't want to speak to you because you are black. They are mean. And they just look at you like ogh, you are black and, I don't want to look at a nigger. I don't want to look at you. Or they will tell you to get up on the wall and be rough with you and kick open your legs open with their knees. Like they did me. . . . They said, "You fucking nigger, I ought to body slam you." I looked at him like he was crazy. The black officers don't like it, but they (the officers) back each other up. They are co-workers and they are going home and we are staying here—they are going home and they get paid. It is a part of the system; they can't front off each other. The black staff are in a no-win situation—the black staff know it is wrong.

While much of the male prison culture is organized around "tips and cliques" or racial and ethnic gangs (Irwin, 1980), the formal gang culture has yet to penetrate the fences of CCWF. The literature about young women and street gangs is also scarce. Campbell (1991) argues that gang membership is an attempt to maximize the limited options of the urban lower class. Chesney-Lind and Shelden (1992) describe social organizations of young women in their book, *Girls and Delinquency*, with Sanchez-Jankowski (1991) mentioning women only in terms of "property" and sexual objects. A fair number of the younger women interviewed for this study claimed gang membership on the streets, but almost all felt that "gang-banging" had little or no support in the family- and dyad-stratified world of CCWF. There was some evidence, in the form of "sagging pants" or subtly displayed colors among the women arriving at the prison, most often among women sent from the Los Angeles area, but even these minor displays disappeared with-

out any social support for this behavior. Patrice, a young woman who had served time at the California Youth Authority (CYA or YA), makes this point:

> In YA, there was Crips and Bloods, and North and South. Some (of the wards) have relatives in the EME (Mexican Mafia) or the NF (Nuestra Familia). There is really no gang-banging in CCWF. It is part of the childishness at YA. Ventura is close to LA (so that happens there). I am glad that it's not here. I would probably be into that because of my friends. There are cliques here but it's not a gang. I play both sides of the fence (to try to get along). People can get an attitude here if they don't like your friends.

Tabby, eighteen years old at the time of the interview, provides this compelling description of her life in the street gangs and offers an explanation for the lack of gangs at CCWF:

> The older people in prison are not into gangs. They did not grow up in the gang and they were not in it on the streets so there is no need for it in prison. Now I am not gang-banging. There is a difference between being a gang member and gang-banging. I can't gang-bang in here. I am not involved because I am here. It's like the older members. I will always represent the hood, they will always represent the hood even if they are not gang-banging. I will always represent our color. I am down for our color. It represents the people in the hood, the other Bloods that I will always stand up for.

> There is much more gang-banging in juvenile hall, in YA. The people are younger, fresh from the streets. They are also more local. It is easier to do time when you are gang-banging. It is just not necessary here . . . there is no reason to do it here. I don't know why, but the gangs have always been important in the male prisons.

> Gang-banging really doesn't happen in here. There are more coming; I see them on the yard. You can't flag your color here, but I recognize them. There are many more Crips than Bloods. 610 Crip gangs and only 90 Bloods, but we still stand for ours. I am going to be down for my set, no matter who jams me. The other day, I ran into a woman from the Crips, who said to me, "Oh, it's a slob." That is how you dis a Blood, call them a slob or a brand. You dis a Crip by calling them a crab. I told her that she must not know how to speak to someone pleasantly [and] that she must want to go to 504 (Ad Seg).

On the streets, I would have killed her for talking to me like that. I would have shot her in the head and walked away. But here, I know that I want to get out. She is not worth it. You don't have a gun in here and it takes so long to stab someone. Besides, why should I die for a place (Chowchilla) that isn't even on the map? There is really no reason to gang-bang here. I don't live in my hood [while I am here]. I am not going to die for room 27. I will not tolerate being disrespected. On the streets that will get you killed. But here, no. It is important for me to know how I will be remembered. I want to be buried with my rag. The hood is worth dying for, but how would it look if people said, [about me] she died for a place that isn't even on the map?

Another possible reason for the lack of gangs in the female prisons lies in the social power of the older prisoners, particularly those known as the Original Gangsters, or OGs. These women have the respect—and the reputation—that allows them to exist without constant personal challenges to their daily life. Acting as "elder stateswomen," the OGs do not tolerate the "ripping and running" or the rapacious behavior (Irwin, 1980) that characterizes prison gang activities. Instead, the former gang-member may scale down her activity, running hustles or otherwise engaging in the mix without the outward trappings of gang activities. Additionally, the family structure and the activities surrounding the mix may meet the survival needs met by the gangs on the street.

Staff

Zupan (1992) found that while men have historically worked in female institutions, there was a significant range in terms of the proportion of male workers to female prisoners, with California reporting that about 63 percent of its custody staff in female prisons were male. She found that the manner in which male officers were used in these facilities varied considerably (Zupan, 1992:200). In the majority of states (84%), male officers were assigned to posts inside housing units. Compare this "cross-gender" staffing to that of male prisons, where the presence of females in male correctional institutions has been a very recent occurrence (Owen, 1988; Zimmer, 1986). The relationships among male prisoners and staff (Irwin, 1980; Carroll, 1974; Jacobs, 1977; Owen, 1988) have been studied to some degree, with these relationships in women's prisons receiving very little research attention. Historical scholarship (Rafter, 1985; Freedman, 1981) details the oppressive and often sexually abusive nature of the relationship between male workers and female prisoners. Contemporary writers (e.g., Kurshan, 1992) suggest that more subtle forms of oppression, such as invasive searches and privacy violations, char-

acterize the modern relationship. This section, however, skims the surface of these relationships; further investigation is needed to more fully understand the dynamics of the prisoner–staff relationships in women's prisons. These relationships can be categorized into two general patterns: cooperative relationships and conflict relationships.

Cooperative relationships between prisoners and staff. Overall, fairly cooperative relations between prisoners and staff were found in this study. With notable exceptions, most women felt that the staff as a whole was not "too bad, even though you have some that are motherfuckers." Like the staff studied in my first book (Owen, 1988), relationships among the women and staff at CCWF can be seen in terms of the "intersections of interests." These relationships involve a recognition of the common goals shared by officers and prisoners: keeping the peace, avoiding violence, sharing information, and accomplishing the routine tasks of the workday (Owen, 1988:54). For the women intent on "programming," developing a liferound around constructive, structured activities, staff play a role facilitating these interests in several key ways. First, staff provide a measure of security and structure that allow the woman prisoner to "do her own time." Many women, particularly those not involved in the mix or other contraband activities, appreciate the role of staff in maintaining order and providing some measure of safety. Second, staff provide significant information, material resources, and access to desired activities or locations, such as passes, the phone call sign-up list, cleaning supplies, sanitary products, indigent supplies, and the like. In illustrating these relationships, many women agreed that having good rapport with the officers was important to staying out of trouble. As one woman commented, "I like to have a good rapport with the officers. I know I get in trouble and come to prison, but I don't get in trouble while in prison."

Teri states that good rapport comes from knowing officers a long time and having a job that puts you in a reciprocal relationship with officers:

> I have a very good rapport with Ms. S. I know her from CIW, and most of the lieutenants and some of the sergeants from CIW. I was always a clerk. You walk up to them and they know you and they will always say, "Hello, Teri, how are you today?" But sometimes it is, Teri, can you do this, Teri, I need this, Teri, could you help me?

In SHU and Ad Seg, relationships with staff are particularly important. As the women spend most of their time in their cells, the staff become their primary source of information, material items, and interaction. LaDonna, serving a SHU term, describes her relationship with staff in the lock-up units:

See, back here, the cops are your only source of information. You have to get everything, food, sheets everything from them. Now Ms. C—, she's the best one here, this one here. This lady right here. In all three of my shifts, this [officer] is my mama, I love her. I really do.

You learn to ask different officers for different things. You ask them for the Kotex, clothes if you need extra clothes, you ask them for basic state necessities. A lot of officers will not get up and get you nothin'. If you cuss one of them out you ain't got nothin' comin', period. Say, for instance, you cuss them out early in the morning, for some other reason. And maybe about an hour or two later, you ask them for something. Ain't going to get it cause they remember what you do to them two to three hours ago. For instance, her, she's a very compassionate lady but you don't disrespect her, you don't cuss at her cause she does not come at you like that. We have people that do that but Mrs. C. has never raised her voice at one of us, she has never made fun of us or nothin' like that. If she was mad, she would stop talking for two hours and that is worse.

Or she might not give you nothin' for two days, it depends on how bad you do her. And the majority of the time if a girl does her wrong or one of the staff who really loves all of us around here, another one is going to tell her, "Don't do her like that."

Most of the women shared the sentiment expressed in this comment: "Correctional Officers have feelings too. They are human and they react to the way you treat them." Women develop relationships with staff they deal with repeatedly, in either the housing units or work assignments. Housing unit staff, sometimes called "regular staff," develop relationships with the stable population of the general population units. Women get to know the staff and, in turn, the staff learn the nature of social order in their given unit. Routine activities such as count, mail distribution, cleanliness inspection, unit chores, and phone sign-up sheets structure the daily program of the units. Regular staff control the routine in a predictable and recognizable manner. New or temporary staff may jeopardize this predictability and contribute to a nonroutine day. As in prisons everywhere, the women learn the behavior of the officers and base their behavior on that understanding. This comment by Tuck describes this relationship:

Well, you just get to know them—they know you and you know them, you know what to do and you know how to act, you know, if you act with respect they treat you with respect. Period. It's not all bad. I mean, you're in here because you did it, for one. You're here because you let yourself here. They're not the ones who led you here. They're working

here. They're taking care of you. But if you treat them bad they won't
give you nothing. They ain't going to give you nothing if you cussing
at them and hollering, which is only human. You can't expect a person
to get something—so a lot of girls have a tendency to hold them respon-
sible for them being here. These people are not responsible for none of
us being here. They were here when we got here, and just taking care of
us. We take moods out on them, and a lot of times the staff might be in
a mood but you just overlook that, you know.

Many women report developing rapport with their work supervisors. As
described in previous sections, a satisfying program is often contingent on a
positive work assignment. The range of staff reputation and actions toward the
prisoners, like all prisons, is wide. Some officers "will console you, speak to
you, and maybe take you to the office and talk. An officer may call the Friends
Outside office with family problems, things they can't deal with." Other offi-
cers will

get real petty, call us bitches and things you wouldn't believe. Some of
the young officers are into their power, they stay in the bubble. You
know there are some officers that are personal with you, say, "Hi, how
are you this morning, here's your breakfast," but not everybody.

The majority of women who have learned to do their time with mini-
mum conflict recognize the need to develop mutual respect with the officers.
Valerie suggests:

To get respect in here, you have to give them respect. And some officers
are pretty good about that. There are some people in here that go off,
start cussing at you, or start cussing at the cops and shit like that. Of
course, the cop is going to treat you like shit. Yeah, and write you a 115.
Then if you be nice to them and don't give them no hassle and talk to
them with respect, they are pretty good about talking to you with
respect. They show you respect, you show them respect; they are nice,
no harassment.

Vanessa, a short-termer, agrees that respect is key to making one's time run
smoothly:

There's no reason to disrespect them and disrespect yourself. We all
know we have rules to follow and if we don't do them what happens.
But all this cursing them and saying that they're this and that, that's not
worth it.

This comment illustrates some of the contradictions inherent in the social interactions between officers and prisoners. As Sykes (1958) has noted, the daily interactions between staff and prisoners become both personal and distant at the same time. Caryn comments:

> Not everybody likes Mr. X, but I do. I like his attitude. He has a no-nonsense attitude, yes. When he's over there, in my opinion he does his job. He is military—cause I asked him, your father was either a cop or a military officer. He says, "Why do you say that?" I say, "Because of the way you are." He says, "Yes, my parents were strict, and yes you're right, but yours were too and look where you ended up, right?" Anyone else would have went off and got smart. I says, "Yeah, right, but I won't be back." I said, "And besides you're no different than I am." He says, "True, but I'm on one side and you're on the other side. And I hate inmates." I says, "I know you hate me so much that you're being nice to me, right?"

In the more secure housing units, interaction between staff and prisoner takes a less personal form, with steel doors interfering with normal conversation. At times, women prisoners will lose their tempers, shouting at both staff and other prisoners as communication as well as frustration.

Conflict relationships. As Tanya explains, some officers do not give respect to the prisoners:

> They figure, we are inmates, we are not supposed to have a lot coming, you know what I mean? There is a lot of them who are just plain assholes because they take their badge out of control, you have a couple of those. Some of the officers here are really typical assholes. You go to ask them a serious question concerning maybe your health. And they give you attitude—like they don't want to talk to you. They'll say, "It ain't my problem, it is your problem." They will tell us to go to the MTA and we can't go because we don't have a pass and they'll say, "I am not giving you a pass—go somewhere else." That kind of attitude. There is some of them that will not give you a pass. That causes an inmate to go off. Start yelling, have a bad attitude. Start cussing them out, all kind of stuff.

Women repeatedly talk of staff that "come to work in a bad mood and take it out on us." Some report that staff "like to give us a hard time and make the other staff laugh when they make us look like fools." This woman has learned not to react to these taunts:

You gotta learn to laugh it off and turn the other cheek and walk on cause you can get caught up in here cussing them out and get a 115 and things do add up and you'll never get out of here, you know. You just have to turn the other cheek and look the other way. Cause all it is like a little bullshit playin' around, stupid, you know what I'm saying?

A minority of women report that staff have called them inappropriate names, as this comment suggests: "Staff have called us bitches, (or) cunts. They will clown you in front of everyone just to make you look bad or to make their cop buddies laugh." Daisy makes the thoughtful remark that "it is easier for women to get bullied in here. If an officer raises his or her voice to you, some women are petrified. The fear from past abuse comes back and they are scared. Very scared." As the institution has gotten more and more crowded, there was a general consensus that

> the cops have gotten more petty. Now they pay attention to how many Kotex you have been given; whether you are out of bounds. A good cop should only worry when there is something critical. They should allow us to take Kotex without making us count.

Gender relations between male staff and female prisoners. At CCWF, about 70 percent of the correctional staff are male. When asked, many of the women report a preference for male staff, for a variety of reasons. Some women suggested that they preferred male staff because they felt "safer" around them, voicing a conservative view that the "men can protect me more." With the exception of supervising and observing intimate activities, such as showering, physical searching, or dressing, some women said they preferred male staff because "it is more natural to take orders from a man." Other women indicated a preference for male staff due to the prisoner's ability to manipulate the men. As one woman stated, "We have learned to get around men with tears or flattery. None of that works on the female staff because they know it is bullshit." Indicating a preference for male officers, Cherry says:

> I would rather have all men. We've had female officers here, and sure the men don't understand like when you line up for supplies. They'll give you two tampons, or something like that, and they don't understand that you have to change those things. But we had a woman working here— and she did the same thing. And the female officers I've come across— they feel that they have to act mean like a male officer because they don't want to look like we are taking advantage of them because they are a woman. But it is easier to beat a man any day. The male facade is different from (a woman's). But the men are cool with me, I can laugh and talk with them, but the females I have come across, oh no.

While this study did not focus on the staff perspective, I had a few informal conversations with line staff about working with the female population. Some staff, male and female, stated strongly that they preferred working with males. The interpersonal life among the females and the constant questioning of their authority were cited as reasons for this preference. As one staff member said, "I can't deal with the sniveling that goes on here, the 'I broke up with my girlfriend' kind of thing. At least with the men they never bother you with that stuff." A male officer comments that "women inmates will ask you 'why' all day long. The word 'why' is out of their mouth before you even answer their question." Most staff acknowledged the minimal physical threat of the job, particularly in contrast with the more dangerous male prisons. As this male officer states:

> There is no physical danger for staff here, not even in the Seg unit. The danger here is getting manipulated. The men will try to game you but will give up. Women will continue over a much longer time; they are more patient, will work on you a little bit at a time—this will get you walked out of the door. There is also the problem of sexual manipulation here. Females have natural resistance to seduction—males do not and it can get you into trouble here.

Many women felt that male officers particularly had difficulty with the same-sex relationships among the women prisoners:

> [For the male staff], it is like a slap to their ego that you are with another woman. So they are really nit-picky with the homosexual women in here. Their little ego is bruised. How dare you want a woman instead of a man! Then you have some who say, "Hey, that is your lifestyle. As long as you don't disrespect me and rub it in my face and all that, I don't trip." No matter where you are, it is not what you do, it is how you do it. Cause a lot of staff have no idea that I have ever been in a relationship. It is not their business and I keep it that way.

At CCWF, there was no indication of forced abuse by officers and very little discussion among the women about coerced or consensual relationships among staff and prisoners. Rosita, a very young prisoner, offered this comment:

> A sergeant had intercourse with me when I was in juvenile jail. Here they might talk nasty to you—a cop will tell you to suck my dick, but I haven't seen much sex between cops and the girls here. In other prisons, you exchange sex for bringing in anything you want.

Women acknowledged that the opportunity to develop sexual relations was always present, as this long-termer suggested: "I have had ample chances to mess with the officers and the free world staff, but I have lost my taste for men."

Zoom offers further description:

> I've had male staff come on to me. I have had the opportunity to go all the way but no. Cause it is not worth it in the long run. You see people who went all the way and what it cost them. It costs them their job and you wind up in SHU. Staff get fired and walked off the yard for inmate overfamiliarization as they call it. In the end, it is just not worth it.

As part of their general concern for privacy, the presence of male officers caused problems in specific areas, such as showering in the reception unit areas. The showers in the two-tiered buildings afforded less privacy than in the general population-style housing units. Some women saw potential problems in showering in these units:

> If you are short, the officers, you can be seen from the (officer's) bubble. It is degrading. Sometimes you get a shower peeker. I told the other girls to block the shower. Then the officer got an attitude. You could tell.

CONCLUSION

This chapter has described the three types of relationships women at CCWF develop and maintain throughout their incarceration. Agreeing with prior research, this study found that existing relationships with children and family outside the prison and emerging relationships with other women, often through parallel emotional connections, are the two cornerstones of prison life among women. The primacy of these personal relationships, keeping in touch with family and forging bonds with women inside, may sometimes compete for a woman's emotional energy and allegiance. Relationships with staff, however, appear to assume secondary importance for most of the women interviewed. Next, I describe the ways in which women develop and immerse themselves into the overlapping meaning worlds of the prison.

Chapter 6

The Mix:
The Culture of Imprisoned Women

Women sentenced to the Central California Women's Facility found many ways to adapt to their life in prison. The complex and diverse histories of the women incarcerated in this prison community produced a prison culture that is itself complex and diverse across numerous dimensions. These "axes of life" (Schrag, 1944) shape the group design as to how individual women live their own lives and how they live in relation to other women in this prison world.

Three critical areas of life were observed in this study: negotiating the prison world, which involves dimensions of "juice," respect, and reputation; styles of doing time, which include a commitment to the prison code; and one's involvement in trouble, hustles, conflicts, and drugs, known as "the mix" to the women at CCWF. These different dimensions of prison life are not embraced evenly by all members of the prison's population. In fact, they may not shape the liferound of any given prisoner. But taken together, these dimensions comprise the general prison culture among women, and thus shape action and meaning within the prison community.

These dimensions are informed by the liferound of the female prisoner as she seeks to find meaning and rhythm in her time in prison. Participation in prison culture, among the women studied, is dynamic, fluid, and often situational. A woman's participation is determined by a number of factors, including time spent in prison, previous imprisonment, her commitment to a deviant identity, and time left to serve. Immersion in the prison culture is also determined by one's pre-prison experience, one's relationship to time and place, and the range of personal relationships she develops in the prison community. These factors, in turn, shape daily life within the prison and lead to

differences in meaning structure, particularly in terms of the prison code of "do your own time." Defining culture as "a group design for living," this final chapter describes the ways a complex strata of women contribute to and participate in this culture.

NEGOTIATING THE PRISON WORLD

Entering the prison world, like any new experience, involves learning a unique set of strategies, behaviors, and meanings. Women negotiating this world are dependent on two key factors. First, access to information about prison and its culture through prior prison experience, having a relative or friend in prison, one's experience in jails, commitment to a deviant identity, and a woman's street culture provides useful indications of what she expects to find in prison. Second, interpersonal coping skills, cleverness, and an understanding of the prison bureaucracy also determine a woman's success in negotiating this new terrain. Women entering prison may or may not have the experiential background or knowledge necessary to interpret or predict their day-to-day life in confinement. Interestingly, both women who are street-smart or prison-smart and women who are organizationally smart do well in negotiating this world. The prison-smart woman has learned through experience how to manage the prison community's resources and members in a way that allows her to "do her own time." The organizationally smart woman, in contrast, is skilled at interpersonal relations, managing bureaucracies, and recognizing reciprocity in terms of "common courtesy." She also carves out a social existence that meets her needs and minimizes the deprivations of imprisonment.

Becoming Prison-Smart: Gaining Respect and Reputation

Through past incarcerations, continuing contact with the criminal justice system, and a commitment to knowing "what is happening," the prison-smart woman negotiates the prison world on her own terms. The prison-smart woman can turn this specialized knowledge to her advantage, cultivating relationships with both staff and other prisoners that allow her some measure of freedom and autonomy in her everyday life, operating narrowly within the prison's rules and regulations, but often outside their specific intent. Through "prison smarts," a woman builds a personal world in which her prison program, including living situation, job, and other activities, are relatively satisfying and devoid of the ongoing aggravation that prison life can bring. A successful prisoner stays out of the "the mix," maintains personal relationships that are constructive and unlikely to bring trouble, and creates a daily program

that meets her personal and material needs without drawing any negative attention to herself and her activities. Most lifers, once they have gone through their disruptive adjustment period, fit this profile, but other long-termers and those returning for subsequent terms have learned this lesson. Marlisse, a lifer, offers this observation:

> The prison world has changed since 1977 when I started my term. There are a lot more youngsters, indigent women and game-players that do not know how to do time. They are rude, loud, and cause more fights, more homo-secting. There is no longer any place to have solitude here. I used to be that obnoxious. In my first four or five years, I let all the bitterness and anger out. I took it out on the officers and my peers. I did not know the damage that it would do to me seventeen years later. Now I know how to play the game, how to format my time. I can manipulate staff to do what I want without them knowing about it.
>
> All I want is respect. I just want to do my time. I have my job, a list of rules for the room that says "no homosexuality in here, no drugs, and wash your hands after you go to the bathroom." It is that simple. I keep to myself—I used to have a girlfriend that was in the mix. No more. I know how to do my time, what I need to make it easy, and how to please myself. If I like you, and you need something, then I will tell you how to get it. But mostly I keep to myself.

One key aspect of "prison smarts" is the ability to "get things done." Some women attain a reputation for being able get things done. Other prisoners will come to her with questions and requests for advice because of this reputation. Like in male prisons, this person is known as having "juice," possessing information and influence that come through a job or relationships with authority figures. Juice, in both male and female prisons, is the ability to get things done, often circumventing the rules or avoiding the delays experienced by the "nobody" or the "nondescript." The prisoner with juice knows what is happening and how to make it happen, whether the need is legitimate or illegitimate. Randi is well known as someone who can get things done. During one evening in the unit, I observed a young woman who was very tentative and hesitant, possibly somewhat confused, approach Randi with a medical problem. She did not think that she could ask the officer for help herself. Asking Randi to intercede on her behalf, she said, "I don't know who to ask or what to say and no one else will help me." Randi considered the problem, approached the sergeant on duty and, in minutes, the woman in need was out the door to the medical staff. Randi explains her juice comes from working for the yard sergeant: "He knows me and is willing to give me a break or some-

one else if I ask it. Now if I need something, and it is serious enough, I can go to them, and tell them 'I need this now, it is important' and I have got it." Having such relationships and influence did not appear to be disdained by the other women, unlike Sykes's (1958) "centerman," who was seen as more staff-identified than prisoner-identified.

Divine, ending a three-year sentence for cocaine sales, also has juice. She describes her ability to get things done and the advantages she has over other prisoners in getting paperwork (chronos) signed prior to her release:

> If I was just an ordinary person on the yard crew, it would take me three months to get all these chronos cleared—now I can get it done the next day. What if I did not have this access? Here I can walk around the corner and get it done. Staff will sign things for me because they know me. I can talk to the staff, especially the COs.

Critical aspects of "prison smarts" are respect and reputation. The notion of respect is one of the few values held in common with the male prison culture. Also found on the street, the idea of respect, and its opposite, disrespect, shape interaction as well as reaction across most prison communities. However common, respect is a difficult concept to define. In Sykes's 1958 view, the "right guy" is the archetype of respect. He earns this respect by adhering to the prison code and making inmate interests a priority in all relationships. Respect is the cornerstone of doing time. Irwin (1980) argues that the prison code may never have truly represented "right guy" ideals and may have diminished significantly as correction's philosophy shifted from punishment to rehabilitation. In an essay of the contemporary prison code, Renaud (1995) wonders if an ideal form ever existed. In the female prison, the prison code has always been more fluid and flexible, based more on interpersonal relationships than abstract principles (Ward & Kassebaum, 1965). Still, some vestiges of the code, particularly applicable to respect and reputation, remain in the daily life of the female prison.

Respect appears to be based on personal behavior and known history, typically in terms of offense and interaction with staff and prisoners alike. Respect can also be gained through positive as well as negative means. Being able to stand your ground and maintain a positive reputation in dealing with other prisoners seems to be a key to respect in the women's prison. This group interview illustrates some of the critical aspects of respect among the women at CCWF:

TRACY: You respect others for different reasons. It really depends on what you are talking about. If you are talking about the drug scene, and you are holding the bag, you can get respect. If you are into being tough and aggressive, if you beat somebody's ass good enough you have respect.

RANDI: But that is only respect from some people. It totally depends on what you are into here. You can get respect from some people here if you are the bad little girl—the one that is always in trouble. Oh, they respect the hell out of you for that. That is scary. You cannot be good and be respected. You have to be bad.

TRACY: But who the hell wants that kind of respect, anyway?

One way to get respect is to earn a reputation for fairness in your dealings with other prisoners. This respect is cumulative. Randi tells why Divine is a highly respected "Original Gangster":

Divine is respected because she is a convict. She is not an inmate. She does what she can for us. Not because the cops tell her to. If she has something she can change for us in general, she will do it. Without even asking. If we go to her and ask for something, and she can do it, it is done. If you really need to see someone, and you ask Divine to deliver a message to them, she will do it. Because she is a convict.

The concept of reputation is directly related to that of respect. For women invested in the prison culture and lacking attachments to the outside world, reputation in the closed culture of the prison becomes a highly desired commodity. Status in the prison world can be conferred in a variety of ways. Parallel to the male prison culture, women take some pride in adhering to some form of the convict code. The need to be respected was clear among the women at CCWF, but not to the exaggerated extent found in male prison. Having a reputation, being known and being recognized, lifts an individual out of the faceless crowd and gives a woman an elevated prison identity. For those tied to the mix and its values, this type of reputation becomes a centerpiece to prison identity and survival. Of the women interviewed in this study, those most attached to the mix seemed to be the most concerned with this question of reputation and respect. For old-timers, their past behaviors, including earning the appellation "OG" is sufficient. Newcomers, on the other hand, may have to prove themselves in the subtle stratification system. As this repeat offender remarks, "I have many friends in prison but it isn't about being seen and being recognized anymore. It used to be important to be important, but I did not come here to be famous on the yard." Reputation, as in the free world, is based on one's actions but can also be based on public opinion. Randi suggests that reputation may be based on image as well as action:

I find that a lot of people when they get here have these images that they try to uphold. You know what I am saying. At a time, I had an image

that I was trying to uphold about three or four years ago, but I had to
drop that and stop trying to save my god damn face and not put it out
there. So right now I don't have a problem with being honest with noth-
ing, nothing that I do or say.

Tracy adds that the closeness of the prison world makes public opinion impor-
tant:

> A lot of times you do care. You think that what people say about you
> cannot hurt you. But it can. In confined spaces like this, someone puts
> you down, it can bring you to tears in a heart beat. Everything can hurt
> you here. And that is sad, because on the streets you can take just about
> everything and walk away. But you can't walk away in here. You have
> to take it and listen to what they have to say about you, even if it is not
> true.

Recognizing Reciprocity

"Learning the ropes" and the skills to apply this knowledge is especially
valuable in the prison. While much of this knowledge is context-specific and
derived from experience with the prison world, many women are able to
become skilled at managing the prison bureaucracy by relying on cleverness
and ability, without having a commitment to a prison identity. The more-edu-
cated women learn early on to apply skills obtained in their pre-prison life
through schooling, employment, experience, or intelligence. Women who
have clerical, organizational, computer, and additional work skills also gravi-
tate toward better jobs in the institution and become valued workers, thus
gaining juice. Women unattached to the deviant aspects of the prison world
have added value in these job situations. Once these women overcome the
shock of their incarceration, they learn that application of their middle-class
skills and values may go a long way in negotiating the prison environment, at
least that part controlled by conventional authority. The middle-class woman
also depends on the officers in negotiating the world, but in a way different
from having juice. The middle-class woman relies on officers' legitimate
authority and applies middle-class standards of social interaction to these
interchanges. Ellen, a newly arrived, college-educated woman, offers this
view:

> This is a new environment I am in and it will take a little time to get
> used to it. But I can go to Mrs. S or to Mr. C and the other COs if we
> have a problem. Or we can go to the sergeant. You have to adjust to the
> lifers because they have been in a long time and I am a newcomer com-

ing in. But I try not to listen to the women in here. The only ones I listen to are the officers. They are in charge of me, they are the ones taking care of me while I am here. I only trust the officers. I don't really listen to the inmates. I only listen to those in charge.

Some women don't understand that you have to go by their rules. I do. It doesn't make any sense to me (that) these women think they have more authority than the COs over them. The COs will tell you, if you are bitchy to me, then I will be bitchy to you. If you talk to me on an intelligent level, then I will talk to you on an intelligent level. The officers have never been disrespectful to me. The only time they are disrespectful is when people are disrespectful to them. You need to be courteous to them.

Both middle-class and prison-smart women rely on the social skills of courtesy and civility in their interactions with officers and staff. As Victoria, a lifer who has done fifteen years, says, "Why these young girls cuss out the staff and then expect them to lift a finger for them is beyond me."

Many women learn that getting along with officers is a key to negotiating the prison world. Recognizing that officers tend to reciprocate attitudes and behavior, Suzie stated:

To get respect in here, you have to give them respect. And he (staff) is pretty good about that. There are some people in here that go off, start cussing at you, or start cussing at the cops and shit like that. Of course, the cop is going to treat you like shit. Yeah, and write you a 115. Then if you be nice to them and don't give them no hassle and talk to them with respect, they are pretty good about talking to you with respect. It is simple: they show you respect, you show them respect; they are nice, no harassment.

Taking Someone Under Your Wing

Some newcomers learn to negotiate the prison world by being mentored by someone who "knows what is happening." Most of the OGs discuss the fact that "in the old days, someone would take you under their wing and tell you how to do time. Not anymore; these youngsters don't listen to anybody. I guess they have to learn the hard way." Other women develop nonromantic but close relationships with their roommates and feel that it is their responsibility to set them straight, as Tootie tells it:

Like when Marta moved into our room, I told her how it was and I took more to her and I just got real honest with Marta and ran things down

about me and told her things about certain people that she should know to open her eyes. She was nineteen years old. At the end of that, she started seeing the real for what it is. She still wants to go to the yard, and rip and run, but I know she would get tired of that. I tell her, "Why you got to go out to the yard every day?"

Divine gives her perspective on respect:

There are people here who are older and people who are younger. But I still have to earn respect. I just don't get automatic respect because I am forty-seven years old. I have to act like I am forty-seven years old. And act like I have some sense. If you act like an ignorant youngster, you get treated like an ignorant youngster. And there are youngsters that act like they are forty-seven. I did not know these things when I first started doing time. When I first started doing time, we had people who would take care of us. We had older people who had been in the system a while, who took you under their wing and we listened. Nowadays, these youngsters, they don't listen. But now you have people you don't even want to be bothered by telling them because they will come off at you (like you are) crazy. You try to avoid conflict wherever you can, because that is the best way to do your time, just avoid conflict. If I see somebody that is really acting stupid, wants to be loud and boisterous and act a fool, I stay out of their way. Nothing I can say to them is going to change that; they are going to have to learn the hard way. I can just look at people and tell how they are going to be. Most people you just leave alone.

Left to their own devices are women who do not possess the skills for negotiating a bureaucracy, the prison smarts to work the system, nor a "protector" who watches out for them. These women spend much of their day disorganized and frustrated at their inability to get anything done, or choose to "run the yard and stay in trouble." Rory, a woman with one more year to go on a three-year term, offers this advice to a newcomer:

The biggest thing that I will tell them is to keep to yourself. And to stay out of everybody else's mess. You have to do your own time. You came here alone and you will go home alone. The only way you are going to get home is to take care of yourself. You are number one. And a lot of people, especially youngsters in here, get involved with other bitches, the yard, or other mess and they are not thinking about themselves.

As another prisoner explained, "Some women are way out of their territory here; they need help from someone who knows what is happening." Due to

their lack of experience with the prison world, their lack of juice and overall lack of understanding of the way things work, and their overall inability to organize and develop a strategy for managing the bureaucracy, these women are likely to stumble through their first weeks or months in the prison, lacking the knowledge of the prison-smart woman, the know-how of the bureaucratic operator, or the advice, guidance, or protection of another prisoner.

STYLES OF DOING TIME

Allegiance to the prison code is stratified. The prison social order is based on the stage in one's prison career (youngsters and old-timers), commitment to convict or conventional identity, length of sentence, and level of commitment to prison culture. Styles of doing time are based partially on this stratification but, as Irwin and Cressey (1962) have argued, they are also based on dimensions of pre-prison experience. These styles are further dependent on the in-prison experience, related to the personal relationships previously described. As a woman learns to negotiate the prison culture, she is also exposed to a variety of styles of doing time. At CCWF, there was considerable evidence that these styles of doing time constituted elements of a career, with different behaviors and attitudes at the beginning, middle, and end of the prison term. In some sense, doing time is related to the day-to-day business of developing a program and settling into a satisfying routine. The construction of an approach to doing time is also dependent on the types of systems adopted to give shape and meaning to these activities. Descriptions of male prisons discuss these meaning systems in terms of argot roles, as well as prison culture. In the women's world, there are few static roles used in the everyday interaction—a fact also suggested by Ward and Kassebaum (1965).

Two of the most significant contributions to one's style of doing time are somewhat related: commitment to a deviant identity, particularly a criminal identity, and stage in one's criminal and prison career. This section discusses the "convict code" and the conflicts between old-timers and youngsters.

The Convict Code

Although the convict code among women is not nearly as important as that among men, prison culture is found in the female version of the convict code. Within the male code, described by Sykes and Messinger (1960) and others, the primary rules are "do your own time" and "protect the convict interest," with their implications for group solidarity. This code has carried over to the female prisons with some significant modifications. Although Ward and Kassebaum (1965) did not find a monolithic code that promoted

group cohesion, the women at CCWF use the ideal of the convict code in set-
ting and discussing standards of behavior. When asked to described the con-
vict code, the following terms were mentioned throughout the course of this
study:

> "Mind your own business."
> "The police is not your friend: stay out of their face."
> "If asked something (by staff), you do not tell."
> "Do not allow rat-packing—fight one on one only."
> "Take care of each other."

There was universal agreement among the old-timers, specifically the
OGs, that the code has changed. Victoria, a lifer in her late forties, suggested:

> You used to know that your back was covered. With all these young
> kids, these gang-bangers, there is less code now. But there is no support
> for gang behavior in prison. When the gangs first came, I thought, "This
> is my home and you are not going to come in here and ruin what we
> have done." These kids are so young, coming in with so much time.
> They have no upbringing from the streets, no values, no foundation to
> build on. They have no remembrance of anything. The kids are crude,
> rude, and loud. Sometimes you have to say to them: "What the fuck do
> you think you are doing?" And then the next thing you know you have
> a (prison) kid—I have gotten tired of taking someone under my wing
> and now I keep to myself.

This feeling of disapproval of the younger generation was held by many
women:

> There is a difference between the younger generation and the older gen-
> eration. These youngsters are rude, disrespectful, and inconsiderate.
> They have never been taught. Even when they get locked up, they are
> back on the yard, harder than before. They always say, "We [are] the
> babies here." Well, when I first came, I didn't even know how to act. So
> many youngsters come to prison and they think they are going "to kick
> it on the yard." Youngsters want to be noticed, to put their stuff out.
> They can be loud and obnoxious. I used to tell them (the rules, the
> code), like not to tell on nobody but I have given up doing that. Years
> ago, you just didn't tell; I was taught the old way. It's not like the old
> days. I learned from the old school, in the sixties. Then the convicts
> stuck together. If you went down, you just took it. You didn't bring
> nobody down with you. "Do your own time." That was the rule.

A few women have borrowed elements of the male code and avoid interaction with officers at all times. Toni, a forty-eight-year-old woman who has served almost twenty years, commented:

> I still go by the code. I won't have a position where I have to work next to an officer. Now people tell (inform to staff): they don't have common sense; they think they have street knowledge and don't realize that it is different than prison knowledge. The conflict here is age, not race like with the men. Most of the youngsters are gang-bangers. With the male prison gangs: a life or death situation, a power struggle. With women, it is an emotional struggle. Women are weaker, I guess.

Related to this idea is the distinction between "inmates" and "convicts." This repeat prisoner, Misti, offers the perspective of the old-time convict:

> It is how you carry yourself. A lot of women carry themselves like a bunch of wimps. There are a lot of inmates here, but you have to realize that there are a lot of convicts here too. I don't understand what an inmate is because I have never been an inmate. I have always been a straight-up convict. I don't give a fuck. You tell me what to do and I am not going to do it. The judge sent me here to do my time and that is all I am going to do for you guys. Yeah, I got your W number, I belong to the state, but I am telling you like this, I am coming here to do my time, I am not coming here to program, to do what you want me to do. My name is Misti and if you got anything else to ask me, ask me. That is just how I am. But a lot of other people, as an inmate, they will get all scared and stuff and run and tell the police this and that. You don't run to the police. If you have a problem, then you take it to your fellow inmate, or your fellow convict. Don't go to the police with your problem. I would take it to my family—the first place I would go—to my dad or to my brother.

One central aspect to the code and styles of doing time is a perspective on informing on other prisoners to the staff, also known as "telling," "ratting," or "snitching." While severely censored in male prison culture, contemporary female prison culture seems to tolerate a higher level of "telling" than in the past. Randi adds:

> Now we have a lot of stupid people in here—people who don't know the code. It used to be, you snitched, you got cut. It was strict about stealing and ratting. Now the "ho's" can rat all day long and no one will kick their ass. Before you would get a chance if you messed with my woman, but no chance for stealing or ratting. In '89, it started to change.

However, there was some support for certain types of informing, a finding that opposes any descriptions of male prison culture. Blue describes the ambivalence women feel over a strict interpretation of the "code":

> One of the main thing about the code is "don't snitch." It is good to tell for certain things, like if someone gets jumped or somebody got stabbed. But it is just little things that people tell. If you have a fight in your room, let it stay in your room. Why do you want it to get out so you can end up going to jail? Not too long ago, two people were doing some dope in my room and the cops came in. When the cops came in, the girl threw the outfit behind my locker but they knew (it wasn't mine) because in my record from day one, I am not into drugs. I don't use drugs on the street either.

In some ways, respect can mean adhering to the convict code, but it also concerns one's behavior toward other prisoners and staff. A respected prisoner does not cause trouble for other prisoners and is not "messy." Being messy generally involves gossip and less than truthful behavior, but it can be extreme and involve more serious trouble too.

A minor dimension of respect involves responding to physical challenges. While fights are not an everyday occurrence, being ready to defend yourself contributes to such a reputation, as Birdy describes:

> Respect means you can stand up for yourself. You can lose respect if you lose a fight in the open but you can fight in the room and lose without losing respect. If others call you a bitch, or test you out in the open. Being tested can be like "Come on, bitch, you want me, here I come."

Jackie, a younger woman with many years' experience in doing time, offers this perspective:

> Although I am young, I have experience with older people. I am in the old school. [We are] the OGs in society—we just look at these youngsters and shake our heads. Some people see prison as fun, as a vacation. People get homey in here; their life is here; they get scared when they get close to the gates. They are not willing to break the bad habits from the street that got them here.

And these habits from the streets become "the mix" at CCWF.

The Mix

The final dimension of prison culture found at CCWF is the amorphous concept of "the mix." For the vast majority of the women interviewed and

observed, "the mix" is generally something to be avoided. As Mindy tells us, "The mix is continuing the behavior that got you here in the first place." Few women claimed to be presently involved in the mix, but many stated previous involvement. Throughout the interviews these behaviors (and, in a sense, this state of mind) was an important dimension of prison life, something to be aware of and to be avoided. In giving their advice to newcomers, almost everyone interviewed suggested: "Stay out of the mix." In its briefest definition, the mix is any behavior that can bring trouble and conflict with staff and other prisoners. A primary feature of the mix is anything that can "have your days taken" (meaning reducing "good time" credits) or result in going to "jail" (SHU or Ad Seg). A variety of behaviors can put one in the mix. The most frequently mentioned issues were related to "homo-secting," involvement in drugs, fights, and "being messy," that is, being involved in conflict and trouble.

Staff are also aware of the trouble inherent in being in the mix. Randi recalls her wild days: "Staff told me I'd be alright when I got out of the mix; they said once you get into to the groove of things; you'll be alright." Being in the mix also involves "being known," in a negative sense. As Roxy, a newcomer serving time for violating her drug offense probation, says, "The mix can be anything that gets you in trouble and causes you to lose time. It can be the dope fiend mix, the homosexual mix, the fighting mix, and the 'working for the cops mix.'"

Most of the women interviewed stated that going home is their first priority, but suggested that some women are more at home in prison and do not seem to care if they "lose time." It appears that those involved in the mix do not act out of an outside orientation, instead devoting their time (and risking their days) for in-prison pursuits, such a drugs, girlfriends, and fighting. Lily, a middle-class woman serving time for embezzlement, remarks on those "in the mix":

> The majority of people who run things in here never had anything in their life—their mothers were whores. Not that I have anything against that. At least they are not stealing. I was fortunate that I had a structure in my life. These people have no values, no convictions. They run the street all their lives. Here they are big because they get $140 draw, and get a box every quarter. Where else in the world can that be the top of life? They have it going on. Then they parole, and it is not so good anymore, and on the streets, they are not running shit. So then they get a case, come back and hey, they are big daddy now (snaps fingers). Well, where else can a very large woman with bad skin and no teeth come and have a haircut and be daddy? And have all the little girls running after them?

Cherry offers that the term "the peoples" also describes those in the mix:

> You hear (the term) the peoples. You will say, "Well who, girl, who is doing all this?" And they will say, "The peoples." Just watch. There are a lot of them who are rolling [in material goods]. They got dope, gold and stuff; the earrings—one woman has seventeen pairs. They are not going to do nothing—they don't do the transactions, the fights, they don't hold the drugs. They are just going to receive everything. It happens in my room: they order others around—[they says things like] "Wash my clothes, wash my shoes off, light my cigarettes, make my coffee; go and get this from so and so. So and so, I doubled on them, I want you to go kick their ass and open their locker and take all their shit. You ain't going to do that for me?" It is so ugly. These are people who have never had love. It has been proven that negative attention is more acceptable than no attention. (Sarcastically) It is wonderful to be in prison and know these things exist.

Tabby adds that the mix is the only way to support yourself if you have no material support from the outside:

> The mix here is the loud types, selling drugs but the mix is really in you, you are like that on the streets. The homegirls know how things are and [tell you] I have to sell this. Some people don't have people on the streets to take care of them, to send them anything. You have to do something in here to survive, [whether it's] to sell dope or steal.

Tootie indicates that she has been on the edges of the mix in the past:

> People in the mix want to be seen. They care about being on the yard more than anything else. I have always been around the mix people, but ever since I got here, no way. I have done cool way down. And now I shoot out there every blue moon and holler at everybody but I shoot right back here. When I first got here, they told me to do this and that, and I said I don't want to go with you. I don't want your coat. I would rather freeze than get all caught up in that. When I ain't got, I will go without.

The mix also involves not minding your own business, violating a tenet of the old convict code:

> The girls that go out here and want to hang with their little groups, get involved in situations that they don't need to get involved in. They start

stuff. Some women are messy. Instead of letting things be, they like to make things keep going and going. Instead of just kicking back and don't cause yourself any problems, and just go on and do the program like you put yourself into. You need to get it out of the way so you can go home. I have a friend who was supposed to go home in November, and she just lost her date; now she don't know when she is supposed to go home. It is from being in the mix—being with the wrong crowd. Doing what she feels like doing and not programming. Me, I get the impression that people in the mix don't want to go home. That they have nothing to look forward to on the streets. They like being here with their buddies. Clowning and talking about people. Then problems start when women run to the deputy and tell them what is going on. It doesn't call for that.

There was a general consensus that the yard was the primary location for activities composing the mix. A good majority of the women in this study stated that they avoided the yard as much as possible. Observations over time and the survey responses support this contention. Even on beautiful spring days or evenings, the yard rarely has contained a significant proportion of women. At least two thousand of the women housed at CCWF would be eligible to go to the yard in the evenings or the weekends. Observations and interviews with both staff and prisoners suggest the yard rarely has more than four hundred women at any one time. Special events are an exception. Most women spend time in their units, particularly their rooms, avoiding the mix in the yard. Less than 5 percent of the women interviewed in the survey indicated that they spent their free time on the yard.

Judy, a middle-class disabled prisoner, agrees that many women, particularly newcomers, are leery about going to the yard:

I have never, ever been afraid, but I get along with all sorts of different people and I am that way out on the streets. I have worked in construction in the worst part of Sacramento and I have never been afraid. I agree that it is pretty safe here, but there are a lot of girls with low self-esteem who are afraid to leave the housing unit to go out to the rec area, where the library is. I guess they are afraid in here of what they call "in the mix," the drug culture—all that goes on in the yard so if a girl is trying to be good, trying to stay clean or whatever, trying to do her time, she is afraid to go out there. I think that is a shame to be afraid to go to the library. They look at me and think I am crazy. They ask me if I go out there alone and I say, of course. And I have taken young, twenty-year-old girls with me to the library, who were afraid to go out there and tell them, you will be okay with me, I promise. They afraid of the

unknown. They know the mix is going on out there. They are afraid that someone might start a fight out there and they might get involved in this fight and go to 504. I think they want to be good so they stay away from anything (that will get them in trouble). You do see that kind of fear in here.

As suggested above, the mix has various components. Three of these are discussed: the drug mix, the homosexual mix, and the fighting mix.

The Drug Mix. For many women, the drug mix is the embodiment of trouble. The risks involved in obtaining and using drugs, the expense of drug use in the inflated market of the prison, and the ultimate loss of time due to sanctions attached to this use are the damages that result from drug use in prison. The drug mix is "continuing the behavior that brought you here." The use of drugs and the risk attached to this use are also related to changes in the content of prisoner culture, as this group conversation suggests:

CANDY: When I was at CIW, I was in the mix. I used to deal when I worked in the mailroom. But then it was a whole different breed of convicts. You have convicts and inmates. I dealt for two and a half years and never got caught. I would not do that here. You can't.

TORY: You can't. The minute you get a load in, somebody is out there going, "Hey, I know she got drugs in on her visit."

VALERIE: They come out of visiting and twenty people rush to get to her. That is not too obvious. Or they will come in front of the unit and wait for you, holler down the hall for you. And you know certain po-lice are up on it and they still do it. They don't give a damn. Ms. R—she sees everybody who is loaded and if you slip up one minuscule of an inch, she will get you. This is her house as well as ours. She knows who is loaded and she is going to bust you. She doesn't have to say anything to you. And then we have other cops who don't give a shit. They know. It makes the rest of us get caught up in something that we don't want to get involved in.

The dynamics of the drug mix are described by Randi:

I am an addict. A garbage can addict. So for me, I can't really be around none of it. I don't want it in my face. I ain't well. But I can try my damn-dest to stay clean. On the 26th of this month, I will be clean a whole year. There was a time that I wouldn't mind going in with the rat race but when they started taking time, uuhuh, I got out. The pressure of being in the mix starts to get to you. Hell, that's what sent me to prison.

When you are in the mix, you are always in debt. You are always strung out, always scared, (worrying) is your money going to get here on time, am I going to get doubled on? You have to rely on friends (from the streets) for money. Once I needed $350 in street money, quick. I told them that I was strung out and I needed it.

I got strung out when I moved from one unit to another. I was more in check in the other unit—it was more relaxed, and then I moved down here, it was, like Oh my god, it was so tense and I got lassoed in and once I got in to it, they had me. It is like preying on old weaknesses. An old homegirl came down and told me, "I got this great shit; just try it for me and tell me how you like it so I can tell everybody how it is." I pushed it off and pushed it off and one day she caught me at an extremely weak moment and I said, "Fuck it, I don't care, give it here." I took it and I did it and it was like, YEAH, HEY NOW. It didn't take much at all to get back in the mix.

Then I was always on a constant hustle, like if I could move three or four bags, I could have two for me. It was a constant hustle to get everyone else to shoot up so I could have mine. And not get in debt. I would hit up all the dope fiends—all the dope fiends. I knew who they were. It feels good to be out of it now.

Tracy argues that some women begin to use drugs while in prison:

Anybody can get in the mix. You can get new inmates that have come in here and never used heroin on the streets. They hang around the wrong people and they are $300 to $400 in debt before they even know it. And then they start taking it out of your butt. You know what I mean? You don't have the money to pay them off and you can't get your people to send it in to you. Then you get your ass beat and you still have to pay it. Then they will double on you. You get a week before they double on you. You are paying $100 for an $8 piece on the street.

Money to buy drugs comes from a variety of places. Most women report that cash money is rarely used. Instead, the most common approach is that money is placed on the dealers' books by someone from the outside. This is known as "placing money on the wire." Women will also sell their jewelry, clothes, canteen, and the box (quarterly package). One woman appraised a small necklace I was wearing, saying, "You have got $300 right there," noting that if I was in the drug mix, I would "lose my jewelry in a heart beat."

Those involved in the mix generally traffic in merchandise as well as drugs. These women possess an inside orientation and seem to show little regard for returning to the streets, as Cherry observes:

The ones moving the merchandise around here are the ones who you got into debt in the first place. The rich and famous people around here (laughs). The big ballers are the people who came here doing two or three years and they are stuck with eight, nine, ten, twelve years because they can't stay out of the mix. They don't care enough about themselves to want to go home, to stay out of trouble here, that is what it is.

Some women mentioned the risk of AIDS as deterring their drug use, as Tootie offers:

I saw that Magic Johnson video at work. After I saw that, I felt sick to my stomach because of what they were saying in the video (about risk factors). I have not been using no protection, using no rubber every time when I was out there. My mama says, I would have known it by now, but I need to know myself. Here, you have people running around, using the same syringes, knowing they have it. You use the same syringe from one yard to another. There are not that many syringes here. A syringe will run you a hundred dollars. Cash money, or a hundred dollars' groceries, or cash to the books.

The drug mix, then, works against the features that create stability in one's life at CCWF. For women wanting to go home, drug use and its accompanying dangers become "not worth it."

The "homosexual mix." Most women, those involved in same-sex relationships and those not participating, agreed that the "homosexual mix" was a place of trouble. While drugs and fighting seem to make up a good proportion of the mix, some women see that having same-sex relationships makes up the "homosexual mix." This woman describes herself as an "assertive lesbian on the streets":

Most of the femmes are confused (about this) in here. They want that touch, that feeling. But girlfriends can get you in trouble. You have to be careful. It took me a long time to learn this. Now this place scares me. It used to be fun, a playground. No more. When I was involved with women, I used to beat them, and talk trash to them. In lesbian life you do it to get affection. I am still hurt about the way I treated them in the past. (I acknowledge that) I did all those things, my crimes, hurting my woman, but it is all over now. I have been evil.

But most of these women are used to being misused by a man. They don't understand anything but being treated bad. I think there is some

abuse in the homosexual culture on the streets. Now it is too hard to get sexually involved with someone in here—there is so much switching.

Lexi, a young black woman, details her stabbing by her intimate partner several years ago at NCWF:

I was stabbed by my roommate at NCWF. She was my homosexual part-ner and she started getting involved with heroin and I didn't use in there so I told her I was moving out. I tried to move out but the regular staff was on vacation—most of the regular staff can tell when there is going to be trouble. They are real observant. They are familiar with the inmates. They watch which ones are troublemakers, which ones are helpful. And they can tell by watching, even if you are not doing anything right then— your conversation, the way you carry yourself, if you respect staff, if you respect inmates. I had been on that unit for a year and a half and I had a good relationship with the staff. I still helped my staff—he never did no favors or nothing, he was nice, but just watched us. When this started to happen, one officer saw me start to withdraw; he noticed it, he picked it up. My roommate wanted me to be with her always. That staff asked me if I was having a problem. I knew he could tell. I wanted to tell him that I really was having a problem, but I didn't want to get a rat jacket. I was planning to move when Mr. S came back from vacation—I was looking for a way out of the situation. He said that if I was still having the prob-lem when he came back from vacation, then we would talk about it.

I told her I wanted to move, but she thought I was playing. I wanted to go home on my date and I didn't want to fight anybody. I was trying to get myself out of that situation. She was selling my stuff to pay for her dope. I had hoped to move that night. They told me I had to wait until tomorrow to move me. We starting fighting about 10 P.M.—I was yelling, "You have used me, you have taken advantage of my kindness," telling her she was a dirty bitch. In a way I loved her because she was a good person.

I think women's relations are intensified—to be a woman and to know what you want in a relationship and your life. Say you have a man, they run all over the place and do this and do that. You be really loving this person. I was real nice to her; it was like a man/woman relationship with me and her. I was nice to her, just the same way I would do my man. I would cook for her, clean the room. She was more of the aggressive type. A lot of women are not actually just gay. They go with girls that look like boys because they are accustomed to being with men, so they be with them.

I went to the room and we were yelling. We were throwing stuff around. I grabbed her and we started fighting. The scissors were in the room, the blade was 8 inches long. They were just there; we had taken them from the PIA laundry—it was not planned. I was beating her and she said, "I am going to stab you, you whore." The officers could hear us fighting but they could not open the door.

I was stabbed all over—she almost pierced my heart. She stabbed me seven times; she bit me. I blacked out. I didn't realize that I was stabbed until I stood up. I had blood all over me and then I stood up to catch my breath and I seen the blood on my gown. See, when you first get stabbed, the wound closes up and they were afraid there was internal bleeding. All I remember is her telling me, "I am going to stab you, ho."

I was angry and I was hurt that she could do this to me. She was telling me that she loved me after the stabbing. We were both taken to Ad Seg. It was my word against hers about who started it. There was no witnesses. I did thirty-one days in Ad Seg. She got one year in the SHU at CIW. The unit officer came to see me when I was in Ad Seg.

When I got out of Ad Seg, I was real scared; she (the perpetrator) had friends on the yard and a sister in law. I could not sleep, I wouldn't talk to nobody; I never knew who could be plotting against me. My roommates knew how hard it was on me. I was dreaming about the stabbing. The lieutenant called me in because my roommate told him that I was jumpy and not sleeping. It was a real emotion trip. I kept dreaming that she was stabbing at me. I didn't talk to nobody for almost two years. I didn't go into detail (and) discuss it with my family or anyone.

We are supposed to be separated, but I eventually ran into her in the clinic. She was talking to me, saying, "Hey, how have you been?" I was just looking at her; she acted like it didn't happen, then she said, "You hate me" and I said no, but I have asked the Lord to forgive us. My friends have given her a hard time. She also called me on the streets, asking me to forgive her. At one time, she was going to be transferred here, but my counselor interviewed me and told me that my C file said we were enemies. I told her I didn't have a problem with her and then she went to Avenal and not here. We were scared of seeing each other. But now I think that it would be okay if she were here. I have never felt that I should get her back. I just have never understood how she could do that to me. I did not testify against her, so there was no DA filing. She is out now, back with her husband and doing good. She has five kids. I didn't want to see anything bad happen to her.

I was really trying to sort out "why." Why did she have to stab me? She could have beat me up, hit me with anything, but why stab me? The seriousness of it started to get to me because she could have killed me. That made me realize that my daughter would have been by herself. That is where the bitterness came in.

The fighting mix and being messy. A third feature of the mix at CCWF overlaps both the drug mix and the "homosexual mix." Like Sykes's (1958) gorillas, few women take the role of enforcer, collecting drug debts, or "evening the score" for others. But conflict can exist apart from these activities as well. Conflict may be either verbal or physical. The wide majority of conflict is verbal: these conflicts are likely to be interpersonal, a disagreement over behavior, an interpretation of bad will, or a personality clash. Such conflicts are likely to arise in face-to-face interactions among roommates or workmates. Women in the "fighting mix" often use force or coercion as a way of bullying other prisoners. Related to the styles of doing time discussed earlier, some women feel they have a right to take advantage of a woman if she can't "stand for her own." The typical conflict relationship rarely accelerates into outright fighting and may often be "cooled out" through talking or intercession by a third party, typically a roommate, homegirl, or family member. Sometimes overlapping with the drug and homosexual mixes, the fighting mix may surface in enforcing the standards of a drug deal (collecting debts or retribution for failed promises to deliver) or intimates may engage in verbal conflict, arguing with each other.

Fighting, the physical form of conflict, occurs in several ways: "lovers' quarrels" accelerating beyond the verbal, drug deals or other form of contraband trade gone sour, insults magnified beyond the verbal sparring of everyday life at CCWF, or, most rare, assaults on strangers or acquaintances. Another form of the conflict mix is being "messy," usually interpreted as one who gossips or instigates conflicts among inmates. Also known as "he said, she said," gossiping and rumor-mongering leads to many hurt feelings and open conflicts within the prison population. "Cutting up" is another feature of being messy and involves making derogatory remarks about another woman, both behind her back and to her face. Mindy describes this process:

They can cut you up so bad, it makes the next person dislike you. Let's say us three are sitting here. I could tell you so much, cutting her up; cutting up means talking bad, talking negative, talking against her to you, that the next time you see her you would not even want to speak to her. Now, you wouldn't have any reason not to speak to her because you don't know her, but if you listen to what the next person told you, you may want to not speak to her, or fight her, or something harmful. When

there isn't any call for it. That's how the mix is up in here. You have to watch what kind of crowd you get in. The messy people that like a lot of "he say, she say." That likes to fight, likes to gang-bang—that have nothing better to do. They are institutionalized. There is some that likes to fight.

But there is some that are not messy. They mind their own business and they know there is a time to be a kid, time to act rowdy and a time to act civilized. Some just like to act rowdy and uncivilized, starting a lot of mess. They either love going to Ad Seg or they figure they won't get caught. They will fight you because you got a new pair of tennis shoes and they don't.

Jealousy here starts a lot of fights. Jealousy, gossip, people who don't care start a lot of mess. There is jealousy over jobs, pay slots, getting a box. You see somebody who don't get a box. They feel offended because they don't get one. You can get really nice stuff in your box. They get nice clothes that they never even thought about in the streets because then they were so much into drugs and doing crime that they ain't got time to think about looking halfway decent. And that envies a person. Especially if it is one of their homeys (who think) you are dressing (up) now. You think you are too good for us. But I guess when you put on clothes from the streets, you do feel different. But not that different. Or they will take you for granted. And want to be better than the other one. Just because they can run this person, they want to run you too. And if you don't do what they say, then they want to fight. It is a trip.

CONCLUSION

The majority of women at CCWF serve their sentences, survive the mix, and return to society, resuming their lives in the free community. Many return to circumstances not of their making, such as abuse and economic marginality, which re-create the conditions of their original offense. Others continue making self-destructive choices of drug use and other criminal behavior. While it is beyond the scope of this monograph to assess the impact of imprisonment on the future of women prisoners, many women wanted to comment on the immediacy of the impact of their imprisonment. Some women argued that prison was

> the best thing that ever happened to me. I know I would be dead if I hadn't been sent here. It has made me stop and think about what I was doing to myself and my kids.

Other women interviewed agreed: prison gave them a "time out" from their self-destructive behavior on the streets and provided an incentive not to return to their previous lives. As Blue suggests:

In prison, I found out who I was. Because on the streets I was trying to be somebody that I wasn't. While I was in prison, I was trying to fit in where I wasn't welcome, but I tried to make an impression, just to fit in the crowd. To be kicking back and laughing. And I found out that that wasn't really even true on the streets. I did try to impress somebody to be with them. If I didn't fit in, I didn't. It was like, in here, when I got here, seeing that I had to be around so many women and my roommates, I used to sit there and think. Then I started going to church. And I found out who I am and what I want to do in life. I know it is not easy, but can't nobody do it but you. You know, you can't change yourself unless you want to change. And I wanted to change.

I probably would have been dead if I had not come to prison. I probably would have ended up dead. I was living too fast and I was too young to be living that fast. I should have been already getting my degree from college, and I should have been getting my life together where I had my own apartment and my own job. And having a little car—not no fancy car or nothing—just something to get around in. But I didn't. I had it— but it wasn't because I had a job. It was because I had dirty money.

Last year when I made my decision that I was ready and I had come to know myself. I have been through a lot. The experiences I have been through, I don't want anyone else to go through because it is not good. I have been stabbed, I have been shot. I got raped when I was in the eighth grade. There are things that you can walk around once you know yourself.

I try to be calm. There are days where I get in arguments, but it does not end up to nothing. Like I tell them, if you want to sit down and talk to me, woman to woman, then we can. But if you want to stand here and argue with me because I learned that from years ago. It is not going to lead nowhere. And the first thing they say is, "Come on, let's fight. Let's go." And I will look at them and say, "No, I want to go home. I don't know what you want to do."

These convictions notwithstanding, it is important to emphasize the damage of imprisonment, as conveyed in these comments by Morgan, a long-termer serving both time for violence and a SHU term for continued violence inside.

Prison makes you very bitter. It makes you bitter, and you become dehumanized. I've been in prison since I was seventeen, I have been abandoned by my family members, and anyone else who knew me out there. Being in prison forces you to use everything that you have just to survive. From day to day, whatever, you know it's very difficult. It's difficult to show compassion, or to have it when you haven't been extended it.

Being in prison all this time, I didn't feel like I belonged, I didn't feel adequate enough to deal with the inadequacies I felt were inside. A person looking at me would not have known that.

But I am finally to a point that I am really in tune with myself. I detached myself as far as socializing, and being in crowds and different things that made me very uncomfortable or paranoid. I was aware of it, so I was able to fight it within myself. It's not very easy for people to do that. You get so caught up in a fantasy that it becomes real. You be caught up and put in a situation right again repeating the same thing. You can't break it cause you don't recognize it. And you know the bottom line is that this is no rehabilitation, no one comes here and gets rehabilitated. Society puts so much effort and money and energy into building institutions, and for what? I feel like mothers make the whole universe. And you know rapists, baby-killers, killers, serial killers, all come from somewhere and it starts in a child at a young age—and if you are neglected, if you are abandoned, different emotional trips as a child, and you grow up, then how are you a perpetrator when you were a victim?

I feel that, in society as a whole, women are subject to being made the victim. I was a victim that turned perpetrator but everybody has an instinct of survival for themselves. You understand what I'm sayin'. Because I was a woman in society, I was put in the situation where it was a do or die thing, and I did. And the courts don't understand it, the State of California, there's no self-defense laws, there's no laws that says, hey, you're a woman. Tough luck.

Yeah, I would consider myself just playin' the hand that I was dealt. And in life no one asks for the hand that they're given. Now that I'm older, I can change it or stay with the situation or complain about my present situation, or whatever, but you know I don't choose to do that, I choose to say, hey, okay, yeah, and so now it's time for me to take responsibility, I'm not a seventeen-year-old—you know I say hey, I recognize what has happened and I recognize what I want to happen in the future. It is up to me.

Yeah, it comes from reading, exploring, and whatever. Mainly, just a lot of reading. When they kept me back here (in SHU) for a period of time, for three years and then the two years, they kept me back here (in SHU), you know you have nothing but self. And it's easy for someone to try to take your dignity or whatever, take the things that are inside, to take from you, like they took my clothes, they took my hair products, they took my makeup, they took the things that I like about myself. The physical things that people see. They took those things.

But that's when I had to build on what was inside of me. And still grow and still let a person see that hey, you know I'm still the same person. You can't see the things that you would see if I was afforded my personal things but hey, I'm still alright. And I fought it, man, I fought it—just fighting it within, cause I knew what they were doing to me, I knew what they were trying to do. You know they came and they counseled me with medication, different psychiatric evaluations. And, no, I'm not going to let you do it, because I'm not going to take what I know is in me, and I know that I have a problem, of course, everyone in prison has a problem. But my problem is not more extreme; it's nothing that can not be dealt with at a young age. You can't throw your hands up at me and I'm only twenty-six. And so many people have. You know what I mean, and it just makes you fight even more.

Once a woman organizes her program and life in the prison, some women begin to think about their lives and what brought them to prison. Divine, ending her third term in prison, makes this statement:

See, when you come in here, you deal with exactly who you are. You become who you really are and you deal with feelings that you have not had to deal with in years. All this is coming out. You are gaining your weight back, you are getting pretty again. I was not pretty when I was out there. I think I am pretty now and you feel good about yourself. And then you start remembering all this shit that you did to all these people and it hurts. You become who you are. Right now I am Divine but my real name is Shelly. Out there I was Moms—the dope dealer. They come in here on A Yard and they look at me and they do not know who I really am because on the streets I did not look even remotely like this. I even acted different out there because I was under the influence. Not only of drugs, but of the lifestyle. You come in here and become who you really are.

Randi, listening to this heartfelt statement, echoes her sentiments:

Here you can become you. And you can get what is inside really out. And sometimes that is not really pretty. And for some people that can be very scary. You have to learn to be honest with yourself here. You can't hide behind a bunch of lies like maybe you did on the streets. It is not what you made (dealing). In here it can be about who you are and what you are if you are honest about yourself. It is the hardest thing in here and it is the step that hurts everybody the most. You have to realize what you have done to people and the things you have done wrong.

This study is an initial attempt to describe and understand the prison community as lived by the several thousand women who come to make a life in prison in contemporary society. As argued in the introduction, imprisonment in this state affects a disproportionate number of women of color and those marginalized by circumstances of family background, personal abuse, and destructive individual choice. Women in prison represent a very specific failure of conventional society—and public policy—to recognize the damage done to women through the oppression of patriarchy, economic marginalization, and the wider-reaching effects of such short-sighted and detrimental policies as the war on drugs and the overreliance on incarceration as social control. The story of the women at CCWF, however, is not hopeless. Many women have survived circumstances far more damaging than a prison term and most will continue to survive in the face of insurmountable odds. As Barbara Bloom and I have suggested elsewhere (Owen & Bloom, 1995b), there are in fact solutions to these problems that challenge assumptions about the criminality and disposability of these women. This description of the lives of women in prison then is offered as a starting point for constructive dialogue and public policy concerning the lives and experiences of women on their own terms.

Notes

1. The study of male prisons has a long history in sociology and criminology. Among these studies are Clemmer (1940), Sykes (1958), Sykes & Messinger (1960), Irwin & Cressey (1962), Carroll (1974), Davidson (1974), Irwin (1970, 1980), American Friends Service Committee (1971), Bowker (1977), Cloward (1960), Fogel (1975), Jacobs (1977), and Schrag (1944).

2. While the classic studies of women's prison use the term "homosexual relationship" in describing sexual relations among the women prisoners, I prefer the term "same-sex relationship." The term "homosexual," in my view, is often used in a pejorative way, especially in disciplinary reports, and in the contemporary prison carries negative connotations. Of course, I am not suggesting in any way that this negative connotation was implied by the authors of these classic studies. These same-sex relationships are fluid and varied among the women I studied, calling for a new term that was less narrow than the traditional "homosexual" tag. Many of the intimate relationships among the women at CCWF, I found, were not sexual, but rather emotionally intimate. I ask the reader's indulgence in substituting this new term.

3. Liebow (1993) describes the nature of a population quite similar to women in prison in his ethnography, *Tell Them Who I Am: The Lives of Homeless Women.* This story of homeless women in the Washington, D.C. area parallels the experience of women in prison, particularly in terms of their economic marginality and devaluation by the wider society. I must resist the temptation to quote liberally from Liebow because this work identifies themes common to the present study. Liebow's descriptions of the pathway to homelessness, the diversity of the population, and the mechanisms through which women in the shelters learn to accommodate their lives within the shelter are strikingly similar to that of women in prison.

4. There are many studies that discuss the roles abuse and marginality play in paving the pathway to imprisonment. A short list of these studies includes: Belknap

(1996); Bloom (1996); Dobash, Dobash, & Gutteridge (1986); Downs et al. (1992); Faith (1993); Fletcher, Dixon, & Moon (1993); Gilfus (1992); Heidensohn (1985); Mann (1995, 1993); Merlo & Pollock (1995); Rosenbaum (1993); and Simon & Landis (1991).

5. The study of the abuse of children has typically centered around girls. The study of male abuse—as both children and adults—has drawn little criminological attention in looking at connections between abuse and criminality. Widom's 1989 work improves on this inadequate attention.

6. Valley State Prison for Women (VSP), a "sister institution" opened next to CCWF in the spring of 1996, is expected to take some of the population pressures off CCWF. Even with the new prison coming on line, CCWF continues to make accommodations for the increasing numbers of prisoners entering the system.

7. A "115" is an institutional disciplinary infraction, with penalties based on the severity of the offense. Sanctions include loss of privileges, changes in housing assignment, and possible loss of "good time."

8. W numbers are the identification and registration designations used in California prisons. Women prisoners, except those sentenced to a civil commitment at CRC, receive an alpha-numeric identifier that begins with a W and is followed by a five-digit code. Men receive a similar number (which began with the letter A in the first days of the Department of Corrections). A numbers were used until the late 1960s, and B numbers were used through the 1970s. In the 1980s and through the 1990s, the system has now run up to G numbers, an indication of the huge increase in the prison population. Males and females sentenced to CRC receive N numbers. At CCWF, women are often identified by the "last two" of the identification number. For example, inmate Bricker, W-12345, would likely be announced "Bricker, 45." Among the men, long-termers with A numbers and even B numbers in the population are becoming rare. Among the women, a low W number indicates a long-termer.

9. This statement reflects an unusual acknowledgment of the irony of the use of the term "girl" to describe a population with an average age of thirty-two.

10. The term "fish" denotes a new prisoner, usually implying a naivete with prison life. The term is used regularly by male prisoners and can also be applied to new officers.

11. Only two housing units contain traditional prison cells at CCWF: the very first reception building (503) and the Ad Seg and SHU building (504). Except for the first few weeks in reception, only a very small minority of women do any time in a typical prison cell. The few women who systematically engage in misconduct, particularly violent behavior, will be housed in cells on A Yard.

Bibliography

Adler, Freda (1975). *Sisters in Crime: The Rise of the New Female Criminal*. New York: McGraw-Hill.

Alarid, Leanne, et al. (1994). "Understanding the Nature of Adult Female Criminality." Paper presented to the Academy of Criminal Justice Sciences, Chicago, March.

American Correctional Association (ACA) (1990). "The Female Offender: What Does the Future Hold?" Washington, DC: St. Mary's Press.

American Friends Service Committee (1971). *Struggle for Justice*. New York: Hill and Wang.

Anglin, M. D., & Y. Hser (1987). "Addicted Women and Crime." *Criminology, 25* (2), 359–394.

Applebome, Peter (1992). "US Prisons Challenged by Women behind Bars." *The New York Times*, National Report, November 30, A7.

Austin, James, Barbara Bloom, & Trish Donahue (1992). "Female Offenders in the Community: An Analysis of Innovative Strategies and Programs." Washington, DC: National Institute of Corrections.

Baskin, Deborah, Ira Sommers, & Jeffrey Fagan (1993). "The Political Economy of Female Violent Street Crime." *Fordham Law Journal, 20*, 401–417.

Baunach, Phyllis J. (1985). *Mothers in Prison*. New Brunswick, NJ: Transaction.

Belknap, Joanne (1996). *The Invisible Woman: Gender, Crime and Justice*. Belmont, CA: Wadsworth.

Berg, Bruce (1995). *Qualitative Research Methods for the Social Sciences* (2nd ed.). Needham Heights, MA: Allyn & Bacon.

Blackburn, Virginia (1993). "Drug Treatment and Prevention in Women's Prisons and on the Outside . . . What Works." Paper presented to the National Roundtable on Women's Prison, American University, Washington, DC, June.

Bloom, Barbara (1996). *Triple Jeopardy: Race, Class and Gender as Factors in Women's Imprisonment.* Ph.D. dissertation, Department of Sociology, University of California–Riverside.

————, Meda Chesney-Lind, & Barbara Owen (1994). *Women in California Prisons: Hidden Victims of the War on Drugs.* San Francisco: Center on Juvenile and Criminal Justice.

————, & David Steinhart (1993). *Why Punish the Children? A Reappraisal of the Children of Incarcerated Mothers in America.* San Francisco: National Council on Crime and Delinquency.

———— (1992). "Women Offenders: Issues, Concerns and Strategies." Paper presented to the Western Society of Criminology, San Diego, CA, February.

Blue Ribbon Commission on Inmate Population Management (1990). *Final Report.* Sacramento, CA: State of California.

Bottcher, Jean (1995). "Gender as Social Control: A Qualitative Study of Incarcerated Youths and Their Siblings in Greater Sacramento." *Justice Quarterly, 12* (1), 33–58.

———— (1991). "Dimensions of Gender among Lower-class Adolescents." Paper presented to the American Society of Criminology, San Francisco, November.

———— (1986). "Risky Lives: Female Versions of the Common Delinquent Life Pattern." Program Research and Review Division, California Youth Authority, Sacramento: State of California.

Bowker, Lee H. (1981a). *Women and Crime in America.* New York: Macmillan.

———— (1981b). "Gender Differences in Prisoner Subcultures." In Bowker, L., op. cit., pp. 409–419.

———— (1977). *Prisoner Subcultures.* Lexington, MA: Lexington Press.

Browne, Angela (1987a). "Assaults between Intimate Partners in the United States." Washington, DC : Testimony before the United States Senate, Committee of the Judiciary.

———— (1987b). *When Battered Women Kill.* New York: The Free Press.

Browne, D. C. (1989). "Incarcerated Mothers and Parenting." *Journal of Family Violence, 4* (2), 211–221.

Burawoy, Michael, et al. (1991). *Ethnography Unbound: Power and Resistance in the Modern Metropolis.* Berkeley: University of California Press.

Bureau of Justice Statistics (1992). "Women in Jail in 1989." Washington, DC: U.S. Government Printing Office.

———— (1991a). "Prisoners in 1990." Washington, DC: U.S. Government Printing Office.

———— (1991b). "Special Report: Women in Prison." Washington, DC: U.S. Government Printing Office.

———— (1990). "Prisoners in 1989." Washington, DC: U.S. Government Printing Office.

Burkhart, Kathryn W. (1973). *Women in Prison*. Garden City, NY: Doubleday.

California Department of Corrections (1995). "Characteristics of Felon New Admissions and Parole Violators Returned with a New Term." Offender Information Services Branch, State of California, Sacramento, CA, April.

———— (1996). "Characteristics of Population in California State Prisons by Institution." Offender Information Services Branch, State of California, Sacramento, CA, March.

———— (1990). "California Prisoners and Parolees." Offender Information Services Branch, State of California, Sacramento, CA.

Camp, George, & Camille Camp (1985). *Prison Gangs, Their Extent, Nature and Impact on Prisons*. Washington, DC: National Institute of Justice.

Campbell, Anne (1993). *Men, Women and Aggression*. New York: Basic Books.

———— (1991). *Girls in the Gang*. Cambridge, MA: Basil Blackwell.

Carlen, Pat (1994). "Why Study Women's Imprisonment or Anyone Else's?" *British Journal of Criminology*, 24, 131–140.

———— (1989). "Feminist Jurisprudence—or Women-wise Penology?" *Probation Journal, 36* (3), 110–114.

———— (1983). *Women's Imprisonment: A Study in Social Control*. London: Routledge & Kegan Paul.

Carp, Scarlett, & Linda Schade (1992). "Tailoring Facility Programming to Suit Female Offender Needs." *Corrections Today*, August, 152–159.

Carroll, Leo (1996). "Racial Conflict." In M. McShane & T. F. Williams (eds.), *Encyclopedia of American Corrections*. New York: Garland.

———— (1974). *Hacks, Blacks and Cons: Race Relations in Maximum Security Prison*. Lexington, MA: Lexington Press.

Carter, Barbara (1973). "Race, Sex and Gangs among Reform School Families." *Society*, 11, 36–43.

Cernovich, Stephen, & Peggy Giordano (1979). "Delinquency, Opportunity and Gender." *Journal of Criminal Law and Criminology.* 70, 141–151.

Chandler, Edna W. (1973). *Women in Prison.* New York: Bobbs-Merrill.

Chandler, Susan Meyers, & Gene Kassebaum (1992). "Drug-Dependence and Correctional Programming for Women in Prison." Paper presented to the American Society of Criminology, Phoenix, AZ, October.

Charmaz, Kathy (1983). "The Grounded Theory Method: An Explication and Interpretation." In Emerson, R., op. cit., pp. 109–126.

Chesney-Lind, Meda (1993). "Sentencing Women to Prison: Equality without Justice." Paper presented to the Seventh National Roundtable on Women in Prison, American University, Washington, DC, June.

———, & Randy Shelden (1992). *Girls and Delinquency.* Belmont, CA: Wadsworth.

——— (1992). "Rethinking Women's Imprisonment: A Critical Examination of Trends in Female Incarceration." Unpublished manuscript, University of Hawaii, April.

——— (1991). "Patriarchy, Prisons and Jails: A Critical Look at Trends in Women's Incarceration." *The Prison Journal,* 71 (1), 51–67.

——— (1986). "Women and Crime: The Female Offender." *Signs, 12* (1), 78–96.

———, & Noelie Rodriquez (1983). "Women under Lock and Key: A View from the Inside." *The Prison Journal, 63,* 47–65.

Clemmer, Donald (1940). *The Prison Community.* New York: Holt, Rinehart & Winston.

Cloward, Richard (1960). *Theoretical Studies in the Social Organization of the Prison.* New York: Social Science Research Council.

Colley, Ella, & Althea Taylor Camp (1992). "Creating Programs for Women Inmates." *Corrections Today,* April, 208–209.

Cook, Judith, & Mary M. Fonow (1990). "Knowledge and Women's Interest: Issues of Epistemology and Methodology in Feminist Sociological Research. In Nielson, J., op. cit., pp. 69–93.

Covey, Herbert, Scott Menard, & Robert Franzese (1992). "Female Gangs." In *Juvenile Gangs* (pp. 75–87). Springfield, IL: Charles C. Thomas.

Culbertson, R., & E. Fortune (1986). "Incarcerated Women: Self-concept and Argot Roles." *Journal of Offender Counseling, Services, and Rehabilitation, 10* (3), 25–49.

Currie, Elliot (1985). *Confronting Crime.* New York: Pantheon.

Daly, Kathleen (1994). *Gender, Crime and Punishment.* New Haven: Yale University Press.

———, & Meda Chesney-Lind (1988). "Feminism and Criminology." *Justice Quarterly, 5* (4), 497–535.

Datesman, Susan K., & Gloria L. Cales (1983). "I'm Still the Same Mommy: Maintaining the Mother/Child Relationship in Prison." *The Prison Journal, 63* (2), 142–154.

———, & Frank R. Scarpetti (1980). *Women, Crime and Justice.* New York: Oxford University Press.

Davidson, R. Theodore (1974). *Chicano Prisoners: The Key to San Quentin.* New York: Holt, Rinehart & Winston.

Decker, Scott, Richard Wright, Allison Redfern, & Dietrich Smith (1993). "A Woman's Place Is in the Home: Females and Residential Burglary." *Justice Quarterly, 10* (1), 143–155.

DeConstanzo, Elaine, & Helen Scholes (1988). "Women behind Bars: Their Numbers Increase." *Corrections Today, 50* (3), 104–108.

Dobash, Russell P., R. Emerson Dobash, & Sue Gutteridge (1986). *The Imprisonment of Women.* New York: Basil Blackwell.

Downs, William, Brenda Miller, Maria Testa, & Denise Panek (1992). "Long-term Effects of Parent-to-Child Violence for Women." *Journal of Interpersonal Violence, 7* (3), 365–382.

Easteal, Patricia W. (1993). "Overseas-Born Female Inmates in Australia: A Prison within a Prison." *Journal of Criminal Justice, 21*, 173–184.

Emerson, Robert (Ed.). (1983). *Contemporary Field Research: A Collection of Readings.* Boston: Little, Brown.

Erez, Edna (1992). "Dangerous Men, Evil Women: Gender and Parole Decision-making." *Justice Quarterly, 9* (1), 105–127.

Ewing, C. (1987). *Battered Women Who Kill.* Lexington, MA: Lexington Books.

Faith, Karlene (1993). *Unruly Women: The Politics of Confinement and Resistance.* Vancouver: Press Gang Publishers.

Faupel, Charles (1991). *Shooting Dope: Career Patterns of Hard-core Heroin Users.* Gainesville: University of Florida Press.

Federal Bureau of Prisons (1991). "Female Offenders: The June 7, 1991 Forum on Correctional Issues—A Record and Proceedings." Washington, DC: Federal Bureau of Prisons.

Feinman, Clarice (1986). *Women in the Criminal Justice System.* New York: Praeger.

——— (1983). "An Historical Overview of the Treatment of Incarcerated Women." *The Prison Journal, 63* (2), 12–25.

Felkenes, George (1994). "Female Gang Members: A Growing Issue for Policy Makers." Paper presented to the Western Society of Criminology, Berkeley, CA.

———, & Howard K. Becker (1993). "Comparison of Hispanic and Non-Hispanic Gang Members in Los Angeles County." Final Report. Claremont, CA: The Claremont Graduate School.

Fishman, Laura (1990). *Women at the Wall: A Study of Prisoners' Wives Doing Time on the Outside.* Albany: State University of New York Press.

Fletcher, Beverly, Linda Dixon Shaver, & Dreama Moon (Eds.). (1993). *Women Prisoners: A Forgotten Population.* Westport, CT: Praeger.

Flynn, Elizabeth Gurley (1963). *The Alderson Story: My Life as a Political Prisoner.* New York: International Publishers.

Fogel, David (1975). *". . . we are the living proof": The Justice Model of Corrections.* Cincinnati: Anderson.

Fonow, Mary Margaret, & Judith A. Cook (Eds.). (1990). *Beyond Methodology: Feminist Scholarship in Lived Research.* Bloomington: Indiana University Press.

Foster, T. W. (1975). "Make-believe Families: A Response of Women and Girls to the Deprivations of Imprisonment." *International Journal of Criminology and Penology,* 3, 71–78.

Fox, James (1984). "Women's Prison Policy, Prisoner Activism and the Impact of the Contemporary Feminist Movement." *The Prison Journal, 64* (1), 15–36.

Frake, Charles (1983). "Ethnography." In Emerson, R., op. cit., pp. 60–67.

Freedman, Estelle B. (1981). *Their Sisters' Keepers: Women's Prison Reform in America.* Ann Arbor: University of Michigan Press.

Freud Lowenstein, Andrea (1984). *This Place.* Boston: Pandora.

Garabedian, Peter (1963). "Social Roles and the Process of Socialization in the Prison Community." *Social Problems,* Fall, 140–153.

Geertz, Clifford (1983). "Thick Description: Toward an Interpretive Theory of Culture." In Emerson, R., op. cit., pp. 19–36.

Giallombardo, Rose (1966). *Society of Women: A Study of a Women's Prison.* New York: John Wiley & Sons.

Gilfus, Mary (1992). "From Victims to Survivors: Women's Routes of Entry and Immersion into Street Crime." *Women and Criminal Justice, 4* (1), 62–89.

——— (1988). *Seasoned by Violence/Tempered by Law: A Qualitative Study of Women and Crime.* Dissertation submitted to the Florence Heller School for Advanced Studies in Social Welfare, Brandeis University, Waltham, MA.

Giordano, Peggy, Sandra Kerbel, & Sandra Dudley (1981). "The Economics of Female Criminality." In Lee Bowker (Ed.), *Women and Crime in America* (pp. 65–81). New York: Macmillan.

Glaser, Barney, & Anslem Strauss (1967). *The Discovery of Grounded Theory.* Chicago: Aldine.

Glick, Ruth, & Virginia Neto (1977). *National Study of Women's Correctional Programs.* Washington, DC: U.S. Government Printing Office.

Goetting, Ann (1985). "Racism, Sexism and Ageism in the Prison Community." *Federal Probation, 49* (3), 10–22.

———, & Roy M. Howsen (1983). "Women in Prison: A Profile." *The Prison Journal, 63* (2), 27–46.

——— (1982). "Conjugal Association in Prison: Issues and Perspectives." *Crime and Delinquency, 28* (1), 52–71.

Goffman, Erving (1961). "On the Characteristics of Total Institutions: The Inmate World." In D. Cressey (Ed.), *The Prison: Studies in Institutional Organization and Change.* New York: Holt, Rinehart & Winston.

Gora, JoAnn Gennaro (1982). *The New Female Criminal: Empirical Reality or Social Myth?* New York: Praeger.

Greenfield, Lawrence, & Stephanie Minor-Harper (1991). "Women in Prison." Bureau of Justice Statistics, Special Report. Washington, DC: U.S. Department of Justice.

Greenhouse, Stephanie (1991). "Facts about Women and Crime." Rockville, MD: National Victims Resource Center/NCJRS.

Hairston, Creasie Finney (1989). "Men in Prison: Family Characteristics and Parenting Views." *Journal of Offender Counseling, Services, and Rehabilitation, 14* (1), 23–30.

——— (1988). "Family Ties and Imprisonment: Do They Influence Future Criminality?" *Federal Probation, 52* (1), 48–52.

Hannah-Moffat, Kelly (1995). "Feminine Fortresses: Women-centered Prisons?" *The Prison Journal, 75* (2), 135–164.

Hannum, T. E., F. H. Borgen, & R. M. Anderson (1978). "Self-concept Changes Associated with Incarceration in Female Prisoners." *Criminal Justice and Behavior, 5* (3), 271–279.

Harlow, Caroline Wolf (1993). "HIV in US Prisons and Jails." Bureau of Justice Statistics, Special Report. Washington, DC: U.S. Department of Justice.

Harper, Ida (1952). "The Role of the 'Finger' in a State Prison for Women." *Social Forces, 31,* 53–60.

Harris, Sara (1967). *Hellhole*. New York: E. P. Dutton.

Heffernan, Esther (1972). *Making It in Prison: The Square, the Cool, and the Life.* New York: John Wiley & Sons.

Heidensohn, Frances (1985). *Women and Crime: The Life of the Female Offender.* London: Macmillan.

Henriques, Zelma (1982). *Imprisoned Mothers and Their Children—A Description and Analytic Study*. Lantham, MD: University Press of America.

Hoffman-Bustamante, Dale (1973). "The Nature of Female Criminality." *Issues in Criminology, 8* (2), 117–156.

Holt, Norman, & Donald Miller (1972). *Exploration in Inmate–Family Relationships.* Report No. 46, Research Division, Department of Corrections, Sacramento, CA: State of California.

Huling, Tracy (1991a). "New York Groups Call on State Lawmakers to Release Women in Prison." Correctional Association of New York, press release, March 4.

———— (1991b). "Breaking the Silence." Correctional Association of New York, mimeo, March 4.

Human Rights Watch Project (1996). *All Too Familiar: Sexual Abuse of Women in U.S. State Prisons*. New York: Human Rights Watch.

Hunter, Susan (1984). "Issues and Challenges Facing Women's Prisons in the 1980's." *The Prison Journal, 64* (1), 129–135.

Immarigeon, Russ, & Meda Chesney-Lind (1992). *Women's Prisons: Overcrowded and Overused*. San Francisco: National Council on Crime and Delinquency.

Inciardi, James A., D. Lockwood, & A. Pottinger (1993). *Women and Crack-Cocaine.* New York: Macmillan.

Irwin, John, & James Austin (1994). *It's about Time: America's Imprisonment Binge.* Belmont, CA: Wadsworth.

———— (1980). *Prisons in Turmoil*. Boston: Little, Brown.

———— (1970). *The Felon*. Englewood Cliffs: Prentice Hall.

————, & Donald Cressey (1962). "Thieves, Convicts and Inmate Culture." *Social Problems, 10*, 142–155.

Jacobs, James (1977). *Stateville: The Penitentiary in Mass Society*. Chicago: University of Chicago Press.

Jensen, Gary, & Dorothy Jones (1976). "Perspectives on Inmate Culture: A Study of Women's Prison." *Social Forces, 54* (3) 45–56.

Johnson, John (1982). "Trust and Personal Involvement in Fieldwork." In Emerson, R., op. cit., pp. 203–215.

Kiser, George (1991). "Female Inmates and Their Families." *Federal Probation*, September, 56–63.

Klein, Dorie (1973). "The Etiology of Female Crime: A Review of the Literature." *Issues in Criminology*, 8 (2), 3–30.

Koban, L. A. (1983). "Parents in Prison: A Comparative Analysis of the Effects of Incarceration on the Families of Men and Women." *Research in Law, Deviance, and Social Control*, 5, 171–183.

Korn, Richard (1992). Excerpts from "A Report on the Effects on Confinement in the Lexington High Security Unit for Women." In W. Churchill & J. J. Vander Wall (Eds.), *Cages of Steel*, pp. 123–127. Washington, DC: Maisonneuve Press.

Kruttschnitt, Candace, & Sharon Krmpotich (1990). "Aggressive Behavior among Female Inmates: An Exploratory Study." *Justice Quarterly, 7* (2), 271–389.

———— (1983). "Race Relations and the Female Inmate." *Crime and Delinquency, 29*, 577–592.

———— (1981). "Prison Codes, Inmate Solidarity and Women: A Re-examination." In M. Warren (Ed.), *Comparing Male and Female Offenders* (pp. 123–141). Beverly Hills: Sage.

Kurshan, Nancy (1992). "Women and Imprisonment in the U.S." In W. Churchill & J. J. Vander Wall (Eds.), *Cages of Steel* (pp. 331–358). Washington, DC: Maisonneuve Press.

Lanier, Charles (1987). "Fathers in Prison: A Psychological Exploration." Paper presented to the American Society of Criminology, Montreal.

Larsen, James, & Joey Nelson (1984). "Women, Friendship, and Adaptation to Prison." *Journal of Criminal Justice, 12* (5), 601–615.

Lee, Cheoleon, & Barbara Bloom (1995). "Women Inmates and Disciplinary Infraction: A Causal Model." Paper presented to the Western Society of Criminology, San Diego, February.

Leger, Robert G. (1987). "Lesbianism among Women Prisoners: Participants and Non-participants." *Criminal Justice and Behavior, 14*, 463–479.

Lemon, Max (1992). *A Program Review of Selected Female Prison Traditional and Non-Traditional Vocational Training Programs.* Master's thesis, Department of Criminology, California State University, Fresno, CA.

Liebow, Elliott (1993). *Tell Them Who I Am: The Lives of Homeless Women.* New York: The Free Press.

Lindquist, Charles (1980). "Prison Discipline and the Female Offender." *Journal of Offender Counseling, Services, and Rehabilitation, 4,* 305–318.

Logan, Gloria (1992). "Family Ties Take Top Priority in Women's Visiting Program." *Corrections Today,* August, 160–161.

Lord, Elaine (1995). "A Prison Superintendent's Perspective on Women in Prison." *The Prison Journal, 75* (2), 257–269.

Maher, Lisa (1992). "Reconstructing the Female Criminal." *Southern California Review of Law and Women's Studies, 2* (1), 131–154.

Mahn, Susan (1994). "How Women Support a Crack Cocaine Habit." Paper presented to the Academy of Criminal Justice Sciences, Chicago, March.

—— (1984). "Imposition of Despair: An Ethnography of Women in Prison." *Justice Quarterly, 1* (30), 357–385.

Mann, Coramae Richey (1995). "Women of Color in the Criminal Justice System." In B. Price & N. Sokoloff (Eds.), *Women in the Criminal Justice System* (pp. 118–135). New York: McGraw-Hill.

—— (1993). *Unequal Justice: A Question of Color.* Bloomington: Indiana University Press.

—— (1984). *Female Crime and Delinquency.* Tuscaloosa: University of Alabama Press.

Marshall, Catherine, & Gretchen Rossman (1989). *Designing Qualitative Research.* Newbury Park: Sage.

McBurney, Katherine (1991). Project on Substance Abuse Program Needs for Female Offenders, Office of Substance Abuse Treatment, California Department of Corrections, Sacramento, CA.

McCarl-Nielson, Joyce (Ed.). (1990). *Feminist Research Methods: Exemplary Readings in the Social Sciences.* Boulder: Westview.

McCarthy, Belinda (1980). "Inmate Mothers: The Process of Separation and Reintegration." *Journal of Offender Counseling, Services, and Rehabilitation, 13,* 5–13.

—— (1979). *Easy Time: Female Inmates on Temporary Release.* Lexington, MA: D. C. Heath.

McClellan, Dorothy (1994). "Disparity in the Discipline of Male and Female Inmates in Texas Prison." *Women and Criminal Justice, 5* (2), 71–97.

McConnel, Patricia (1989). *Sing Soft, Sing Loud.* New York: Atheneum.

McCorkle, Richard (1993). "Personal Precautions to Violence in a Maximum Security Prison." Unpublished manuscript, Department of Criminal Justice, University of Nevada–Las Vegas.

McCullough, Malcolm, et al. (1994). "HIV Infection among New York State Female Inmates: Preliminary Results of a Voluntary Counseling and Testing Program." Paper presented to the Academy of Criminal Justice Sciences, Chicago, March.

McKenzie, Doris Layton, J. Robinson, & C. Campbell (1989). "Long-term Incarceration of Female Offenders: Prison Adjustment and Coping." *Criminal Justice and Behavior, 16* (2), 223–237.

Merlo, Alida, & Joycelyn Pollock (1995). *Women, Law and Social Control.* Boston: Allyn & Bacon.

Miller, Eleanor (1986). *Street Woman.* Philadephia: Temple University Press.

Miller, Marsha (1991). "Women Inmates and Recidivism in Delaware." Mimeo. Wilmington: Delaware Council on Crime and Justice.

——— (1990). "Perceptions of Available and Needed Programs by Female Offenders in Delaware." Mimeo. Wilmington: Delaware Council on Crime and Justice.

Mitchell, A. E. (1969). *Informal Inmate Social Structure in Prisons for Women: A Comparative Study.* Ph.D. dissertation, University of Washington.

Morash, Merry, Robin Haarr, & Lila Rucker (1994). "A Comparison of Programming for Women and Men and US Prisons in the 1980s." *Crime and Delinquency, 40* (2), 197–221.

Morris, Allison, Chris Wilinson, Andrea Tisi, Jane Woodrow, & Ann Rockley (1995). *Managing the Needs of Female Offenders.* Report from the Center for the Study of Public Order, University of Leicester, Leicester, United Kingdom.

Morris, Pauline (1967). "Fathers in Prison." *British Journal of Criminology, 7,* 424–430.

Moyer, Imogene L. (1985). *The Changing Roles of Women in the Criminal Justice System.* Prospect Heights, IL: Waveland.

——— (1984). "Deceptions and Reality of Life in Women's Prisons." *The Prison Journal, 64,* 127–139.

Naffine, Ngaire (1987). *The Construction of Women in Criminology.* London: Allen & Unwin.

National Institute of Corrections (1989). *NIC Special Topic Session: Women Offenders under Community Supervision.* Draft Report. Washington, DC: National Institute of Justice.

National Institute of Justice (1991). "Drug Use Forecasting." Washington, DC: National Institute of Justice.

Nielson, Joyce McCarl (1990). *Feminist Research Methods: Exemplary Readings in the Social Sciences.* Boulder: Westview.

O'Connor, Thomas (1994). "The Differential Impact of General Strain." Paper presented to the Academy of Criminal Justice Sciences, Chicago, March.

O'Leary, Margaret, & Don Weinhouse (1992). "Colorado Facility Helps Women Overcome Barriers to Education." *Corrections Today*, August, 194–199.

O'Melvveny, Mary (1992). "Portrait of a U.S. Political Prison." In W. Churchill and J. J. Vander Wall (Eds.), *Cages of Steel* (pp. 112–122). Washington, DC: Maisonneuve Press.

Oregon Department of Corrections (1991). "White Paper: Oregon's Female Offenders." State of Oregon, Salem, OR.

Owen, Barbara, & Barbara Bloom (1995a). "Profiling Women Prisoners: Findings from National Surveys and a California Sample." *The Prison Journal, 75* (2), 165–185.

———, & Barbara Bloom (1995b). "Profiling the Needs of California's Female Prisoners: A Needs Assessment." Washington, DC: National Institute of Corrections.

———, & Barbara Bloom (1994). "Pathways to Imprisonment: Women's Lives before Incarceration." Paper presented to the Academy of Criminal Justice Sciences, Chicago, March.

——— (1993). "Violence among Women Inmates: A Profile of Women in Security Housing Units." Paper presented to the American Society of Criminology, Phoenix AZ, October.

———, & Caryn Horwitz (1990). "Women's Prisons Revisited." Paper presented to American Society of Criminology, San Francisco, CA, November.

——— (1988). *The Reproduction of Social Control: A Study of Prison Workers at San Quentin.* Westport, CT: Praeger.

Parker, Edward, & Charles Lanier (1992). "An Exploration of Self-concepts among Incarcerated Fathers." Paper presented at the American Society of Criminology, New Orleans.

Paulus, Paul, & Mary Dzindolet (1993). "Reaction of Male and Female Inmates to Prison Confinement: Further Evidence of a Two-Component Model." *Criminal Justice and Behavior, 2* (2), 149–166.

Pearson, Jennifer (1993). "Centro Femenil: A Women's Prison in Mexico." *Social Justice, 20* (3–4), 85–126.

Pettiway, L. (1987). "Participation in Crime Partnerships by Female Drug Users." *Criminology, 25*, 741–766.

Pollock-Byrne, Joycelyn M. (1990). *Women, Prison, and Crime.* Belmont, CA: Wadsworth.

———— (1986). *Sex and Supervision : Guarding Male and Female Inmates.* Westport, CT: Greenwood.

Price, Barbara R., & Natalie J. Sokoloff (1982). *The Criminal Justice System and Women.* New York: Clark Boardman.

Propper, A. (1982). "Make-believe Families and Homosexuality among Imprisoned Girls." *Criminology, 20* (1), 127–139.

———— (1981). *Prison Homosexuality: Myth and Reality.* Lexington, MA: D. C. Heath.

Rafter, Nicole H. (1992). "Criminal Anthropology in the United States." *Criminology, 30,* 525–545.

———— (1985). *Partial Justice: Women in State Prisons, 1800–1935* Boston: New England University Press.

———— (1983). "Prison for Women, 1790–1980." In M. Tonry & N. Morris (Eds.), *Crime and Justice: An Annual Review of Research* (vol. 5, pp. 129–182). Chicago: University of Chicago Press.

———— , & Elizabeth Stanko (1982). *Judge, Lawyer, Victim, Thief: Women, Gender Roles and Criminal Justice.* Boston: Northeastern University Press.

Ray, Melvin C., & Earl Smith (1991). "Black Women and Homicide: An Analysis of the Subculture of Violence Thesis." *The Western Journal of Black Studies, 15* (3), 144–153.

Reinharz, Shulamit (1992). *Feminist Methods in Social Research.* New York: Oxford University Press.

Renaud, Jorge (1995). "Challenging the Convict Code." *Prison Life Magazine,* July–August, 30–35.

Resnick, Judith, & Nancy Shaw (1980). "Prisoners of Their Sex: Health Problems of Incarcerated Women." In Ira Robbins (Ed.), *Prisoners Rights Sourcebook: Theory, Litigation and Practice* (pp. 319–413). New York: Clark Boardman.

Rosenbaum, Jill Leslie (1993). "The Female Delinquent: Another Look at the Family's Influence on Female Offending." In R. Muraskin & T. Alleman (Eds.), *It's a Crime: Women and Justice* (pp. 399–416). New York: Prentice Hall.

———— (1991). "The Female Gang Member: A Look at the California Problem." Paper presented to the American Society of Criminology, San Francisco, November.

Rosenbaum, Marsha (1981). *Women on Heroin.* New Brunswick, NJ: Rutgers University Press.

Rothman, David (1971). *The Discovery of the Asylum.* Boston: Little, Brown.

Rubin, Lillian (1976). *Worlds of Pain: Life in the Working-Class Family.* New York: Basic Books.

Ryan, T. A., & James B. Grassano (1992). "Taking a Progressive Approach to Treating Female Offenders." *Corrections Today*, August, 184–186.

Ryan, T. A. (1984). *Adult Female Offenders and Institutional Programs: A State of the Art Analysis*. Washington, DC: National Institute of Corrections.

Sanchez-Jankowski, Martin (1991). *Islands in the Street: Gangs and American Urban Society* Berkeley: University of California Press.

Schissel, Bernard (1992). "Degradation, Social Deprivation and Violence: Health Risks for Women Prisoners." Paper presented to the American Society of Criminology, New Orleans, November.

Schrag, Clarence (1944). *Social Types in a Prison Community*. Unpublished M.A. thesis, Department of Sociology, University of Washington.

Schwartzman, Helen (1993). *Ethnography in Organizations*. Newbury Park: Sage.

Selling, L. S. (1931). "The Pseudo-family." *American Journal of Sociology*, *37*, 247–253.

Simon, Rita J., & Jean Landis (1991). *The Crimes Women Commit and the Punishment They Receive*. Lexington, MA: Lexington Press.

Smart, Carole (1976). *Women, Crime and Criminology: A Feminist Perspective*. London: Routledge & Kegan Paul.

Smith, Douglas, & Raymond Paternoster (1987). "The Gender Gap in Theories of Deviance: Issues and Evidence." *Journal of Research in Crime and Delinquency*, *24*, 140–172.

Sommers, Ira, Deborah Baskin, & Jeffrey Fagan (1994). "Getting Out of the Life: Crime Desistance by Female Street Offenders." *Deviant Behavior*, 15, 125–149.

———, & Deborah Baskin (1992). "Sex, Race, Age and Violent Offending." *Violence and Victims*, *7* (3), 191–201.

Spradley, J. (1979). *The Ethnographic Interview*. New York: Holt, Rinehart & Winston.

Stanton, A. (1980). *When Mothers Go to Jail*. Lexington, MA: Lexington Books.

State Concurrent Resolution 33 Commmission (SCR 33), California State Legislature (1993/4). *Final Report on Female Inmate and Parolee Issues*. Sacramento, CA: California Department of Corrections.

Steffensmeir, Darrell (1983a). "Organization, Properties and Sex Segregation in the Underworld." *Social Forces*, *61*, 1010–1032.

——— (1983b). "Sex Differences in the Patterns of Adult Crime: 1965–1977." *Social Forces*, *58* (4), 1080–1109.

——— (1982). "Trends in Female Crime: It's Still a Man's World." In B. R. Price & N. Sokoloff (Eds.), *The Criminal Justice System and Women* (pp. 89–104). New York: Clark Boardman.

——— (1980). "Assessing the Impact of the Women's Movement on Sex-based Differences in the Handling of Adult Female Defendants." *Crime and Delinquency*, 26, 340–356.

Straus, M. A., & R. Gelles (1980). *Behind Closed Doors: Violence in American Families*. Garden City, NY: Anchor.

Straus, M. A., R. Gelles, & S. Steinmetz (1990). *Physical Violence in American Families*. New Brunswick: Transaction.

Strickland, K. (1976). *Correctional Institutions for Women in the U.S.* Lexington, MA: Lexington Books.

Sykes, Gresham, & Sheldon Messinger (1960). "The Inmate Social System." In R. Cloward (Ed.), *Theoretical Studies in the Social Organization of the Prison* (pp. 5–19). New York: Social Science Research Council.

——— (1958). *Society of Captives*. Princeton, NJ: Princeton University Press.

Tittle, Charles (1969). "Inmate Organization: Sex Differentiation and Influence of Criminal Subcultures." *American Sociological Review*, 34, 492–505.

Ward, David, & Gene Kassebaum (1965). *Women's Prison: Sex and Social Structure*. Chicago: Aldine-Atherton.

Warren, Marguerite (1981). *Comparing Male and Female Offenders*. Beverly Hills, CA: Sage.

Watterson, Kathryn (1996). *Women in Prison: Inside the Concrete Womb*. Boston: Northeastern University Press.

——— (1973). *Women in Prison*. New York: Doubleday.

Wax, Rosalie H. (1982). "The Ambiguities of Fieldwork." In Emerson, R., op. cit., pp. 175–190.

Weishit Ralph, & Sue Mahan (1988). *Women, Crime and Criminal Justice*. Cincinnati: Anderson.

Wellisch, Jean, M. D. Anglin, & M. L. Pendergast (1994). *Drug Abusing Women Offenders: Results of a National Survey*. Washington, DC: National Institute of Justice.

Widom, Cathy Spatz (1989). "Child Abuse, Neglect, and Violent Criminal Behavior." *Criminology*, 27 (2), 251–366.

Williams, Larry, L. T. Winfree, & H. E. Theis (1984). "Women, Crimes and Judicial Dispositions: A Comparative Examination of the Female Offender." *Sociological Spectrum*, 4, 249–273.

Williams, Virgil, & Mary Fish (1974). *Convicts, Codes and Contraband*. Cambridge, MA: Ballinger.

Wooldridge, John D., & Kimberly Masters (1993). "Confronting Problems Faced by Pregnant Inmates in State Prisons." *Crime and Delinquency, 39* (2), *195–203*.

Wright, Kevin (1989). "Race and Economic Marginality in Explaining Prison Adjustment." *Journal of Research in Crime and Delinquency, 26* (67), 89.

Zalba, S. (1964). *Women Prisoners and Their Families*. Albany: Delmar.

Zimmer, Lynn (1986). *Women Guarding Men*. Chicago: University of Chicago Press.

Zupan, Linda (1992). "Men Guarding Women: An Analysis of the Employment of Male Correctional Officers in Prisons for Women." *Journal of Criminal Justice, 20*, 297–309.

Subject Index

A

abuse, 41; impact of 44, 48–49; multiplicity of, 41, 42; return to after imprisonment, 190; survey data, 42–43; spousal, 51, 54; and trust issues, 44; "Worlds of Pain," 42. *See also* pathways to imprisonment

access to prison. *See* research methods

Administrative Segregation (Ad Seg): daily routine, 114; reasons for being sent, 113; term length, 114

age, 85; generational conflict between inmates, 176, 177

Axes of Life, 167

A Yard, 74, 113; Ad Seg, 74, 113; geography of, 112; processing, 79; programming, 80. *See also* Administrative Segregation; CCWF; Receiving and Release; Security Housing Unit

B

body receipt, 75

B Yard: special needs inmates, 100; specialized medical unit, 86. *See also* disabled inmates

C

California Institute for Women (CIW), 5, 37, 47, 69; compared to CCWF, 69, 70–71

California Youth Authority (CYA), 46, 49

CCWF (Central California Women's Facility) 5, 9, 63; bubble, officer station, 34; control center, 26; education building, 30; family visiting units, 25; geography of, 25–26, 28–29; Receiving and Release, 29, 74–79; size, 5

child offenses, 111, 112; "baby-killers," 111; "child-case," 121; privacy regarding, 112; scorned, 121

children, 54, 119, 127; effect of imprisonment on, 121, 123, 127; importance of, 54, 120, 121; motherhood, role of, 11, 12, 13, 58, 121; reunification with, 121; survey data, 120, 120; visitation, 127–29

classification, 64

commissary purchases, 104

condemned row, 117

controlled movement, 75

convict code, 175; allegiance to, 176; doing own time, 176;

Author Index

A

Adler, Freda, 4, 11
American Correctional Association
 (ACA), 10, 101, 120
American Friends Service Committee, 195
Anglin, M.D. and Hser, Y., 44
Austin, James, 13

B

Baskin, Deborah, 10
Baunach, Phyllis J., 1, 4, 16, 120, 121
Belknap, Joanne, 195
Berg, Bruce, 19, 24, 28
Bloom, Barbara, ix, 1, 11, 14, 16, 36, 41,
 55, 64, 88, 97, 100, 120, 121, 192, 194
Bottcher, Jean, 49, 50, 58
Bowker, Lee, 197
Browne, Angela, 16
Bureau of Justice Statistics (BJS), 10, 101

C

Cales, Gloria, 4, 120, 121
California Department of Corrections
 (CDC), 45, 65
Campbell, Anne, 157
Carroll, Leo, 3, 152, 157, 159, 193
Carter, Barbara, 152
Chesney-Lind, Meda, 1, 9, 10, 11, 14,
 15, 41, 43, 49, 50, 157
Clemmer, Donald, 3, 63, 193
Cloward, Richard, 193
Cook, Judith, 23
Cressey, Donald, 3, 6, 41, 175, 193
Currie, Elliott, 15, 49

D

Daly, Kathleen, 15
Datesman, Susan K., 4, 120, 121
Davidson, R. Theodore, 3, 152,
 193
Dixon, Linda Shaver, 1, 194
Dobash, R. Emerson, 4, 194
Dobash, Russell P., 4, 196
Downs, William, 196

E

Emerson, Robert, 21, 24
Ewing, C., 16